ORIENTAL WATERCOLOR TECHNIQUES

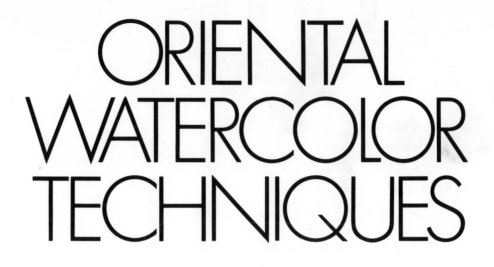

Happy May 20th 1989

Mary Lou

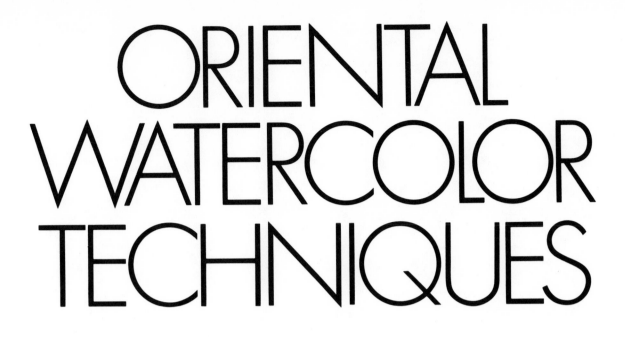

ORIENTAL WATERCOLOR TECHNIQUES

BY FREDERICK WONG

WATSON-GUPTILL PUBLICATIONS/NEW YORK

PITMAN PUBLISHING/LONDON

Paperback Edition
First Printing 1983

Copyright © 1977 by Watson-Guptill Publications

First published 1977 in New York by Watson-Guptill Publications,
a division of Billboard Publications, Inc.,
1515 Broadway, New York, N.Y. 10036

Library of Congress Catalog Card Number: 77-24976
ISBN 0-8230-3390-2
ISBN 0-8230-3391-0 pbk.

Distributed in the United Kingdom by Phaidon Pres Ltd., Littlegate
House, St. Ebbe's St., Oxford.

Manufactured in U.S.A.

 4 5 7 8/88

ACKNOWLEDGMENTS

I was given my first watercolor set in 1943 by an old family friend named Harley F. Drollinger. It came in a cardboard box complete with brushes, palette, and *tubes* of pigment! To complete the package, Mr. Drollinger included a watercolor "pad," obviously sealed by mistake on all four edges, and lastly, a small, slim text.

This book was, perhaps, the most remarkable gift of all. It was Eliot O'Hara's *Making Watercolor Behave.* I can recall to this day how unbelievable it seemed that those magnificent paintings and demonstrations could evolve from the same materials I now had at hand. I can also remember reading the text avidly, but I did not squeeze those glistening tubes or mar the pristine whiteness of that beautiful block of papers until months passed.

That is how my involvement with the watercolor medium began thirty odd years ago. To get from "there" to "here" could not have been accomplished without the help and understanding of many kind and talented people. Al and Grace Gentsch, Bernard and Hildegarde Rooney, Lez Haas, Ralph Douglass, Randall Davey, and John Tatschl were some of the many fine instructors I had from elementary school through college, all of whom I recall with fondness and respect. Each made invaluable contributions toward my development as a painter and, along the way, instilled in me a love for drawing and a respect for tools.

Professionally, I owe much to Chi Kwan Chen, who initiated my interest in Oriental materials through the example of his own beautiful paintings. He also introduced me to Frank Cho, owner and director of Mi Chou Gallery in New York City, my first professional affiliation. Ned and Pei Owyang, subsequent directors of Mi Chou, gave me my first one-man exhibition. Harry Kulkowitz, director of the Kenmore Galleries in Philadelphia, and Doug Jones, of the Jones Gallery in La Jolla, California, have seen me through many lean periods.

Ted Kurahara, with whom I shared my first loft-studio, and Joe Phillips, my current partner, are painters and friends of long standing. They were both instrumental in initiating my involvement in teaching, first at Pratt Institute in Brooklyn and then at Hofstra University in Hempstead, New York.

Private collectors such as Mrs. James M. Skinner, Jr., Mr. and Mrs. Francis C. Huntington, Mr. and Mrs. J. Dennis Delafield, Mr. and Mrs. William E. Little, Mr. Roy R. Neuberger, Mr. Ben F. Rummerfield, and many others have been enormously supportive with their continuing interest in my work.

Finally, none of this would have been possible without the support of my family. My mother, widowed early with six small children, never questioned my interest in art at a time when all male members of Chinese families growing up in America during the Second World War were directed into the physical sciences in order to learn skills which could eventually be used to rebuild a devastated homeland. My brothers and sisters gave of their time, energies, and funds to see me through many troubled, indecisive times, and I hold them all in deep and abiding affection. And now my wife, Yvonne, and our two little girls, Mary Kendall and Kim Meredith, have extended this long line of friends and relatives who have given me their love, understanding, and encouragement. To all of them, with love and respect, I dedicate this book.

CONTENTS

Introduction 8

1. BRUSHES 10
Characteristics of the Brush 11
Western Brush 11
Oriental Brush 11
Creating Brushes 12
Holding the Brush 14
Old Versus New Brushes 14
Other Tools 18

2. PAPERS 22
Absorbent Papers 23
Nonabsorbent Papers 24
Paper Composition 24
Chinese Papers 24
Japanese Papers 24
Paper Thicknesses 26
Colors and Textures 26
Paper Sizes 28
Care, Handling, and Storing 28

3. WASHES 30
Controlling Washes 31
Flat Wash 31
Graded Wash 32
Multiple Wash 32
Free-flowing Wash 34
Restricted Wash 38
Wash Into Wash 38
Wash Against Wash 38
Estimating Your Paper's Moisture 38
Directional Flow 41

4. STROKES AND TEXTURES 42
Oriental Versus Western Watercolor 43
Try a "Brushstroke Painting" 43
Demonstration 1. Halloween 58
Demonstration 2. Queens Plaza 63

5. SPECIAL EFFECTS 68
Wet Paper 69
Limited Wetting 69
Supplementary Techniques 70
Wet and Dry Crinkling 72
Back Painting 75
Limitations 75

6. TREES AND VEGETATION 76
A Tree's Structural Pattern 77
Trunks and Branches 77

Foliage 77
The Total Tree 78
The Forest 78
Shrubbery, Fields, and Grasses 82
Seasonal Changes 82
Demonstration 3. Morning in Summer 84

7. SKY, WATER, AND FOG 88
Effects of Light 89
Clear Sky 89
"Empty" Sky 90
Cloud Forms 90
Bodies of Water 90
Reflecting Surfaces 92
Water Movements 92
Forms in Fog 96
Demonstration 4. Fog This Evening 97

8. STRUCTURES 100
Understanding Solid Forms 101
Understanding Structural Groups 101
Simplifying Structural Groups 104
The Skyline 104
Streets and Bridges 104
Rural Structures 106
Check Your Viewpoint 106
Structural Details 106
What to Include 106
Demonstration 5. Bridge 107

DEMONSTRATIONS AND GALLERY 112
Demonstration 6. Scholar 113
Demonstration 7. Vendor 116
Demonstration 8. Summers Ago 120
Demonstration 9. Lion Dance 123
Demonstration 10. Returning 128
Gallery 129

9. MOUNTING AND FRAMING 138
Mounting Materials 139
Mounting and Countermounting 139
Matting Materials 142
Mat Proportions and Cutting 142
Single and Double Mats 144
Fabric-covered Mats 144
Framing Materials 146
Assembling Procedure 148
The Studio 149

Bibliography 150
Index 151

INTRODUCTION

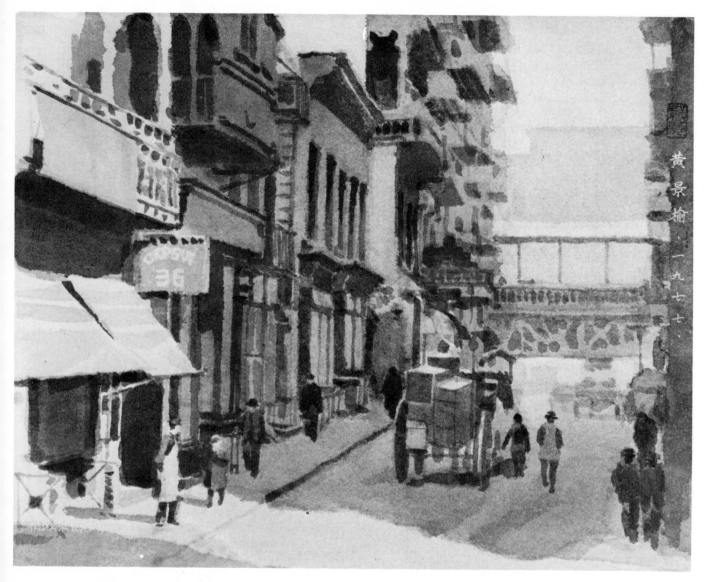

Pell Street, *14" x 19" (36 x 48 cm), collection of the artist. This painting, commissioned for a television documentary, was developed from a very grainy black-and-white photograph of historical Chinatown in New York City taken some sixty years ago. In this case, the use of such vague pictorial reference material proved to be a blessing in disguise. The very lack of definition in the photograph permitted me more latitude in personal interpretation. I was able to focus on basic structural forms without being overly distracted by architectural details. Compositionally, the painting is quite simple. The perspective is essentially one point, with the street moving directly away from the viewer. The angularity of the scene is softened by the light source, creating a variety of shadows, which in turn, establish a strong sense of space and three-dimensionality.*

HAVING NEITHER the skill, knowledge, nor insight, I would not presume to instruct you in classical Oriental painting techniques. Painting in the Orient is a time-honored skill developed through an understanding of calligraphy and its attendant tools and materials. Even today, Oriental watercolors relate more closely to calligraphic — drawing — skills than to the more familiar Western approach, which calls for the manipulation of larger color forms. Accurate representation of nature is not critical in Oriental painting, but the successful realization of the emotional impression of natural forms in their environment is paramount.

In this text, you and I will be concerned with the tools and materials of the East and how to adapt them for Western watercolor painting. Hopefully, with greater understanding of these unfamiliar materials, you will develop sufficient interest to lead you to deeper investigations and experimentations of your own. The end result may be paintings which will combine both Western and Oriental attitudes into unique works of a highly personal character.

My paintings were influenced by a host of watercolorists whom I've long admired and, in some cases, tried to emulate in the pursuit of "style." When it became obvious that I could not be "them," my only recourse was to use all the things I had learned from these talented painters and simply be myself.

My experimentations with Oriental tools in combination with the more familiar Western materials has led to paintings of nature in which I use soft colors in uncomplicated compositions. It has proven to be a very satisfying way for me to convey my feelings for nature in its many changing, shifting forms.

I am not particularly concerned with specific scenes and places. I am more taken with the idea that my paintings should represent the "universal" landscape, cityscape, or still life. If my painting of a harbor should remind you of Stony Brook Harbor, that's fine. It is only significant that I've successfully painted for you and for me the *feeling* of a harbor, bathed in a soft morning sunlight.

Many of my paintings are developed from memories of other times and places. Given a little stimulation—a nudge to my senses, a sound, perhaps changing light or time of year—a mental picture is sometimes recalled. The outlines may be blurred, but emotional clarity is there.

I would like to suggest a final thought to you. The more competently you develop your drawing skills, the happier you will be with your paintings. If you should find the progress of a painting disquieting, it may be your inability to logically and accurately locate forms in space rather than any shortcomings in the technical handling of tools and pigment.

In the chapters here I will introduce a variety of materials and techniques which may be unfamiliar to you. I think you will find the experience of using these "new" old tools provocative and rewarding. I wish you well.

1. BRUSHES

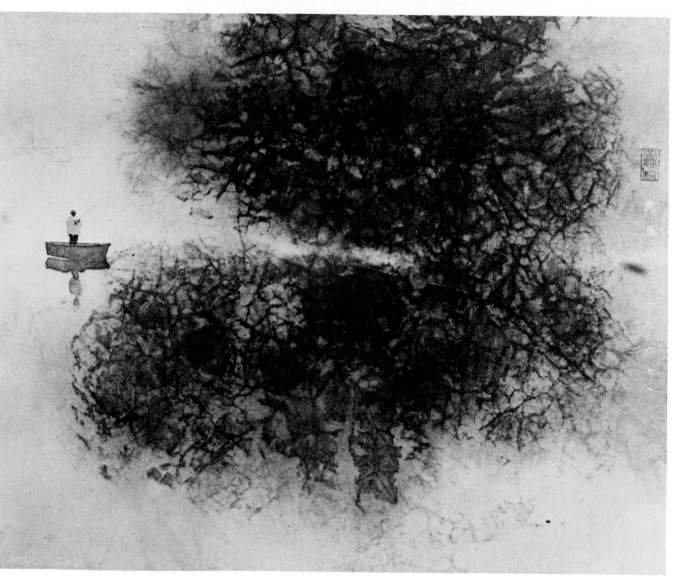

Idyll, *15" x 19" (38 x 48 cm) private collection. The major problem in this painting was in controlling contrasts —large against small, dark against light, and a sense of peace against agitation. Because the large tree mass and its reflection dominated the center of the painting, it was imperative to balance this force by including the image of the small, calm fisherman casually standing in his rowboat, casting into the mass of shadows and reflected agitation. The mirror reflection of the man and boat suggests there is no strong movement in the water's surface, just as the cast image of trees, although active in appearance, conveys the feeling of calm waters through the clarity of its form.*

I HAVE A large painting hanging in my studio. It contains one Chinese word, the calligraphic symbol for "Buddha." It is a beautiful piece of work, painted with black ink, and the strokes are confident, vigorous, and precise. The painting is three feet by five feet—and the artist used a household broom for a brush! In the hands of this talented calligrapher, the broom became the ideal tool, as fully satisfying and functional as a red sable brush might be for you and me.

CHARACTERISTICS OF THE BRUSH

The brush, for all its many sophisticated functions, is really a very simple instrument. It is no more than a handle to which a bundle of hairs have been attached. Its basic function is to carry and distribute a quantity of pigment onto a surface. Given this simple description, it is astonishing to realize the large variety of brushes available to the painter. Brushes can differ in the type of hair and its quality and quantity, in the length of hair both outside and inside the ferrule, and in the manner in which the hairs are bound together. The handle can also vary in length, shape, and thickness.

The demands which we impose on our brushes determine which brush will best serve our needs. The calligrapher who did the painting on my wall used a broom, not for the novelty of it, but because it gave him the performance his artistic expression required.

What should we, as watercolorists, require of our brushes? I think you would agree that our brushes should do what we *ask* of them—consistently and well. Specifically, I like my brushes to maintain a precise point if they are round, and a clean edge if they are flat. The hairs should be resilient with a quality I describe as "bounce," which means the ability to return quickly to their original shape when excess water is shaken out. The feel of the whole brush should be evenly balanced in the hand, without being heavy at the head or handle.

Brushes are very personal tools. Like a comfortable pair of shoes, they should "feel" right. That degree of comfort develops through continuing and satisfying use. I enjoy tools that I have used over the years, sometimes to the point where they have passed the stage of meaningful service. With considerable reluctance, I then try to find other uses for them. To avoid having to break in a new brush at a critical time, I would suggest using several brushes of identical size and quality alternately—much as a good tennis player will use several racquets of uniform weight and stringing—to avoid the traumatic possibility of one day having to change to a fresh, untried tool at a critical moment.

WESTERN BRUSH

The finest Western watercolor brush is a meticulously conceived painting instrument, a product of both hand and machine. While there are other serviceable watercolor brushes on the market, it is the red sable brush that is the standard by which others are judged. Made from selected tail hairs of the kolinsky—also known as the Siberian mink or the red Tartar marten—this brush maintains its point easily and naturally. Dipped into water, a brush of this quality will reform its point quickly when shaken. I maintain several red sables in my collection of brushes, ranging in size from a #4 to a #12.

ORIENTAL BRUSH

In order to use the Oriental brush effectively, it is essential to understand that it was first designed as a writing tool. Calligraphy — the art of writing — was, and is, an extremely high art form in the East. The instrument developed for writing is the identical brush that the Oriental artist uses for painting. Oriental painting depends upon the skillful use of brushstrokes—in contrast with Western painting, which makes

greater use of masses of color and tone. Quality calligraphy and quality painting, therefore, are inseparable in the Orient.

The Oriental brush, then, is a tool that essentially *draws* rather than paints. Because of this important distinction, the construction of the Oriental brush and the manner in which it is used are considerably different from its Western counterpart.

The handle is commonly made from a small length of hollow bamboo, although more precious materials such as gold, jade, silver, and ivory have been used in the past. Bamboo, however, is functionally ideal, combining with the tuft of hair to form a very light, maneuverable tool which can react quickly and fluidly to the skilled manipulations of the painter.

Brush hair, of course, is the most critical part of any brush and is usually the factor which determines the price. (Five years ago, the hairs of the famed red sable brush cost an estimated $1,500 per pound!) There are recorded cases of brushes having been made from selected babies' hair, mouse whiskers, or chicken down. Fortunately for our wallets, the selection of hair for Oriental brushes has become more practical: now in common use are sheep, wolf, and rabbit hair. Wolf hair is brown and sturdy and ideal for strong stroking. Sheep and rabbit hairs are white, softer than wolf hair, and can be used for both bold and delicate work.

One additional part to the Oriental brush is worthy of mention. A new brush will have a tubular cap of bamboo, fitted tightly over the hair end for protection. This covering may also be made of cone-shaped metal or clear plastic and is folded at the tip. After a brush has been used and cleaned, it should be reshaped and allowed to dry in the air. So trying to reinsert a brush into the cap would risk damage to the hairs. There is also the hazard of mold forming on the hairs if the brush is recapped when still damp. So, once the brush has been used, this cap should be discarded and not saved for reuse.

CREATING BRUSHES

A brush is an ideal instrument for both painting and calligraphy because it can serve the *general* function of laying down pigment and the *specific* function of controlling the paint. When it falls short of our expectations, the cause is most likely our inability to exercise the degree of control we would like. With the great variety of brushes on the market, both Western and Oriental, I think it is safe to say that virtually all our technical needs can be satisfied.

In ancient China, the painter-calligrapher would, as a matter of course, devise his own brushes to suit his specific needs. There are recorded cases of artists using sugarcane stalks, the tips of which had been sucked and squeezed dry, or the fibers of a particular species of mountain bamboo, which, when incorporated into a brush, could draw lines as crisp and clean as a sword cut.

I do not create brushes. Occasionally I will restyle an old brush in an attempt to solve some textural problem in a novel way. I save many of my well traveled, disreputably worn brushes for this reason. These are the brushes I feel free to play with. With a single-edge razor blade, I will try to alter the configuration of the hair by gently scraping from the ferrule outward to the tip. If I feel particularly adventurous, I might draw the brush across the surface of a fine-grade sanding block several times. This will fray the hairs unevenly and remove those hairs which are partially broken. The result should be a brush that is interesting precisely because it is functionally unpredictable.

One fact that you should keep in mind when you are "creating" a brush is simply that you want to develop the unfamiliar result. The well-made commercial brush is designed to be predictable — and rightly so. You are paying a premium price for a sturdy brush that will hold its point or edge. In attempting to restyle a brush, you are really hoping for a result that will suggest spontaneity, and perhaps even conceal the fact that the brush was the performing tool.

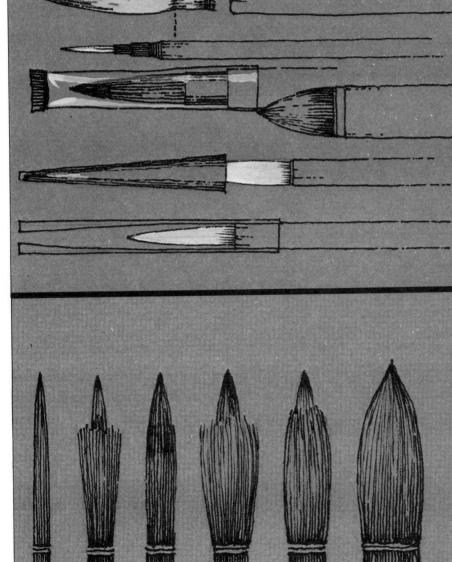

Western Watercolor Brush. *The Western watercolor brush is made in three parts: the hair (top left) shown tied at the belly, which is the thickest part of the hair; a seamless metal ferrule (top right); and a wooden handle (center). The drawing of the brush in cross-section (bottom) shows the construction of the brush. Note the length of the hair inside the ferrule compared to that portion of hair outside; ideally, a good watercolor brush will have at least as much, if not more, hair inside than outside. This concealed portion of hair is tied, inserted into the metal binding, and given a drop of setting compound, the dark patch, to hold the hairs in place. The larger end of the ferrule is then tightly crimped to the wooden handle.*

Oriental Brush. *The top drawing shows the two-part construction of the round Oriental brush; the dotted line across the base of the hair indicates the approximate depth of insertion of hair into the bamboo handle. Reading downward, the second brush is thin, has very few hairs, and is set into two narrow cylinders somewhat resembling a ferrule. The third brush has a clear plastic protective cap over the hair, the fourth brush is short and stubby, made from wolf's hair, and the fifth has a cone-shaped metal cap. At bottom is a cross-section of a bamboo cap, illustrating the inside taper.*

Construction of Oriental Brush. *Unlike the Western brush, whose hairs are gathered to form a natural point, the Oriental brush is built around a central core. The brush is increased in circumference as layers of hair are added to the core. When the desired size has been reached, the bundle of hair is tied, glued, and inserted into the open end of the bamboo handle.*

HOLDING THE BRUSH

In calligraphy, the Oriental brush is traditionally held vertical to the paper and at right angles to the axis of the wrist. In addition, it should be dead center to the writing surface, tilting neither left nor right. This represents the standard, classical posture for Oriental calligraphy. The brush is held a little closer to the hairs for writing small characters and at the far end for larger, bolder stroking.

In the act of writing with a brush, the fingers and hand move as a unit, with a minimal amount of wrist action. The brush is never "wiggle-waggled," which would mean that the fingers are applying uneven and unneccessary pressure to the brush. The wrist is held level and in light contact with the table surface, while the underside of the lower arm is in contact with the table for support. In writing small symbols, the left hand is sometimes placed underneath the right wrist.

However, writing large characters requires almost unbelievable mental and physical discipline. The strokes are so broad and exuberant that the entire arm must be brought into play. For the arm to move freely and fluidly, the artist-calligrapher must suspend it entirely off the writing surface, allowing only the tip of his brush to touch the paper. And once the brush contacts the paper, the stroke must begin immediately! You can readily see that there is no room for hesitation at this point. The brush is held lightly, the wrist is firm, the elbow will flex, the shoulder will rotate, but the total concentration of the artist is focused on the tip of his brush and the imminent action of his first stroke.

Oriental calligraphy is an exacting art, involving great discipline, and it is only after the standard grip has been mastered and brush rapport totally established that certain individual variations are considered acceptable.

Traditional Oriental *painting* permits greater flexibility in the ways the artist can hold the brush. While the calligrapher must hold the brush absolutely perpendicular, the painter can manipulate the brush in any manner, holding it in any grip which will give him the strokes of the character he desires. However, since the painter and calligrapher are often one and the same person, those skills and the sense of discipline evident in the calligraphy will be equally obvious in the painting.

Holding the brush in the manner of the Oriental calligrapher is fine—if you have been trained for years in this tradition. It would be an interesting experiment for you to try this grip in some painting exercises, if only to realize the amount of physical discipline and concentration needed to establish any kind of control over the tip of the brush.

For our purposes, I would definitely advise the more comfortable Western grip, which means holding the brush as you would a pencil. The key here is simply to be comfortable. For broader stroking and for less precise work, I tend to grip the brush toward the end of the handle. As the painting develops and more details are needed, my grip shifts downward, closer to the hairs.

OLD VERSUS NEW BRUSHES

The difference between new and old brushes is really a matter of how you feel about old friends and new acquaintances. Most of us have several trustworthy companions, tested and found reliable through time and experience, as well as new friends who are yet to be tried, but who look promising. It is pretty much the same with brushes, or, for that matter, with any tools we use frequently. Instinctively, I reach for the familiar brush, knowing in advance how it will perform. But there does come a time, of course, when the old brush will not do the job. When this happens, it is unnerving not to have an immediate replacement. In recent years, I have made it a practice to break in identical brushes, two at a time. Since I rarely work with more than four brushes at any one time — usually one sable, one round bamboo, and two square-ended hakes (small and medium)—it is not difficult to keep track of those in use and the ready substitutes.

While the new hake brush requires no breaking in beyond the attention given to any new Western brush, the round bamboo needs one preliminary step. In the store,

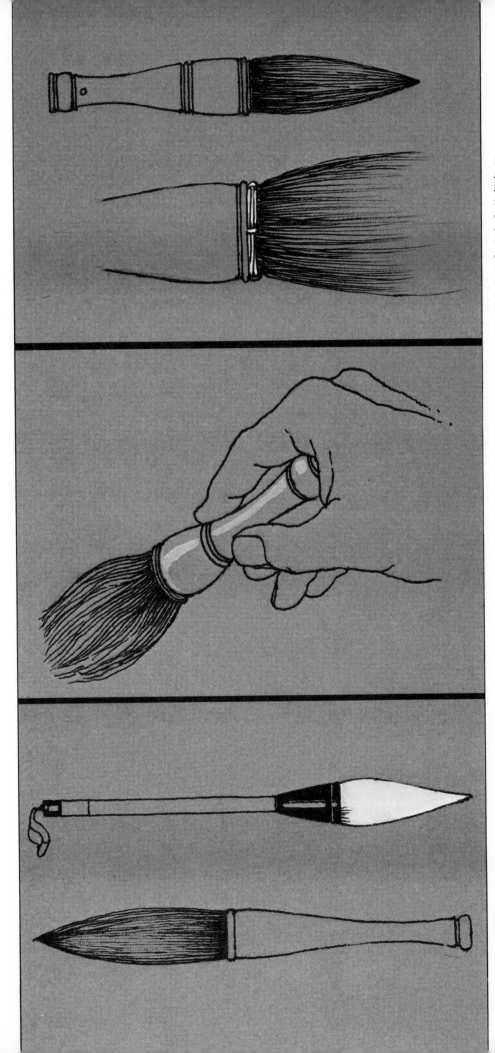

Short-handled Brush. *This stout, short-handled little brush was designed for bold, calligraphic stroking, its total length almost equally divided between 3 inches of hair and 3¾ inches of handle. When new, the hair is held to a point with a starch solution. After it has been used, the hair will flare more. The enlarged detail shows wire binding at the base of the hair, but outside the handle. At the juncture of hair and handle, the brush measures 1 inch in diameter.*

Holding Short Brush. *Because this brush has such a short handle, you should hold it between the thumb and fingers, with the base nestled against the upper palm. The handle is short and bells out to accommodate the large bundle of hairs; thus there is a definite, and probably deliberate, imbalance toward the end of the head. Used properly, the action of this brush would be similar to the swing of an ax in the hands of a skilled woodsman: the heavy ax head would do most of the work, and the hands of the woodsman would impel and guide the stroke.*

Two Variations. *These represent variations of the short-handled brush. Both have longer handles and should be gripped closer to the top for balance. The Chinese brush with a straight handle, shown at the top, may be held in the classic manner, but the stouter, more contoured handle on the Japanese brush below, Shodo Hokoku, is more comfortably gripped with the base against your palm or held like a pencil in the Western fashion. The Japanese version has the same rough configuration as the Chinese, but the handle is longer than the hair. Also, the hairs are softer and will hold a point when wet, whereas the hairs of the stubby Chinese brush, are more bristlelike and will not gather easily to a point.*

Rare Bamboo Brush. *I have a single stalk of bamboo that was made into a brush (top) without any gluing, tying, ferrule, or hair! The center drawing shows how the brush portion is actually the natural bamboo fibers. As you see at the bottom, stroking is unpredictable—at least for me—ranging from very fine to heavy and bold. Sent to me from Japan years ago, the brush is about 16 inches long. To create this brush, the bamboo was stuck into the ground and allowed to stand for several months until the bacterial action of the soil broke down all but the filaments. This soft, fibrous portion became the brush, while the part left above ground served as the handle.*

Hake Brushes. *My favorite wash brush is the Japanese hake—or flat brush—made from horsehair, with a chiseled edge and a flat handle. The two hake brushes at the top show the change in handle configuration to accommodate the greater width of hair. The vertical profile view at left illustrates the manner in which the hair is clamped between the two flanges of the handle, with a remarkably short length of hair held in place. In the enlarged detail at lower right, two parallel rows of stitching—one through both the flanges and the hair, the other just through the flanges—lock the hair tuft in place. Hake brushes are available in widths ranging from ½ inch to approximately 5 inches. Handles are generally close to 10 inches long. In addition to its ability to carry a full charge of liquid, it also can be used effectively as a mounting tool.*

Broad Brushes. *The two "fluted" brushes shown here are actually contructed of a series of round Chinese brushes doweled together side by side. They can be used for washes, but are probably better suited for mounting paper. The longer one consists of 18 units bound together to create a brush 7½ inches wide; the hairs are 3 inches long, and the handle is cut in a gently curving arc to a maximum of 3½ inches. The other brush has a handle twice as long as the hair.*

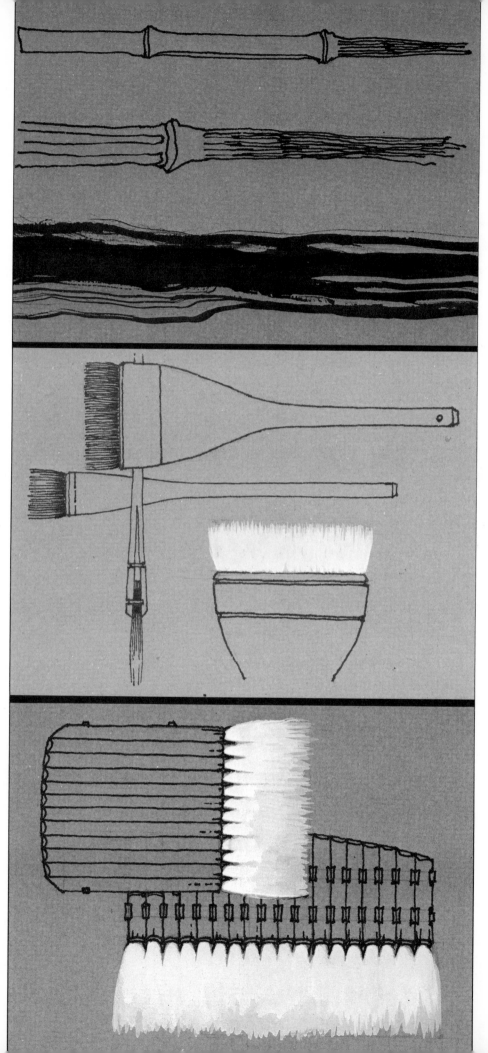

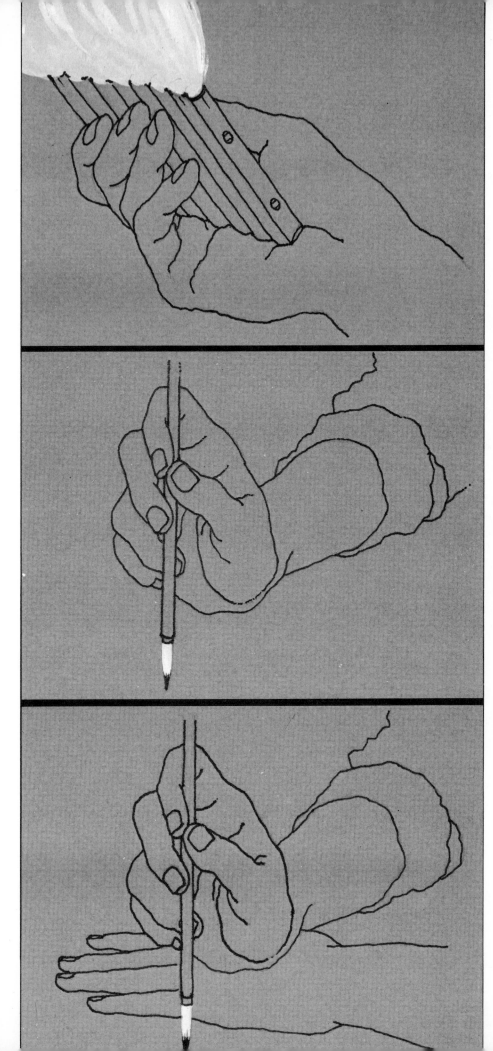

Holding the Broad Brush. *This brush is held with the entire hand —the curved base flush against the palm—and wielded like a wallpaper brush.*

Traditional Brush Grip. *In traditional Oriental calligraphy, the brush is held perpendicular to the paper surface, with the hand tilted upward at the wrist. The brush is held lightly, but firmly, in place with the first three fingers and thumb. The little finger rests lightly against the third finger. The ball of the thumb contacts the back surface of the brush, while the index and middle fingers touch the front. Held vertically in this position, the brush will then rest against the knuckle of the third finger. The fingers should never curl tightly inward, forcing the brush to come into contact with the palm. Properly positioned, the brush will be suspended lightly, with no tension or stress felt in the arm, wrist, or fingers.*

Supporting the Hand. *Sometimes the left hand is used to pillow the right wrist when writing small characters or drawing details.*

the hairs are usually held to a sharp point by a thin coating of starch, which must be worked out before the brush is used. To do this, dip it in clear water and gently work the point against the side of your paint dish or on the surface of your palette. Keep in mind that this brush does not have a metal ferrule; undue pressure may crack the bamboo holder.

If you intend to use this brush primarily for stroking, I would suggest *not* removing all the starch solution from the entire length of hair. A little stiffness at the juncture of hair and handle will help you retain the point more easily. On the other hand, if you want the brush to carry more liquid, then you should gently work out all the starch. This will free the hairs, allowing them to flare more and hold a greater amount of wash as a result

OTHER TOOLS

While the brush is the ideal tool for carrying and distributing pigment, there are other instruments we can use if precision and control are not critical factors. Many of these tools are alternate means of developing textures or clever ways to move a large quantity of wash to cover a large area. A good natural sponge can soak up a substantial amount of liquid, and you can then squeeze it over the paper surface. This particular attack is effective with Oriental papers (which are discussed in Chapter 2, "Papers"), since the sponge does not contact the soft surface, and there is no possibility of damaging the paper by abrasion. The delicate Oriental papers preclude the use of any rough or sharp instrument, no matter how inventive.

I have occasionally used an eyedropper or the top of an India ink bottle in an attempt to work smaller areas with some degree of control. A plastic squeeze bottle will serve the same purpose.

Cleansing tissue is a material which can be used to imprint color areas in direct contact with watercolor paper. The tissue is crumpled and balled while dry, then dipped into the wash mixture. The moist ball of tissue can then be used to imprint directly, or can be carefully opened and placed flat onto the Oriental paper — but never rubbed! If the tissue is sufficiently wet, colors will spread quickly into the paper. However, if the tissue is only damp, a slightly moistened hake brush can be used to pat the tissue to release more color into the painting surface.

Several pieces of freely torn tissue, coated with wet color and applied in overlapping layers, provide another interesting technique. Mounted paper (discussed in Chapter 9, "Mounting and Framing"), is a more feasible ground for this attack. The tissue is gently put into place while wet and allowed to dry in place. Once dry, the layers are lifted off easily. A plastic spray bottle can also create interesting effects when used in conjunction with this process. Allow the layers of tissue to dry partially. Then spray the area with a fine mist, causing the color washes to run. After the total surface has completely dried, remove the pieces of tissue. There should be an interesting combination of hard- and soft-edge washes on your paper.

What you should keep in mind when you use these tools and techniques—along with any you may invent — is that they will probably not represent total pictorial solutions. Chances are that you will have to work them gracefully into the total context of the painting through additional brush manipulations.

CARE AND MAINTENANCE

Over the years, I have gotten into the habit of cleaning my immediate work area at the end of each day. It is not a major "policing up" of the entire studio, but this routine does entail emptying and washing out my water containers, making sure that the pigment tubes are tightly capped, and cleaning out paint trays and dishes—except those holding wash mixtures I want to save. I cover these containers with self-sealing plastic wrap. Most important, I tend to my brushes.

At the end of a long working day, it seems only natural to want to leave the studio "as is." But brushes should *never* be left "as is." Not only is it refreshing to start the next day with all your tools clean and ready for use, it also makes sense to care for

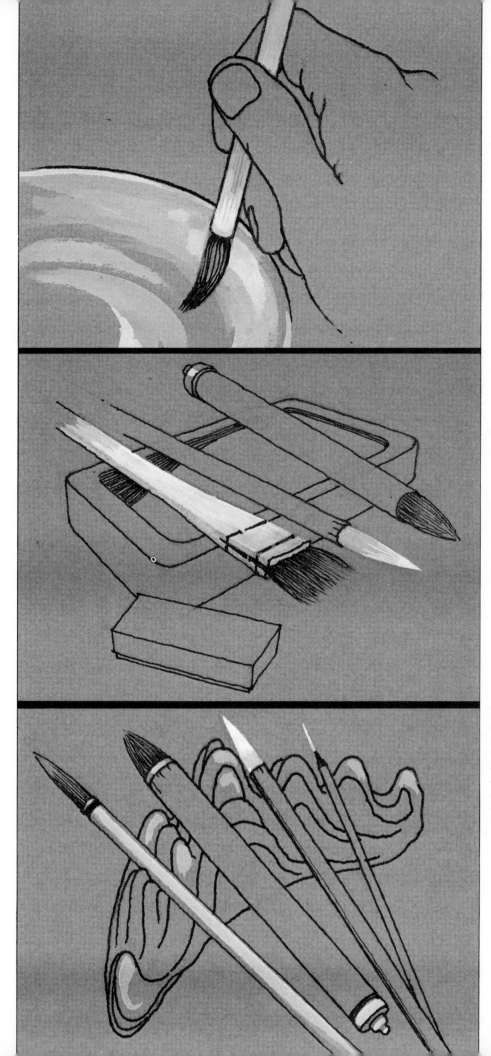

Breaking in a Brush. *The first step in breaking in a Chinese brush is to remove the coating of starch used to shape and protect the hair. You can do this by dipping the brush in water and gently kneading the point against the side of your paint dish or at an angle on the surface of your palette.*

Drying Brushes. *Brushes should be air dried horizontally before storing. The quickest way, after they have been cleaned and reshaped, is to place them with the hair end overhanging the edge of your palette or some other work surface.*

Brush Rest. *The traditional Oriental painter uses a brush rest, putting damp brushes in the notches to maintain an orderly work table and avoid any mishaps. I use my ceramic rest for those brushes I use continually—but only when they are bone dry, so I avoid any moisture buildup at the hair base.*

good tools daily, if only to insure longevity and continued quality performance.

Oriental brushes require essentially the same care as any good Western brushes, with some differences.

1. Wash your brushes in lukewarm water, using a mild soap solution. A cake of hand soap is ideal. Wet the soap first, holding it in your left hand. Stroke the brush across the soap several times, rotating the handle in order to cover all sides thoroughly. Use your fingers to work the lather deeply into the brush. Do not try to force soap into the base of the hair by jabbing it into the bar of soap. Remember, the Oriental brush does not have a metal ferrule and is a little more fragile than a Western brush.

2. Rinse the brush out thoroughly in cool water and shake out the excess moisture. You can roughly reshape the hairs to a point with your fingers or draw the brush across an absorbent paper towel.

3. The brush should be allowed to air dry by laying it flat, with the hair end extended over an edge, perhaps of your palette or work table. The important thing is not to allow the damp hairs to touch or butt up against another surface while drying.

4. The hake brush should be cleaned occasionally at the base of the hairs, where they join the handle. Since the hake is generally used for large wash techniques, residue tends to build up at this seam. I use a stiff, but not sharp, palette knife to scrape this residue away. While the brush is still damp from cleaning, I press the knife firmly along this juncture and scrape evenly outward toward the hair end. I do this on both sides, scraping in the same direction several times, until most of the sediment has been removed. I then wash and rinse out the brush again. This will free the hairs considerably and will restore much of their resilience.

5. After the brushes have been reshaped and dried, I store them vertically in a cylindrical container, hair end up. Those brushes in more frequent use I lay on an Oriental brush rest. These rests can be extremely ornamental—made of wood, stone, metal, or ceramic, and notched to hold several brushes. Their purpose is to allow the painter-calligrapher to maintain an orderly table while in the process of painting. Wet brushes are thus easily accounted for and there is less possibility of accidentally marking the paper or working table. I use my brush rest to keep my brushes on hand for the next day's work. But make sure that the brushes are dry before laying them on the rest. Since the rest inclines the brushes with the hair end up, any moisture left in the hairs would tend to run downward and gather inside the handle against the glued end. If this happens often enough, the glue and binding will crack, allowing individual hairs to fall free, and eventually the whole tuft will loosen and separate from the handle.

6. In transporting a quantity of brushes, assemble them with the hairs facing in the same direction. A couple of heavy rubber bands will bind them into a tight roll. Around this cluster of brushes, I wrap a bamboo place mat, making sure that the mat extends beyond the tips of the brushes. This mat not only protects the brushes against accidental contact with other objects, but allows air circulation in the event that the brushes are still damp.

Fortunately, the average round Oriental brush is relatively inexpensive. It is a good practice to keep a variety of sizes on hand. The hake brush can be more expensive—commensurate with its larger size—and not as easy to find, but it *is* available in more comprehensive art supply houses and in their mail-order catalogs.

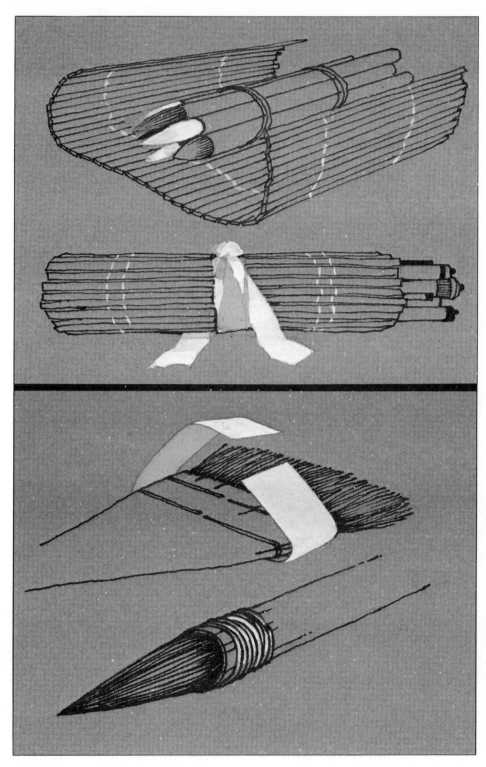

Transporting Brushes. *A bamboo place mat will protect brushes which need to be transported. Brushes can be bunched together, then wrapped or individually rolled into the mat. Be sure the mat extends beyond the hair end in order to protect the tips from damage.*

Extending the Life of Brushes. *Oriental brushes deteriorate more quickly than Western brushes. They are very durable tools when used in the traditional manner of the East, but when subjected to Western techniques—which generally means more immersion in water—the handles will split and the hairs will shed. Wrap a layer of masking tape at the juncture of the hair and handle on the hake brush (top) to extend its life and prevent excess moisture from seeping inside the hair base. Allow the brush to dry out completely—several days to be sure—before taping, and use as little tape as possible in order to maintain the balance of the brush. When the bamboo handle of the round brush (bottom) shows signs of splitting, bind it with nylon thread and cover the threads with a thin layer of waterproof white plastic glue.*

2. PAPERS

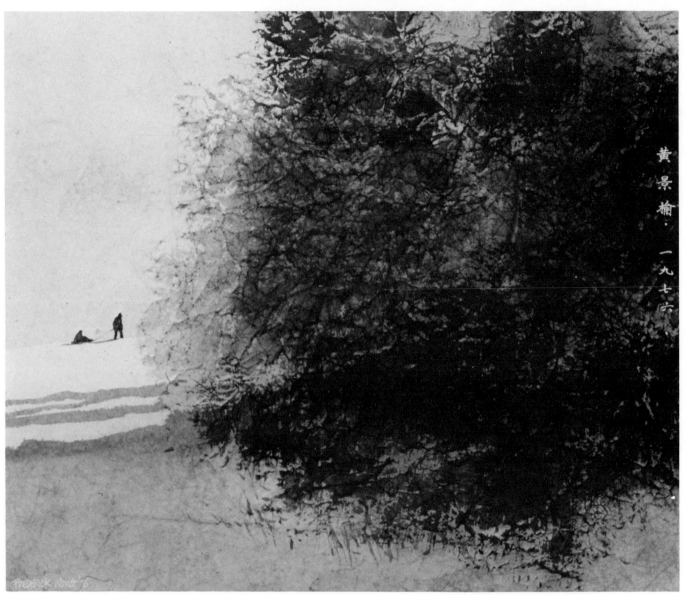

New Snow, *15" x 18" (38 x 46 cm), collection Mr. and Mrs. John G. McGoldrick, New York. The effect of crisp shadows cast onto a snowy white slope, a sky darker than ground cover, and two figures moving uphill, all serve to balance this painting dominated by mass forms in the foreground moving into the middleground area. I tried to emphasize the ground moving in a gentle, steplike arc up the slope in order to express the sensation of the land curving and actually existing behind the heavy foliage areas.*

THE CLASSICAL Chinese painter was also a calligrapher and poet. The indispensable tools of his profession, which he called "The Four Treasures of the Room of Literature," included the brush, ink, inkstone, and paper. There is no mention of pigments other than ink—black only—and the reason is evident when you realize that the greater portion of most Oriental paintings is calligraphic in character—that is, drawn in ink rather than painted in colors.

The invention of paper in A.D. 105 is attributed to T'sai Lun, a member of the Chinese Imperial Court. Until paper was introduced, narrow, vertical strips of bamboo were used. For writing smaller documents, silk proved to be more convenient. However, while bamboo was economical, it was also clumsy and heavy; but silk was too expensive for general use. Therefore, it is of almost equal significance that T'sai Lun also developed an easy manufacturing process using cheap materials such as rags, tree bark, hemp, and fishnets!

It would be impossible to underestimate the significance of the invention of paper. For instance, the Gutenberg Bible, perhaps the earliest European book printed from movable type, was also one of the few books of which some copies were printed on parchment instead of paper. It has been estimated that producing one copy of the Bible on parchment would require no less than the skins of 300 sheep!

The development of papers for artistic purposes in Western society moved in a direction divergent from that of the Orient, determined, perhaps, by the writing instrument. In Europe, calligraphy eventually relied on the use of the metal nib pen, and papers were manufactured according to the dictates of the hard point. In the Far East, the brush was used for both writing and painting. The relationship between painting and writing is, thus, very direct in the East compared to the West, where painting is a separate art form using a variety of media, tools, and grounds. Silk is still used in Oriental painting today, but paper is the primary surface.

Using Oriental papers for Western watercolors calls for creative adjustments and adaptations. This process might prove to be difficult if your total experience has been solely with Western watercolor papers. The basic difference between the two types is less a question of their material composition than of the workability of their surface and body. Oriental papers are generally more fragile and less textured. But the most significant disparity is in the body of the paper and its ability to absorb water.

ABSORBENT PAPERS

Given the enormous variety of Oriental art papers, with their subtle shadings in size, texture, color, and composition, the simplest way to categorize them is in terms of their absorbent or nonabsorbent nature.

Absorbent papers have an open weave and are unsized, giving great porosity when a wash solution is applied. Well suited for both Oriental painting and calligraphy, this type of paper immediately reflects the sure, disciplined hand as well as the wavering and the equivocal. Adapting this type of paper for Western watercolor techniques is a difficult problem, one which admittedly I have been unable to solve with consistency. Smooth, even washes are virtually impossible to achieve, and if the paper is first dampened, then color intensity is lost.

It is not a precise comparison to say that painting on absorbent papers is like working on blotters. Many of these papers, in addition to reacting quickly to water, are extremely thin. This means that liquids are not only instantly absorbed into the body of the papers but they also penetrate through the papers themselves. If the backing surface is smooth and dense, such as plastic, then the wash solution, having no place to go, will pool and eventually work its way back up into the paper surface. If this area of pigment is then allowed to dry in place, a hard edge will develop around the perimeter of the color. In effect, this becomes a technique whereby the image on the reverse side is identical to that on the face side.

NONABSORBENT PAPERS

All watercolor papers are, of course, absorbent. Unlike oil paintings, watercolors, in order to have any degree of permanence, must effect a tight bond into the paper rather than exist on the surface alone. More accurately put, a nonabsorbent paper is one which will absorb moisture more slowly, allowing pigments to be manipulated on the surface to a greater extent before they sink into the paper. Rarely, if ever, will pigment soak through to the reverse side. This can occur, of course, through conscious design, when the sizing is deliberately cracked (see Chapter 5, "Special Effects").

A paper is rendered less porous by dipping or washing it in a thin solution of ox-hide glue and hardening it with an alum solution. The paper is then pressed to give it a smooth, close texture. When the subject matter of classical Oriental painting dictates slow, finely detailed development, sized paper is used, in contrast to the absorbent, unsized papers which will not permit hesitancy.

PAPER COMPOSITION

Westerners tend to refer to all Oriental papers as "rice" paper, when, in actuality, a greater array of natural substances than rice was and is used in the manufacturing of Oriental papers. In ancient China, a variety of papers was developed through the use of materials found in abundance in a given province. The Szechuan region produced a paper made from hemp; seacoast regions used water fungus; and in northern China, mulberry tree bark was in rich supply and became the basic ingredient in the paper production of that area.

A substantial portion of Japanese art papers is still manufactured by hand in small villages throughout the country, and Japan is perhaps the only country in the world where handcrafting of papers remains an important industry. A wide range of beautiful papers of varying textures, colors, weights, and sizes is produced using plant fibers. Used singularly or in combinations of different proportions, these fibers can create a multitude of surfaces and weights. Kozo is a heavy, long, coarse fiber, while the gampi plant produces a fine but firm, glossy fiber. For balance, the soft, elegant strands of the mitsumata plant are used.

CHINESE PAPERS

It is an unfortunate fact that fine Chinese papers are neither available nor easily ordered here in the United States. However, in large urban centers having a Chinese community, small rolls of absorbent paper can be found in narrow widths. These rolls are actually small lengths of paper delicately glued together to form a continuous strip. One small art shop located in New York City's Chinatown does carry a small selection of paper in cut sheets, but Chinese stationers and bookstores also stock brushes, ink, and paper, more for calligraphic use than for painting.

JAPANESE PAPERS

There is an abundance of Japanese papers on the American market, easily available through large art supply houses or mail order firms advertising in art journals. Both the absorbent and nonabsorbent papers in different thicknesses and textures and in cut sheets and rolls, as well as brushes, inks, inkstones, and pigments are accessible to the American watercolorist.

Among the vast numbers of Japanese papers available here, it is somewhat surprising to find a greater selection of the absorbent, and more difficult-to-use painting paper than the nonabsorbent. This might be explained in part by the growing interest of printmakers in the absorbent variety of papers.

Some of the high-porosity papers I've tried—with only modest success, I might add—are *Hosho, Moriki,* and *Troya.*

Hosho is a thick, very open-weave paper of relatively rough texture. Having some of the nappy texture of a blotter, it will nonetheless absorb a stroke quickly through to

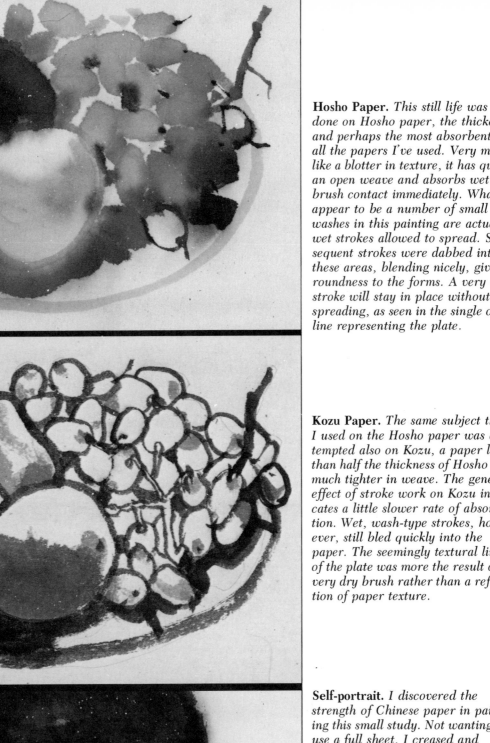

Hosho Paper. *This still life was done on Hosho paper, the thickest, and perhaps the most absorbent, of all the papers I've used. Very much like a blotter in texture, it has quite an open weave and absorbs wet brush contact immediately. What appear to be a number of small washes in this painting are actually wet strokes allowed to spread. Subsequent strokes were dabbed into these areas, blending nicely, giving roundness to the forms. A very dry stroke will stay in place without spreading, as seen in the single outline representing the plate.*

Kozu Paper. *The same subject that I used on the Hosho paper was attempted also on Kozu, a paper less than half the thickness of Hosho but much tighter in weave. The general effect of stroke work on Kozu indicates a little slower rate of absorption. Wet, wash-type strokes, however, still bled quickly into the paper. The seemingly textural line of the plate was more the result of a very dry brush rather than a reflection of paper texture.*

Self-portrait. *I discovered the strength of Chinese paper in painting this small study. Not wanting to use a full sheet, I creased and folded the paper and tried to tear it along the seam by hand. It strongly resisted my efforts, suggesting a somewhat tough fiber content, so I had to use a knife. The paper is very thin—thinner than the standard household cleansing tissue—and, surprisingly, not as absorbent as I had first speculated. This self-portrait was painted, in part, before the paper was mounted. While wet strokes were absorbed quickly, denser pigment mixtures remained in place with some precision.*

its reverse side. A blotter, as fully absorbent as *Hosho*, is of a smoother, close-pore stock, which will resist such immediate and complete absorption.

Moriki is a thin, smooth-grained paper having an ivory-colored cast. It is translucent and delicate, with the ability to take some fine, detailed strokes without spreading too rapidly.

Troya is slightly thinner than *Moriki* and is a much whiter paper. This degree of whiteness is important for color intensity and contrast, particularly since its translucency will be enhanced further when mounted on a white board backing.

The nonabsorbent papers can provide an almost familiar surface for the Western watercolorist. They are deceptively strong, although their textures are generally much smoother than Western papers, and their seemingly fragile nature may be disconcerting. Nevertheless, their surface workability more than compensates for any initial uneasiness the Western watercolorist may experience when first using them. Unfortunately, these sized, tight-grained papers are not found in as wide a selection as the unsized papers. These are the three papers I have worked with.

Shinsetsu is a paper of brilliant whiteness, smooth on one side, with a modest, dry, nappy tooth on the reverse side.

Torinoko is the thickest of the nonabsorbent papers and can be obtained from certain suppliers in two shades of brown, in addition to white. Its texture is almost identical to the *Shinsetsu* papers.

Masa is the paper with which I am most familiar. It has served me well these past fifteen years, and, while very similar to both *Shinsetsu* and *Torinoko* in most respects, it has one additional, practical advantage. *Masa* can be purchased in cut sheets and in one large, continuous roll, 42 inches (107 cm) wide and a full 30 yards (27 m) long. None of the other papers in either category is available here in roll form. Since I occasionally paint in the traditional format of long, narrow, landscapes, the rolls of *Masa* permit me to rid myself of any restrictions that might be imposed by paper dimensions.

PAPER THICKNESSES

Oriental papers vary in degrees of thickness, which does not imply that a thicker paper is necessarily more or less absorbent or nonabsorbent than a thinner paper. *Hosho* is quite thick compared to *Troya* but will also allow a wet stroke to flow immediately through to the back side. A paper can be bulkier to the touch as a result of a coarser fiber composition and a more open weave.

A piece of cleansing tissue is 3/1000 inch thick. Using this tissue as a frame of reference, two sheets of absorbent Chinese paper measure out to 2/1000 inch each. The papers listed below with their relative thicknesses in thousandths of an inch will give you some idea of these delicate grounds.

Hosho	12/1000
Torinoko	10/1000
Shinsetsu	6/1000
Masa	6/1000
Goyu	5+/1000
Kozu	4+/1000
Moriki	4/1000
Mulberry	4/1000
Troya	3+/1000

COLORS AND TEXTURES

In addition to the brilliant whiteness of most Japanese papers, some also come in an unbleached, natural color of soft ivory or beige. *Okawara* is one such paper, and its

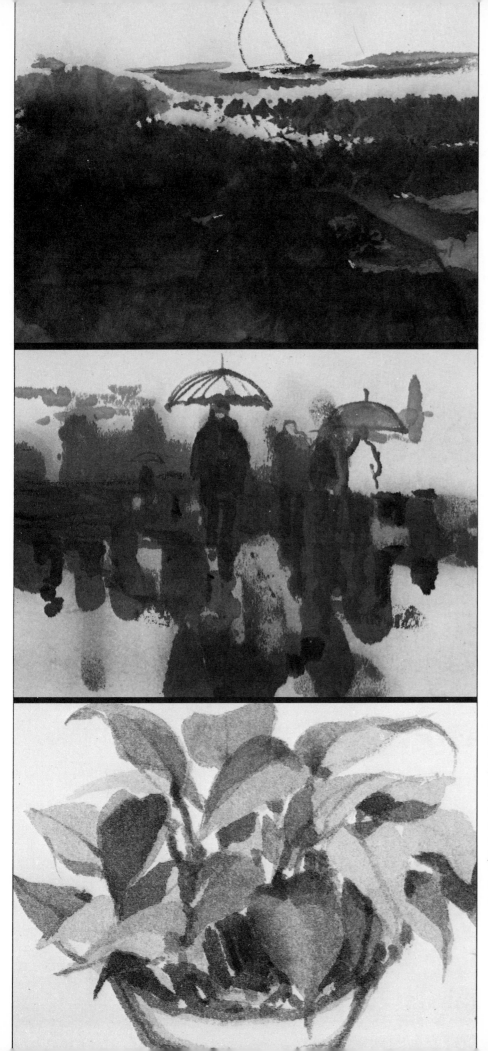

Moriki Paper. *This is an absorbent paper only slightly thicker than Troya. Because of its thin and resilient feel, I decided to try for a dry crinkled effect, an unfamiliar approach to me, since I favor a wet technique using a sized Masa paper. I was able to crumple the Moriki paper easily, untangle it, and begin the painting process without any problems. The major difference between this and my more familiar wet approach was in the use of absorbent paper. My strokes spread very fast, and I was unable to predict, to any degree, what the results would be. After the paper was dried and mounted, I found some very interesting effects which I was able to develop into this small seascape.*

Troya Paper. *In experimenting with Troya, an absorbent paper about one-quarter the thickness of Hosho, I decided to try a blotting technique. I drew a series of very wet, vertical strokes directly onto the mounting board and immediately placed the paper onto this ink pattern. The impression soaked quickly and visibly into the translucent Troya paper. After carefully lifting the damp paper, I placed additional strokes of a drier character onto the mounting board. The next imprint showed a grayer, more textural quality to the line work. I allowed the paper to dry, then pasted it directly over and in alignment with the inked-in areas on the board. This gave a deeper value to the painted-in areas. The darkest strokes were placed after the mounted painting had dried.*

Torinoko Paper. *This small potted plant was painted on Torinoko paper—heavy, thick, and nonabsorbent. I found it a little too stiff for a crinkle technique but very suitable for watercolor handled in the Western manner. The smooth side permitted delicate line work without spreading, and washes stayed on the surface long enough for manipulation. I used the more "toothy" side for this study, and the washes reflected this by appearing dry and almost mat in finish.*

bleached counterpart is called *Suzuki*. The *Moriki* and *Masa* line of papers are also available in a variety of intense colors more suited for graphics than painting purposes.

Textures in Oriental papers do not compare in range to Western surfaces. Sized papers will be very smooth on one side, while the other side will show more texture in the form of a dry, tactile fuzziness. While one can achieve some sense of texture with Oriental papers, it is often achieved through the manipulation of a dry brush rather than the action of the paper itself.

PAPER SIZES

Papers available on the American market vary in size, with some sheets cut into handy sketchpad dimensions of about 9″ x 12″ (23 x 30 cm). Others such as *Hosho* will range upward in odd sizes which measure 19″ x 24″ (48 x 61 cm). *Masa*, available in cut sheets and rolls, is 21″ x 31″ (53 x 79 cm) in sheet size, while *Troya* and *Moriki* are approximately 24″ x 36″ (61 x 91 cm) in sheet size, while *Troya* and *Moriki* are approximately 24″ x 36″ (61 x 91 cm). The above-mentioned *Okawara* and *Suzuki* papers measure 36″ x 72″ (91 x 183 cm), the largest sheets I have found in stock in the United States. Years ago a visiting Japanese calligrapher gave me several large sheets of custom-made, sized papers. They were almost 4′ x 8′ (1.2 x 2.4 m) overall, and of such a personal character that I found I could not effectively use them for my puposes.

CARE, HANDLING, AND STORING

Traditional Oriental paintings were never designed to be hung and continually exposed to light, humidity, dust, and temperature changes. Instead, the vertical scrolls would be brought out and suspended for temporary viewing and enjoyment and then taken down and restored to their storage place. The horizontal scrolls were viewed flat and unrolled, right to left, a section at a time. These paintings were never framed and glazed, nor were they designed for permanent display.

Contemporary works done on Oriental papers will hold up well if given the framing and protection accorded to Western watercolors. These papers, seemingly so fragile, can be as strong as their Western counterparts, given proper care, which means keeping them out of direct sunlight and not subjecting them to continuous low humidity.

If you use Oriental papers, you should store them flat and in an enclosed file drawer, not on an open shelf. If you are using a sized paper, be sure the top sheet has the smooth side up. The more textural side tends to catch dust which is hard to remove, whereas any dirt on the smooth surface can be removed by spraying the surface with water or by gently washing away the dirt with brushstrokes. *Masa* rolls should also be stored flat and kept in their original covering paper until needed.

Handling of these papers should be kept to a minimum. Sized papers can be inadvertently creased, thus cracking the light glue coating. Colors will then penetrate these minute splits in the surface causing a darker buildup where it might be undesirable. Absorbent papers, lacking the protective coating of sizing, should be given even more meticulous attention.

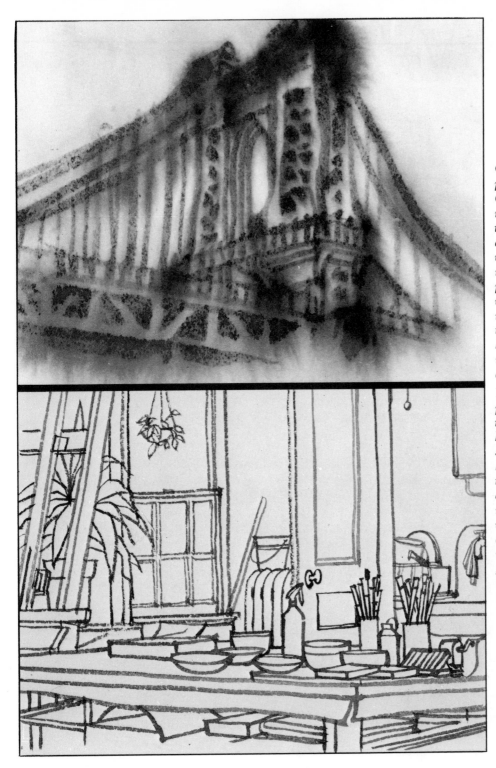

Goyu Paper. *This is an absorbent paper almost halfway between the Chinese paper and Hosho in thickness, with a dry, nappy texture. I tried this reverse painting to test its qualities and found that its weave was tighter than Hosho and, as a result, held back some of the ink penetration. The bridge structure was drawn directly onto the unmounted Goyu; after it dried, I turned it over and pasted it onto a board. The result seen here is the reverse impression without any additional work done on this face.*

Masa Paper. *The qualities of Masa paper are evident throughout this text. Because of its versatility, I have used it with satisfactory results for many years. One aspect I have not touched upon, however, is the ability of this paper to hold a clear, graphic line. In this sketch of my work table, I was able to draw with some precision and be assured of line fidelity. The paper was mounted with the smooth side up, giving it the body and surface quality of a sheet of high-grade illustration board.*

3. WASHES

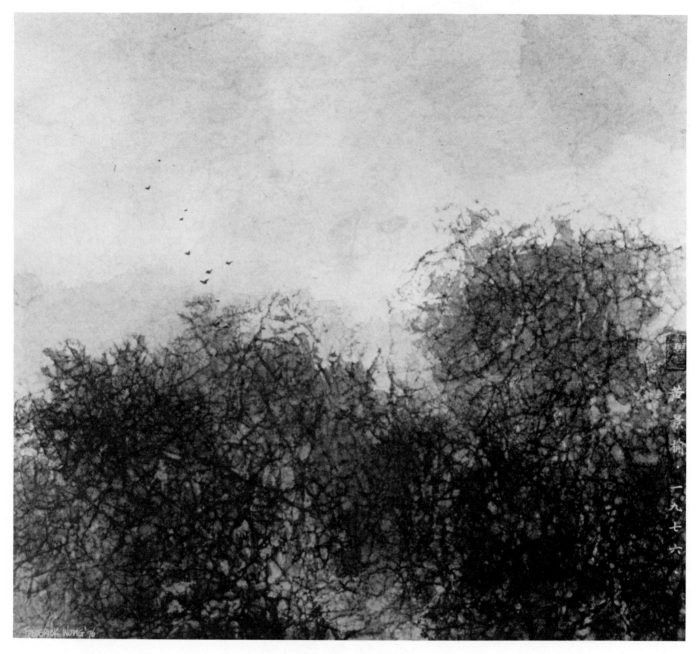

April Morning, *15" x 18" (38 x 46 cm), collection of the artist. Because there are only two major areas in this painting, each occupying almost precisely one half of the surface, it became very important that they be handled with care. The upper sky portion had to suggest space and movement behind the lower half. The mass of trees had to be penetrated with air and light in order to avoid total opacity, which would have created the impression of a two-dimensional cutout form. I also tried to suggest a movement from right to left that would give the tree shapes a slight lateral turning back into the picture plane rather than carrying the eye beyond the viewing surface. Finally, the flight of small birds was added to effect a soft transition between the two halves of the painting and to create a vertical direction on the left to balance the tall tree on the right.*

THE BASIC technique of Western watercolor painting is the wash; in Oriental painting, the basic technique is the graphic use of the brush, which is used primarily to make strokes, rather than washes. By the descriptive use of line work the brush creates most of the forms of an Oriental painting—from the smallest leaf or pebble to panoramic movements of clouds and water.

The wash becomes a delicate supplement to the Oriental painting, adding pale hints of color to trees, mountains, rocks, and occasionally the suggestion of flesh tones. On a larger scale, the wash serves as a backdrop to an Oriental landscape by adding neutral tints of color which define mood rather than delineate form. For example, a soft, velvety gray wash over the entire surface of the painting area would suggest the atmosphere of a winter scene.

It is rare in Oriental painting, however, to see a buildup of layers of washes to achieve form, as in Western watercolors. In the traditional paintings of the Far East, it is this very quality of lightness and purity—the restrained use of washes against the strength and structure of brushwork—that is so appealing.

There is another way in which the wash is used in the paintings of the Orient—a method that seems to fall between the graphic line quality just discussed and the Western wash. This is the calligraphic stroke, a unique action of the brush charged with a fluid mixture of ink or pigment that is precisely applied to an absorbent paper surface. This stroke is neither a sophisticated line nor a massive, delicate wash. It is, instead, a quick, sure movement of the brush, with the unique character of the paper carrying and spreading the fluid mixture outward. The action is described as quick and sure because the blotter-like, unsized paper does not permit lingering while the brush is in contact with its surface. The longer the artist delays—holding the brush at one place—the greater the capillary action of the paper, causing an uncontrollable blob to develop and spread. In addition, the paper will retain that first impression of the brush, recording permanently that moment of wavering and indecision.

CONTROLLING WASHES

Painting on unsized, unmounted Oriental paper is not unlike trying to work on the absorbent surface of cleansing tissue. Unless the artist can handle the calligraphic stroke effectively, unsized paper becomes too confining, restricting the range of values to the darker, and denser shades. If you choose, instead, to work on sized papers (see Chapter 2), you can, with some modifications, apply the Oriental type of washes in the familiar Western manner. Sized paper surfaces tend to retard the speed of absorbency and permit the freer movement of fluid washes.

FLAT WASH

In Western watercolor, the traditional method of covering a large area with one flat wash is to work from top to bottom, quickly moving a puddle of color across the paper and downward until the excess pool is picked up with a dampened brush. This method would be virtually impossible on the unsized and highly absorbent Oriental papers. Rather than having your wash flow across the surface, you would find it spreading uncontrollably.

The traditional Oriental painter used this quality of his paper to work in his favor. Through extended practice, he learned enough about the fluidity of his mixture so that he was able to predetermine how far a wash would spread. He was also able to evaluate how dark a mixture had to be in order to allow for the change in value that takes place in the normal drying process and through the loss of pigmentation caused by the porosity of the paper itself. For when you work on unsized paper, you will see that the outline of the stroke configuration remains, but much of the pigment is actually lost by soaking through the paper. The color value of what remains in the body of

the paper and on its surface is considerably less than the original color value.

However, many of these problems no longer exist if you use sized paper. You can lay your washes effectively and have them remain on the paper's surface long enough to be manipulated and controlled. But handling a large area of wash, even on sized paper, can be a problem. There is always the risk that some absorption will take place while you are attempting to move color evenly across a wide expanse; so I have found it handy to first spray the area to be covered with a light mist of water and then brush on the wash. If the area is extraordinarily large, it is advisable to mount your paper first to preclude any buckling and subsequent pooling of color.

Remember that water added to a wash mixture, whether mixed in the paint dish or on the paper, will thin the mixture, causing it to dry lighter. And when you lay a flat wash, be sure that the brush is sufficiently loaded with the wash solution whenever the brush comes in contact with the paper. If you try to move a wash along with a partially loaded brush, your brush will pick up more color than you leave behind. Finally, keep the board flat until the wash area is dry—even after its sheen has disappeared. Do not tilt the board to create a downward flow, tempting though it may be. Where the moving wash runs into an unexpected dry spot, the color will settle into a harsh, unforgiving line and cause hard edges to develop.

GRADED WASH

A color area that changes in value—gradually moving from dark at one end of the area to light at the other end—is called a graded wash. This can be extremely difficult to render because there is no margin for error. Needless to say, if there is any hitch at all in the smooth transition of value, it is simpler and less frustrating to start again on another sheet of paper. This is one of the benefits of working on inexpensive Oriental papers. Generally speaking, it is a lot cheaper to throw away a sheet of *Masa* than a sheet of Arches!

Here again, it is important that your brush always be fully loaded so that color flows on. If you apply too little paint, you will soon find streaks developing. As you draw your brush across the paper's surface, your brush begins to pick up paint from the previous stroke, rather than add color to it. I favor using a bigger brush than might seem necessary at first glance; the fewer strokes I have to apply, the less chance there is for error.

MULTIPLE WASH

In Western watercolor, there seem to be two schools of thought about using multiple washes to build up color. There is the "school" that minimizes the use of such washes, choosing instead to mix the final color as precisely as possible in the paint dish and apply it in one wash, rather than building up that color by several paler washes on the paper. The benefits of this one-wash method are the great purity and the intensity of color produced; the whiteness of the paper is not diminished as it would be by using many covering washes. Also, the risk of muddy color is lessened by mixing the desired color before it is applied. However, with this method, the artist must be extremely capable in his handling of color; he must be able to establish both value and color intensity at once. At the same time, he must allow for value change in the drying process.

Traditional Oriental watercolor technique relates more closely to the single-wash approach, not for reasons of color intensity or purity, but rather for the immediacy of attack. Multiple washes, as we know them, are rarely used. Stroking into a wet calligraphic stroke would be the closest thing to our technique of using several overlying washes to define form. Additional strokes are sometimes added into this wet mass for greater definition or for soft accents. To create both form and texture, drybrushing is often used *after* the initial stroke has dried.

Much as I admire this technique, I do prefer the multiple-wash approach. It permits me to make more subtle adjustments as I go along, by applying wash after wash. Some color intensity is lost, and there is always the possibility of laying on a

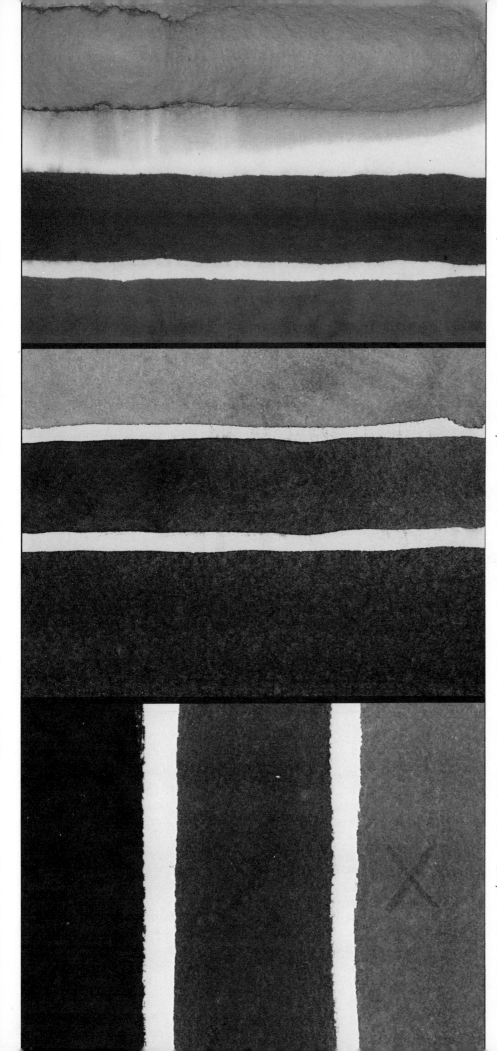

Painting on Unsized Paper. *These three stripes show the effect of unsized paper on wash mixtures. This highly absorbent surface is what the painter must contend with if he chooses this type of ground. The top stripe was painted in a very loose mixture, which immediately spread outward while still containing that first brush impression. The middle stripe was executed with a denser black, also on unsized and unmounted paper, and there is only a slight fraying at the beginning of the stroke. The final horizontal stripe, at the bottom, was placed after the same paper was mounted; no spreading took place at all.*

Painting on Sized Paper. *These three stripes were painted on sized, but unmounted Masa paper. The top stripe was a fluid wash mixture, stroked on with a 1-inch hake brush for rapid color distribution; there was no flaring of color as there was in the top stripe of the illustration on unsized paper. The slight unevenness at the right was caused by the paper buckling. The second stripe was a denser mixture of the same color, also applied on sized, unmounted paper; here you see a uniform, clean movement of the wash. The third stripe was painted after the paper was mounted on a board. There is no difference in the quality of the second and third strokes. By mounting the paper, I have, in essence, given an additional coat of size and prevented the paper from buckling during the painting process. I was able to work easily across the surface.*

Testing Density of Washes.
Here is a simple exercise to compare the relative density of washes. Using a grade B pencil, make three X marks about 2 inches apart on a piece of sized paper, mounted on a board as described in Chapter 9, "Mounting and Framing." Start with a dab of ivory black on your mixing surface and add just enough water to make a pasty mixture. With a broad, chisel-edged brush, cover the first X with several uniform strokes. Add a brushful of water to the previous mixture, blend, and paint over the second X. Add more water and cover the remaining X. When the washes are dry, you should be able to determine the approximate amount of water needed to achieve a particular density by observing how clearly the penciled X shows through.

color which will adversely affect the ground color. However, I am willing to accept these hazards in order to obtain the advantages of greater flexibility.

In using multiple washes on Oriental papers—a Western attack on a surface not really designed for this purpose—the first adjustment you must make is to give the paper enough substance to sustain more brush contact. This means that you must mount the paper, even though it may already be sized. I may work on the paper's surface to a degree before I mount, but I have never completed a painting before mounting. At some point, I must paste the paper down for fear of damaging it in the process of adding more and more washes.

Remember that multiple washes are not meant to conceal. They are, instead, a positive attempt to achieve a greater definition of form, depth of color, or tone by subtly altering, subduing, or heightening the previous wash. In effect, by building up layers of color, you finally attain one unified impression of color and tone. However, successive washes, one painted over another, can create problems. Particularly on Western paper surfaces, several dense washes can develop a certain "chalkiness" in appearance, probably because these papers have harder, less absorbent finishes, with more tooth and bulk. More of the pigment seems to remain on the surface than would be the case if Oriental papers were used.

Another hazard in the multiple-wash attack is "muddiness." This usually occurs as the result of adding one too many washes—or the wrong wash—and eventually both the intensity and the "character" of the color are lost. Oddly enough, I have learned to accept an occasional small area of gray or muddy color when I can place an area of highly intense color next to this patch of "mud" or near it. The contrast seems to heighten the color of both areas. It may be a rationalization on my part, but I tell myself that "muddiness" exists in nature, and given the proper circumstances, it can be effective in your personal interpretation of a scene. What the artist should *never* learn to accept is a muddy cast over his entire painting; this reflects his indecision in establishing clear and precise washes.

Finally, the most familiar problem in trying to lay one wash over another is not giving the base wash enough time to dry thoroughly. Too often, through the artist's impatience to "get at it," a wash is drawn across what seems to be a dry wash—and the results are disastrous!

FREE-FLOWING WASH

For a wash to move very freely, you must add sufficient water to the pigment, but not so much water that your color gets washed out and loses intensity. The quantity of water can be increased to any amount, as long as there is enough pigment left to maintain the correct color. Because this highly diluted wash is very fluid and functions best on damp paper, the result will be a much thinner and lighter wash than anticipated. You can compensate for this lightening of value by starting with a heavier pigment mixture.

If the area is not very large, I use a wide brush to dampen the surface, allowing some puddling of water. For large expanses, I use a sprayer to mist the area. I follow this with quick stroking with a large brush to insure total coverage. Then I casually stroke in my wash, allowing some areas to go unpainted. The wash will move on its own, spreading haphazardly. At this point, I let the wash settle in before proceeding.

When the surface is still quite wet, but movement has stopped, I wait a few moments. I then try tilting one edge of the board slightly and observe the movement of the wash. If it runs away from me quickly and in rivulets, I reverse the tilt and let the board sit flat again; the paper has probably gotten too dry in part, and the wash has started to skid; or perhaps the angle of the tilt was too severe. I try misting the area with a fine spray again, but I do not brush into it. I tilt the board gently away from me. The wash should shift downward in a slow-moving mass. I try to achieve a spontaneous feel to this wash, and hope to get areas with different concentrations of color for a thick-and-thin look. The perimeter of this wash should fade away; clear water on the surface will blur the edge of the wash and conceal any feeling of a border.

Flat Wash on Dry Paper. *This flat wash was painted in the traditional Western manner by moving a pool of color across a small piece of sized, but unmounted Masa paper. By stroking left to right and working quickly downward, moving the puddle of pigment along with a 1-inch brush, I was able to develop a flat wash of consistent density. Since my mixture was fairly heavy, I did not encounter any immediate buckling, which could have caused an uneven tone.*

Flat Wash on Moist Paper. *Here is a flat wash painted on a moistened surface. First, I mounted my paper. After spraying the area with a light mist of water, I stroked over the surface with a 3-inch brush to distribute the fine droplets more evenly and move any excess liquid off the paper to the edge of the board. Using the same wash mixture as I did for the flat wash on dry paper, I quickly painted broad strokes into this moistened area with the 1-inch brush. Unlike the previous method, I was not moving a puddle of color along, but really flooding the surface. Such a wash will spread quickly, but, nonetheless, will be fairly stable and controllable. However, the wash has dried much lighter because of the additional water used to wet the paper.*

Graded Wash. *The graded wash is probably the most difficult wash to execute. There is no room for mistakes. Again using a sheet of Masa paper mounted to a board, I began by applying a fluid wash horizontally, stroking left to right. Before each succeeding stroke, I added more pigment to my basic wash mixture. Each succeeding stroke slightly overlapped the one before —which was still wet—until the area was covered.*

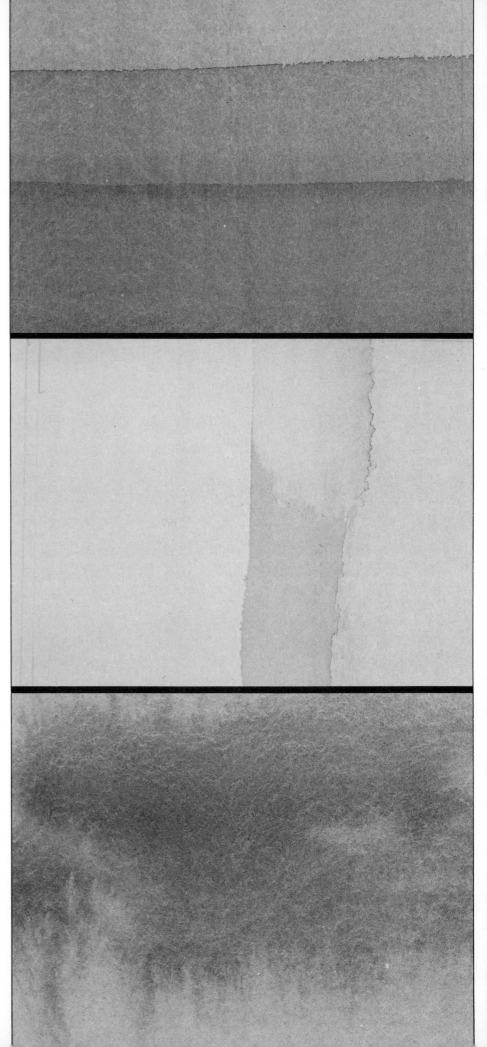

Multiple Wash. *This multiple wash consists of three flat washes, each of which overlaps a portion of the previous wash. The top stripe is actually a single flat wash that covers the entire area. Using the same value, I then covered the lower two-thirds of the ground wash. Again using the same wash mixture, I painted the third stripe over the preceding two washes, just covering the lower third of the area. This final stripe, the darkest of the three, represents a buildup of three layers of wash, each having the same value.*

Overlapping Washes. *Two washes of the same value create a second value where they overlap. I placed my first wash, stroking vertically and moving from left to right, and allowed it to dry. At least I thought it was dry! My second wash, over-lapping the first, picked up part of the still damp undercoat.*

Free-Flowing Wash. *This type of wash moves quickly on wet paper, aided by an occasional slight tilting of the board.*

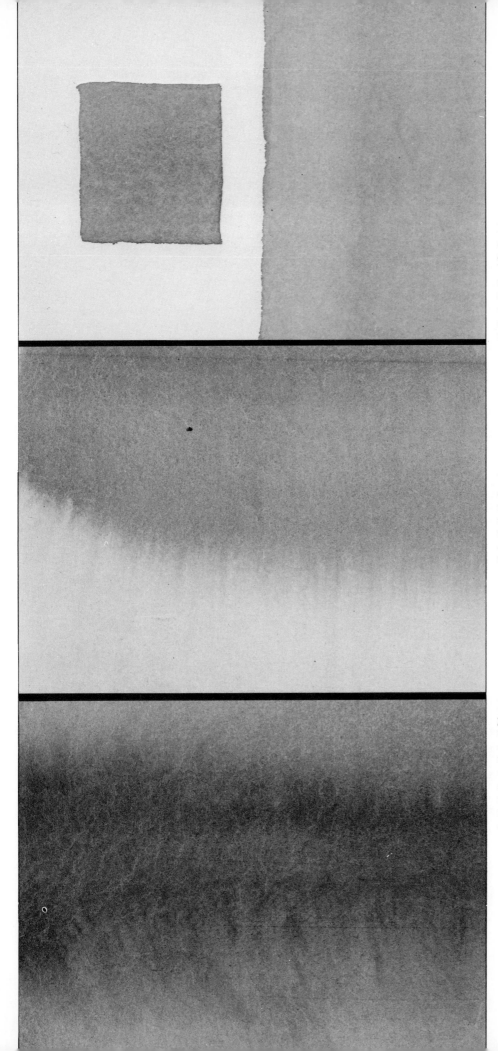

Restricted Wash. *This wash can be handled with ease if the area is small, like the square on the left. When I paint larger expanses like the area to the right, I like to wet the area first with a brush. This wash of clear water defines the area; my wash of color then flows to the edges of the wet shape.*

Wash into Wash. *Here, fresh dark color was washed into another wash which was still wet. I stroked a new wash across the top portion of the moist, lighter ground wash. The result is a soft, fibrous blending of two colors.*

Brush Not Fully Loaded. *Here I painted a darker stripe through the middle of a fluid wash. You can see a soft blending at the top and bottom edges of the stroke. But I did not have a fully loaded brush. The lighter line directly in the center of my stroke indicates that I inadvertently lifted some color from the surface.*

RESTRICTED WASH

You are often called upon to lay washes within fixed boundaries. For this type of wash, sized papers are ideal, having enough body to allow color to move on the surface and permit you to keep within a fixed, contained area. You should learn to paint a small, simple, precise shape in one flat color, showing no straying, streaking, or fraying of edges.

When I paint a broader expanse, I like to brush the exact area first with a light coat of clear water. I allow the paper to dry until damp. At this point, my wash will still move across the paper, but it will not jump and spread. This first coat of moisture also helps to define the limits of my wash. This means that I can stroke quickly with a large brush, and the color will flow to the limits created by the damp area, stopping at the adjoining dry surfaces. Thus, I am able to paint quickly with a large brush, not being overly conscious of the boundary line. I paint to within ⅛ inch of that line. The paper's damp surface carries the wash the remaining distance, stopping only because it meets the dry paper.

WASH INTO WASH

Transparent watercolor is most effective when freshness and immediacy are apparent. Perhaps no other wash technique can better convey this spontaneity than the flow of one wash bursting into the dampened body of another. The idea is to simply allow the damp surface to carry and spread color in an apparently unguided manner.

I begin by moistening my sized paper with a light wash. I allow it to dry until there is no sheen on the surface, and then I quickly stroke a darker wash over the moist paper. The paper reacts immediately by drawing my fresh color into its body, creating a soft, gently fibrous blending.

But washing color into another wet wash of color can be an extremely seductive technique. There is a built-in "siren song" here, and you must beware of the temptation to submit and be overwhelmed by the spectacular image of colors bleeding exuberantly into each other. Keep in mind that the technique, in all its voluptuousness, must be subtly controlled and used selectively for its value to the total painting.

WASH AGAINST WASH

Watercolor painting is a series of brush movements distributing color into color, over color, or against color. You need to be continually aware of what can happen in all these situations; the medium is so fluid that unhappy accidents — as well as happy ones—can often occur. Where color butts *against* color, the following three things can take place.

First, if a new wash is brought into contact with the edge of a very wet color area, a very soft merging will probably appear because the colors will tend to float together. Remember that the paper's surface is still quite wet at this stage. Do not shift your board about. Keep it flat, or the surface film of water will quickly transport your wash in quixotic and unwanted directions.

Second, a light wash can be painted and allowed to settle into a clean, hard edge, relatively free of moisture. However, when the darker mixture is stroked into that edge, an immediate flaring can take place, with the darker wash bursting into the light area.

Finally, when a wash is absolutely dry, a subsequent wash painted to its edge— and overlapping it slightly—will create a third value. Upon close examination, a fine, darker line will be evident at the juncture of the two washes.

ESTIMATING YOUR PAPER'S MOISTURE

It should be obvious, at this point, that much of your success in handling various washes is predicated on your ability to determine accurately the amount of moisture on — or in — the paper. It is easy enough to tell when the surface is *thoroughly saturated* merely by seeing the actual pools of water and their resultant sheen. And by

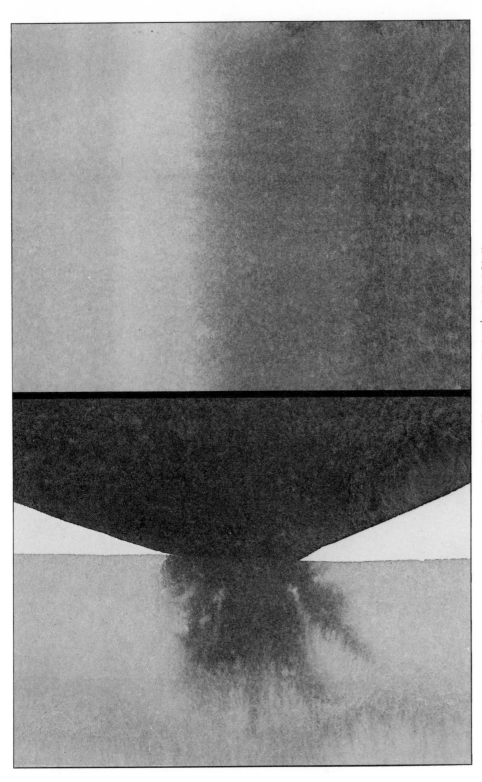

Wash Against Wash. *This soft edge is the result of a dark wash mixture painted against the wet edge of a very fluid wash. The two colors actually float together on a film of water. I painted the lighter wash first, allowing it to flow wetly onto the paper. Then I added the darker wash quickly—and in quantity—along the wet edge of the first wash; the two blended together easily, with a soft movement.*

Color Burst. *The bottom wash was painted first and allowed to settle itself until it appeared dry—but was not. When the darker wash was painted in contact with the first, there was an immediate lunging of the deeper value into the lighter.*

Creating a Third Value. *The wash on the left was painted first and allowed to dry completely. The light wash on the right was then painted to overlap the first slightly. A third value was established, and a dark, hard line was formed.*

Directional Flow. *A directional flow can be created with a fluid wash by moving and tilting the board on which your paper is fastened. The result is a wash with a spontaneous look; but you have more control than with the free-flowing wash. First I painted a very light wash onto a wet surface. Without waiting for the wash to settle, I quickly stroked a loaded brushful of a darker tone into the same area. Some merging took place immediately. I then tilted the board slightly away and to the right; the color moved and created the directional "finger." By reversing the board back to and beyond its original position, then quickly allowing it to sit flat again, I developed the dark, diagonal line in the lower portion.*

allowing more time, or by using a hand-held hair dryer, you can with some ease and confidence, establish a *totally dry* area.

However, it is very tricky to pinpoint that subtly precise degree of *dampness* necessary for a wash to perform in exactly the way you wish. Experience is still the best teacher, and profiting from your mistakes is not just a cliché. I have learned, over the years, to trust my instincts, but my instincts are still not infallible.

DIRECTIONAL FLOW

A wash can be a single, flat, stable area of color, or it can assume a visual direction. By mixing a very fluid wash and painting it onto a very wet surface, you can create a physical, directional flow by tilting the board to various angles. Superficially, this wash appears to be very spontaneous and resembles the free-flowing wash; but actually it is controlled by angling the board. The manipulation of the board gives you control of the wash, rather than allowing the wetness of the paper to determine the primary action of the wet color. Your composition may also dictate the direction of your wash, perhaps calling for a strong left-to-right movement.

4. STROKES
AND TEXTURES

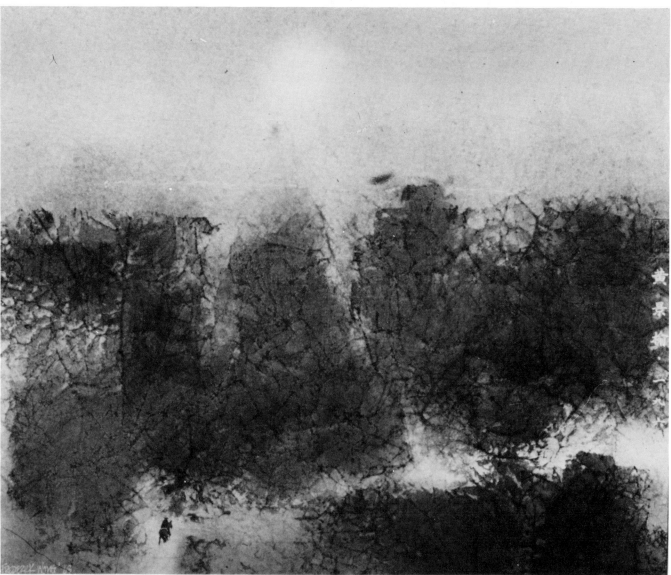

Evening Trail, *15" x 18" (38 x 46 cm), collection Yvonne C. Wong, New York. Traditionally Oriental in feeling, although not through conscious design, this painting juxtaposes man against an overwhelming sense of nature. The small horseman, wending his way up the trail, also brings the viewer's eye into the picture. The pathway breaks up the vertical aspects of the row of towering trees and creates a horizontal, stabilizing movement. The suggestion of light breaking through the mist in the top center area helps to offset the weightiness conveyed by the darker forms below.*

NEARLY 300 YEARS ago in China, three brothers surnamed Wang compiled a marvelous text called *The Mustard Seed Garden Manual of Painting*. Its thirteen "books" or chapters were devoted almost entirely to the study of brushwork and its use in the construction of landscape forms. To give you some idea of the detailed contents of this manual, chapter headings include such specifics as "Book of Rocks," "Book of People and Things," "Book of the Plum," and "Book of Grasses, Insects, and Flowering Plants."

In the first book on painting fundamentals, Wang Kai, using the pseudonym Lu Ch'ai, offered a general list of types of brushstrokes for the beginning painter to practice. Graphically described, they included:

> Brushstrokes like spread-out hemp fibres
> Brushstrokes like entangled hemp fibres
> Brushstrokes like sesame seeds
> Brushstrokes like big ax cuts
> Brushstrokes like small ax cuts
> Brushstrokes like cloud heads
> Brushstrokes like raindrops
> Brushstrokes like an eddy or whirlpool
> Brushstrokes like veins of a lotus leaf
> Brushstrokes like horses' teeth

These and other strokes were recommended for studious practice, sometimes for years, before the student painter would feel capable of developing his own combination of strokes leading to disciplined freedom.

ORIENTAL VERSUS WESTERN WATERCOLOR

The Mustard Seed Garden Manual of Painting beautifully illustrates a basic difference between Chinese and Western watercolor. The ability of the Oriental artist to represent nature accurately and with sensitivity is directly related to the quality and vitality of his strokes. Strokes serve not only as the "skeleton" of a painting, but often the "flesh" as well. In other words, brushstrokes alone are often the total painting.

In Western watercolor, however, brushstrokes rarely play a significant role in the total impact of the painting. We may use our brush to rough out painting areas to be filled in with washes later. Sometimes we might "touch up" a dull patch of color with a few strokes. But rarely does stroke work play more than a minor role.

There is little evidence of stroke activity in my own work for two reasons. First, I favor nonabsorbent papers which permit me to work over their surfaces more than absorbent papers—which tend to pull the stroke more immediately into the surface, as previously discussed in Chapter 2 on "Papers." The second reason is that I prefer to emphasize color over line.

What is a stroke? A stroke, in its purest form, is simply a line created by the movement of the brush. It is one fluid movement of the brush, rather than the meticulously drawn line. A stroke can be short or long, fat or thin, smooth or frayed, soft or hard. A stroke can outline, accentuate, and separate color areas. It can be boldly assertive or delicately unobtrusive.

TRY A "BRUSHSTROKE PAINTING"

In these few pages, I will try to introduce you to some of the more significant aspects of this sophisticated technique. Try them, just for the experience, even though neither you nor I, of course, can hope to attain any degree of success without years of total application. The *tao* or "way" of the brush is very demanding.

But there is no doubt in my mind as to the value of brushstroke technique, even though I have not chosen to use it to any great extent in my own work. It is an

Strokes for Foliage. *These nine brushstroke groupings represent different types of foliage. On absorbent paper strokes of varying degrees of wetness and pressure can achieve a wide range of effects. A, B, D, and I are massive and dense in feeling. The other units are light and feathery, suggesting a more delicate clustering of small leaves. Each group not only conveys the distinctive characteristics of a particular kind of foliage, but also some sense of growth patterns as well. A very pointed, almost dry brush was used to create the horizontal movement of groups E and F; the effect is of layered growth, whereas wet jabs of the brush suggest heavier clusters of leaves settling downward in G and H*

A

B

C

D

E

F

G

H

I

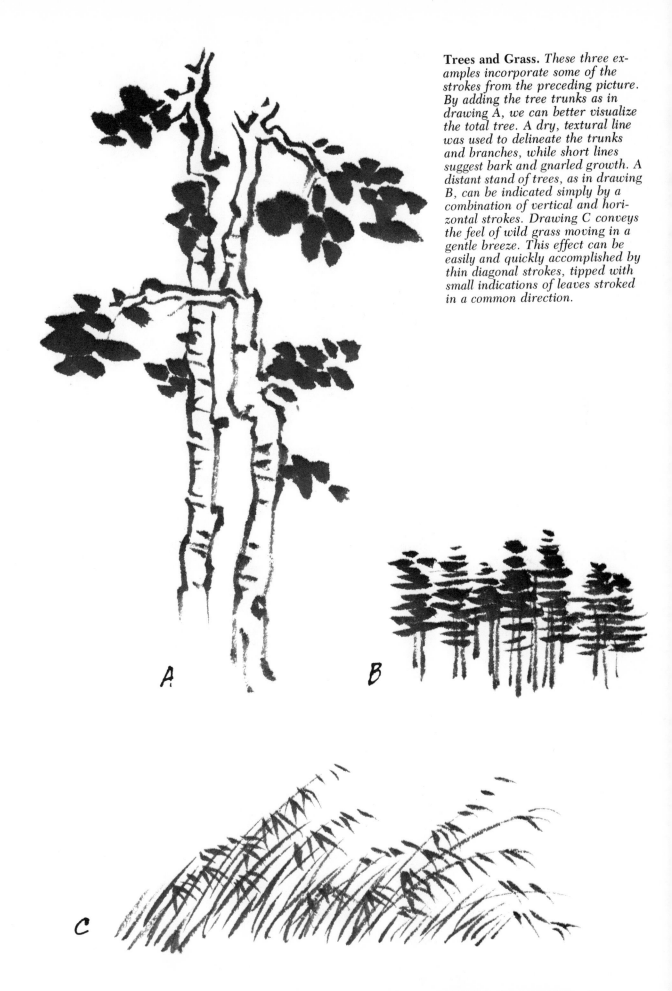

Trees and Grass. *These three examples incorporate some of the strokes from the preceding picture. By adding the tree trunks as in drawing A, we can better visualize the total tree. A dry, textural line was used to delineate the trunks and branches, while short lines suggest bark and gnarled growth. A distant stand of trees, as in drawing B, can be indicated simply by a combination of vertical and horizontal strokes. Drawing C conveys the feel of wild grass moving in a gentle breeze. This effect can be easily and quickly accomplished by thin diagonal strokes, tipped with small indications of leaves stroked in a common direction.*

A

B

C

Bamboo Stalks. *The series of vertical strokes illustrated here are meant to represent one segment of a stalk of bamboo. The subject matter is classical in Oriental painting and is used even today in brushstroke instruction. The brush is held vertically and placed firmly on the paper. The stroke is pulled firmly and surely downward, without wavering or hesitating. The beginning and the ending of this stroke should be strong and conclusive. If you linger, the paper will absorb too much ink from your brush, and the effect will be "mushy" and indecisive. A small break should be allowed between each downward stroke. This will be filled in later with a small connecting horizontal "bone" stroke.*

Bamboo Segments. *These bold strokes also represent bamboo segments, but with a difference. In addition to describing the basic shape of bamboo in one stroke, the attempt here is to have the stroke simultaneously reflect both the vertical graininess and the roundness of bamboo. The brush is dipped first into a gray ink mixture and then tipped with a darker value of the same ink. Holding the brush sideways at about 90 degrees to the thumb and perhaps 30 degrees to the paper, the brushstroke is pulled firmly downward. The result should show gentle shadings within the stroke from top to bottom and left to right. Textural breaks will occur unpredictably, as portions of the brush hairs expend the ink into the paper. These white, grainy, streaks enhance the feeling of three-dimensionality and can even suggest light and shadow.*

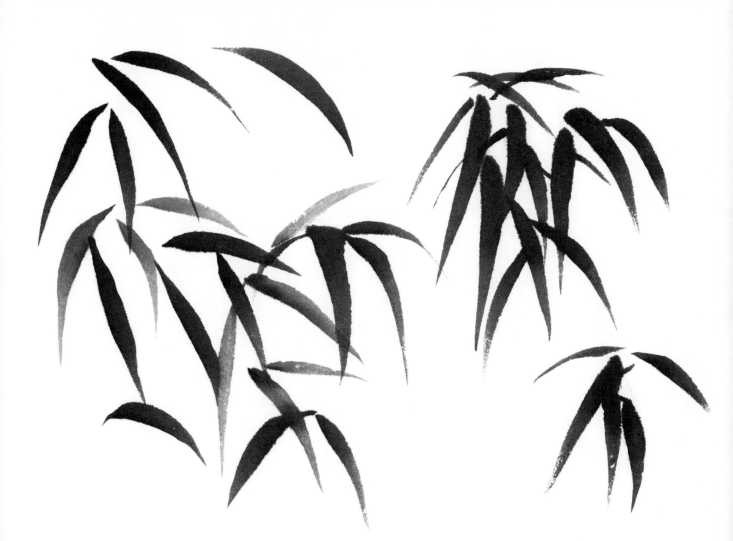

Bamboo Leaves. *As distinctive as the stalks, bamboo leaves are spear-shaped, long, and delicately tapered. Ideally suited for controlled stroke practice, defining these forms calls for sure-handed use of a pointed brush and a precise quantity of pigment. If the brush is too fully charged, the fine point will be lost, and the stroke will be fuzzy-edged. On the other hand, if not enough ink is used, then the stroke will be grainy and coarse. This stroke should also be painted with smooth precision. Do not jab the brush at the paper but, rather, place the tip firmly and pull fluidly. Lift the brush to a gliding stop to finish this stroke, thus automatically accomplishing the delicate, tapered tip of the bamboo leaf. In painting a cluster of leaves, vary the values to suggest leaves in front of leaves, creating a feeling of depth. Start with lighter grays; after these strokes have dried, overlap them with a series of darker forms. Also try some "reverse" stroking. If you are right-handed, try painting a leaf with a right-to-left gesture. Push rather than pull the stroke, and take care to keep the brush hairs from flicking drops of pigment. You will probably find it difficult at first to regulate the proper amount of pressure necessary to smoothly paint a thick shape flowing evenly into a tapered point, but with practice, you can overcome this initial awkwardness.*

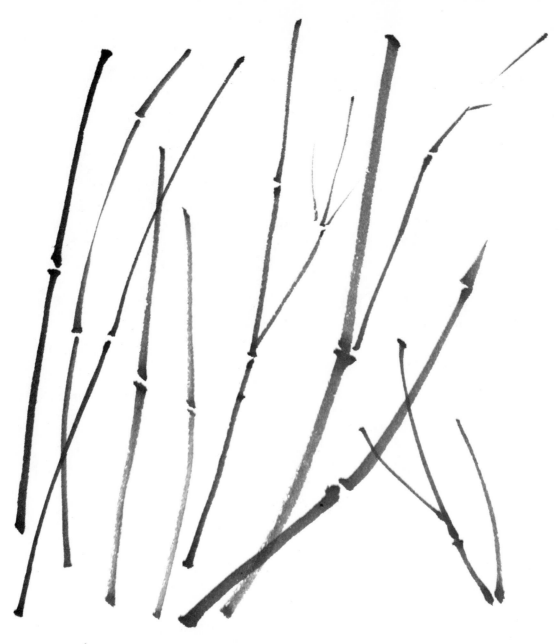

Bamboo Branches. *The thin branches that sprout from the joints of the parent bamboo stalk are stroked quickly with a narrow brush; pause only to break the line intermittently to show the formation of new growth. The feeling of these lines should be gracefully supple. The short, horizontal strokes on the lower left represent the "bone" strokes mentioned in the discussion of bamboo stalks. These are the joints between two bamboo sections. The stroke is formed by placing the brush tip firmly in place—almost a weighty jab—then pulling smoothly to the right before ending with a slight curl. I've exaggerated this curl effect in my illustration to show its direction. In some cases the final movement is upward, but more frequently it is downward. The "bone" stroke derives its name from its obvious resemblance to bone, having a knobbiness at either end.*

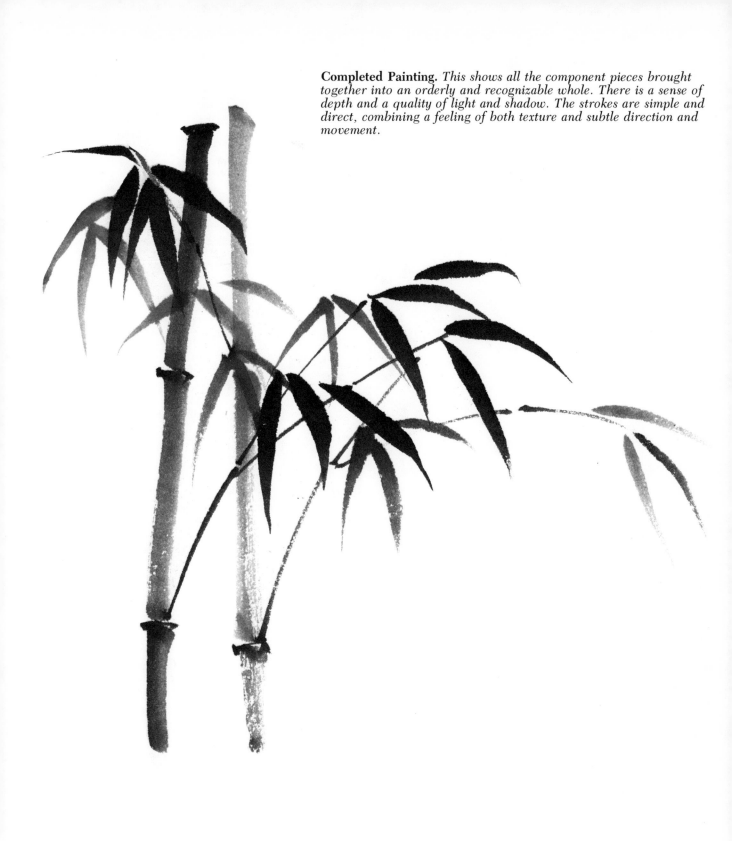

Completed Painting. *This shows all the component pieces brought together into an orderly and recognizable whole. There is a sense of depth and a quality of light and shadow. The strokes are simple and direct, combining a feeling of both texture and subtle direction and movement.*

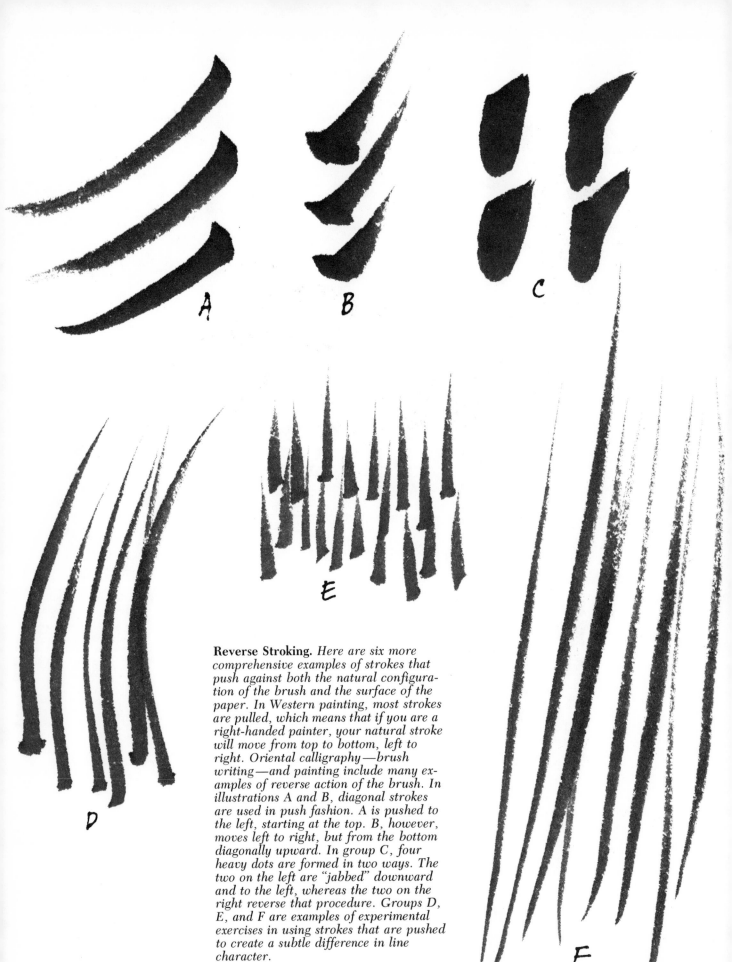

A

B

C

D

E

Reverse Stroking. *Here are six more comprehensive examples of strokes that push against both the natural configuration of the brush and the surface of the paper. In Western painting, most strokes are pulled, which means that if you are a right-handed painter, your natural stroke will move from top to bottom, left to right. Oriental calligraphy—brush writing—and painting include many examples of reverse action of the brush. In illustrations A and B, diagonal strokes are used in push fashion. A is pushed to the left, starting at the top. B, however, moves left to right, but from the bottom diagonally upward. In group C, four heavy dots are formed in two ways. The two on the left are "jabbed" downward and to the left, whereas the two on the right reverse that procedure. Groups D, E, and F are examples of experimental exercises in using strokes that are pushed to create a subtle difference in line character.*

F

Rock Formation. *The massive, craggy rock is a common subject in Oriental landscape paintings. Here strokes become extended lines that describe form rather than act as the form itself. Often these lines are dry to create the sensation of texture. Each dot left behind by a broken stroke becomes a crevice when used to create a panoramic scene. Heavier dots imprinted along a ridge line suggest wooded growth.*

Spatial Relationships. *Strokes, and textures developed through the use of strokes, can convey a great sense of space. In this landscape, the foreground trees are emphatically developed by using the techniques described in the illustration showing strokes for foliage. The eye is drawn into middleground areas by the use of scattered dots. These suggest both foliage and shadow areas within a vast expanse of tree growth that leads to large outcroppings of rock. Finally, two areas of gray are painted in the distant background, leading the eye even further into the landscape. These last two value areas representing far mountains are more smoothly painted and are washes rather than strokes.*

Combining Eastern and Western. *Here I've tried to integrate some of the previously described traditional Oriental techniques into a more Western approach to subject matter. I used large washes to establish the shapes, working with a loaded brush. While these areas were still damp, I stroked in darker values to softly blend in and develop a sense of roundness. Finally, I used short, jabbing strokes of varying shades of gray to represent foreground debris. A dry, textural stroke across the top surface of this rock cluster suggests glistening wetness. This feeling is enhanced by the large, indistinct background form which has been allowed to spread. I achieved the subtle striations in this mass by allowing the wash to partially dry then stroking horizontally into it with clear water. I then used reverse strokes, starting at the ground plane and gesturing upward to create the clumps of wild grass.*

A

Dry Textures. *The seven examples on these two pages were done with a combination of brushes ranging from a fifteen-year-old, badly abused sable to a ½-inch hake brush. Examples A through D show the effect of drybrush stroking with a brush in which the hairs are deliberately frayed. The hake brush was used to paint the two horizontal strokes in E. Because the hairs are less resilient than sable, textures become more quickly evident as the stroke is extended. If a hake brush is unavailable, an old 1-inch, chiseled sable can create the same effect as seen in the two vertical lines in illustration F. The lines in group G were stroked using a new, pointed sable. The brush was fully loaded, and all strokes were made from this single filling. The textural changes become very evident with each succeeding stroke, as the brush becomes progressively drier.*

B

C

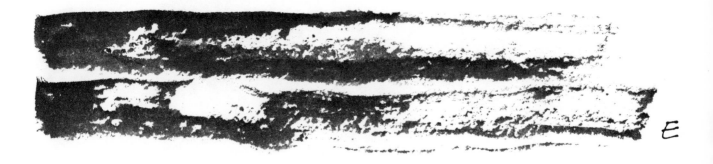

D

E

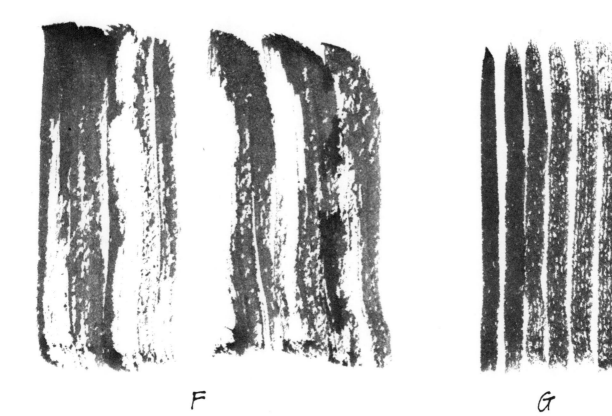

F

G

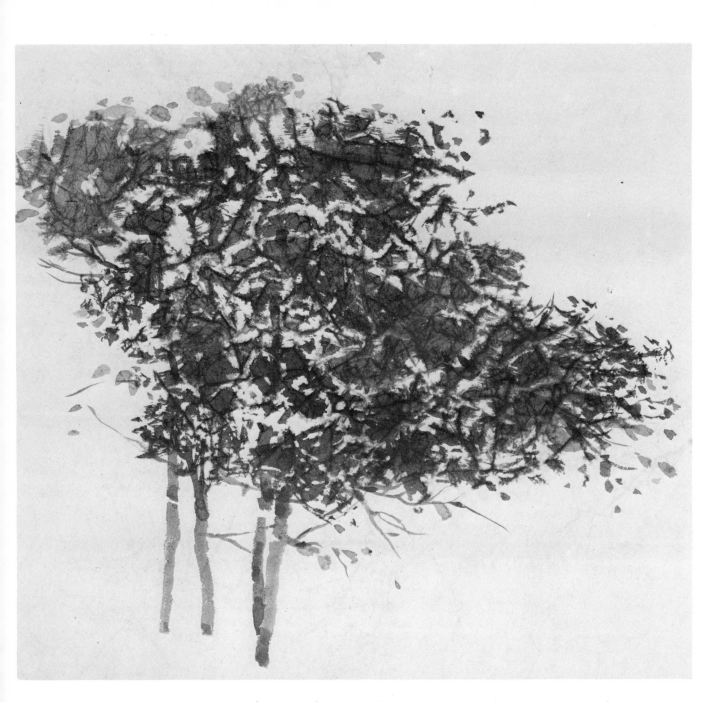

Combining Techniques. *This painting of trees represents my use of Oriental stroke and texture techniques in a Western manner. The mass of foliage was achieved by first crumpling the paper and then stroking across the dimpled surface. (This method is more fully explained in Chapter 5 "Special Effects.") The tree trunks are indicated with single strokes, as are the more delicate branches. Finally, individual leaves are tipped in as accents to both the ball of foliage and its perimeter.*

excellent way of discovering what the brush can do on Oriental paper. You may even find that Oriental brushstroke techniques become a valuable adjunct to your style.

A brushwork painting does not mean total line work to the exclusion of washes. Nor does it mean just doing a wash drawing—making strokes around forms and then filling the forms with washes. The strength of a brushstroke painting is derived from the use and character of the brushwork itself.

Here is a list of suggestions that I think will help you in your first efforts.

1. Rather than use the traditional inkstone and ink stick, use India ink or a tube of black watercolor to save time, energy, and frustration.

2. Initially, use the more familiar sable brush, rather than the Oriental brush for better control. Then try the Oriental brush.

3. Use only absorbent Oriental paper (see Chapter 2 on "Papers") right from the start. The paper has an immediate effect on the quality of your stroke work.

4. Do not mount the paper at the beginning. Mounting retards the paper's ability to absorb your stroke and changes the line character. Mount the sheet (see Chapter 9 on "Mounting and Framing") only after you've determined that it is time to lay in your large wash areas.

5. Keep scrap pieces of absorbent paper at hand for practice strokes and for removing excessive water from your brush.

6. Develop practice strokes from the lightest values to the very darkest. You might also try strokes ranging from very wet to dry, textural lines that you make with very little fluid color in your brush. In the process, observe and learn to "feel" the amount of liquid on your brush in order to establish the necessary quantity to achieve a desired result—from a wet stroke to a drybrush texture.

7. Stroke directly onto your absorbent paper without any preliminary pencil linework.

8. Use "thumbnail" sketches for reference or, better yet, try redoing an old painting. Looking at a black-and-white photograph can also serve the same purpose. This will permit you to concentrate totally on your stroke work.

9. Do not linger. Movement should begin once the brush contacts the paper.

10. Continue working on the same piece of paper even when you think a stroke has gone "wrong." The single, isolated stroke is difficult to evaluate until it is seen in the context of other strokes and textural effects. Don't be prematurely disappointed. Give yourself the opportunity to see a more total image before making a judgment.

I think you will enjoy the practice, though you may or may not find this brush approach usable in your own work. However, you *could* find it exhilarating—a change of pace which will permit you to look at your watercolors from a fresh perspective. I certainly would not advise changing your style merely for the sake of change, no matter how stimulating. But like most artists, you are probably curious by nature, and you will enjoy sharpening your skills through investigating and experimenting with unfamiliar techniques. Only *you* can assess how, if at all, you can integrate this classical Oriental form into your own means of graphic expression. Whatever your decision, I think the effort, time, and energy expended on stroke practice will be completely rewarding. Not only will you have a better understanding and "feel" for the brush— any brush — and its functions, but you will gain insight into Oriental papers.

DEMONSTRATIONS

The following step-by-step studies represent attempts on my part to utilize some facets of Oriental brushwork in Western subjects. I have worked monochromatically, using only an ink stick and inkstone. My brushes included red sables and a variety of Oriental brushes. The paper was absorbent and cut from a very large sheet given to me by a Japanese calligrapher.

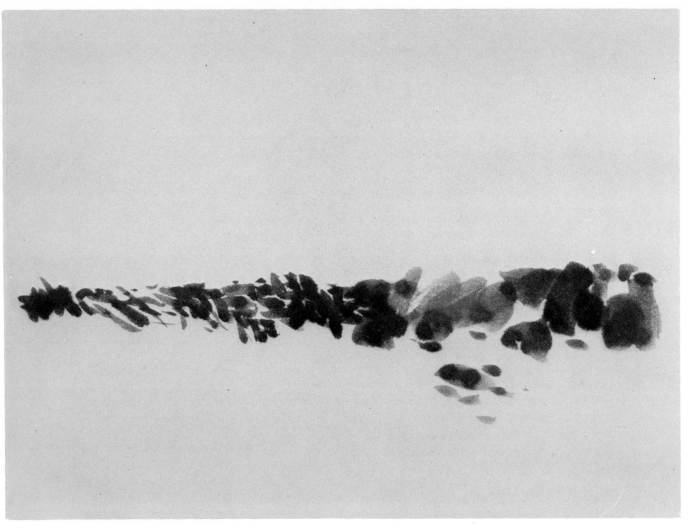

Step 1. *For this black-and-white painting, I chose to work directly onto absorbent, unmounted paper with ink and brush. Without any preliminary drawing, I began to stroke in a series of ink images moving from left to right, trying to keep the strokes irregular in size and value. At the same time, I varied the wetness of the brush in order to create some sense of texture, as seen in the large strokes to the right of center. Absorbent paper will tend to absorb your strokes almost immediately into the surface. If you work with enough speed, a stroke will merge into the preceding one, but if you hesitate for a moment, the strokes will show a distinct overlap, thus creating an intermediate value.*

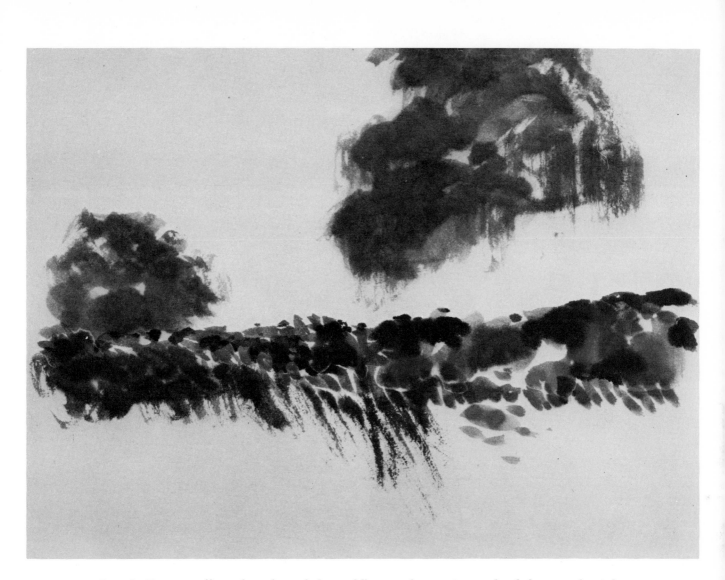

Step 2. *Having sufficiently indicated the middleground area, I next decided to rough in the background and foreground shapes. Using a 1-inch hake brush dipped into a gray ink mixture, I developed the two ball-like shapes through short, arc-shaped strokes. At the outer edges, I switched to a drier brush mixture, again for textural purposes. A round, pointed brush was used dry. At times I stroked in reverse to add the foreground suggestions of wild grass.*

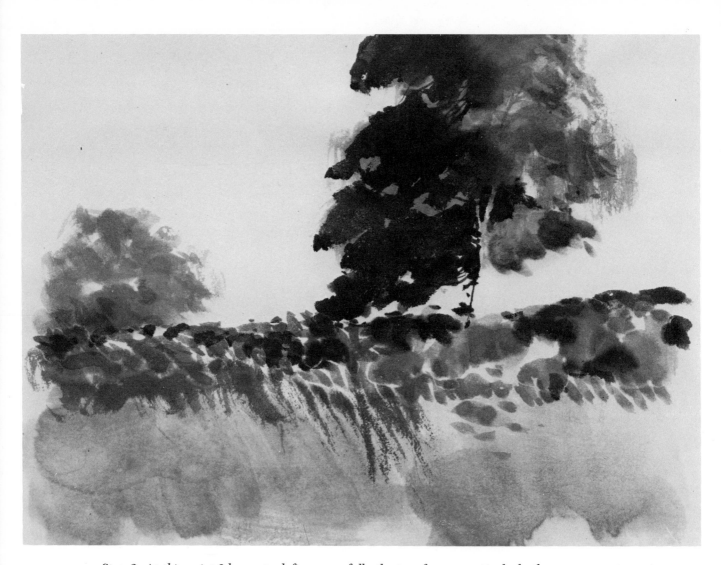

Step 3. *At this point I began to define more fully the tree forms, particularly the one nearer to the viewer, by adding contrasting dark areas. This simultaneously created a sense of a light source. A central tree trunk was formed by painting around it in darker values. The foreground field was covered quickly by using a very wet brush and allowing pools of ink wash to settle into and through the paper. Some of these pools backed up, and I deliberately allowed this movement to dry into the paper. Therefore, some soft edges developed, suggesting a surface undulation. I rather like this effect.*

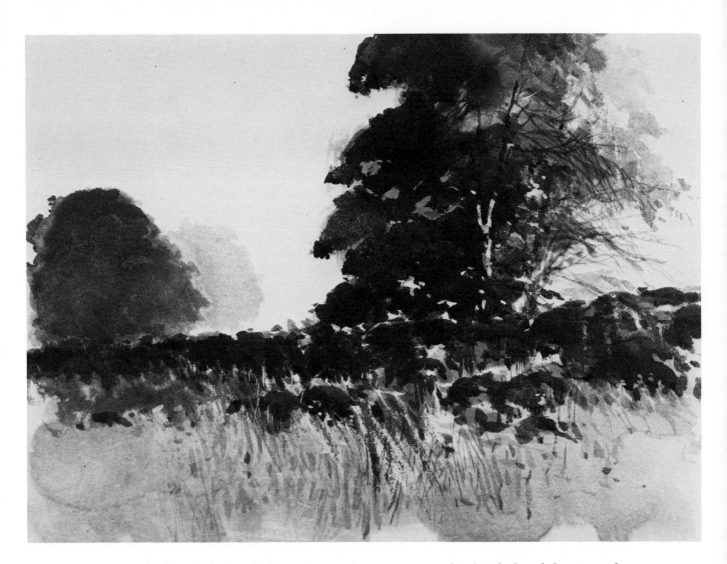

Step 4. *In this phase I worked into the tree shapes in greater detail. I darkened the one on the left and, with a small sable brush, created more indications of large limbs diminishing into smaller branches in the foliage mass on the right. For balance, I also added the faint and distant shape of another tree behind the one on the left.*

All the brush activity up to this point had been stroked onto a sheet of unmounted paper. As a result there was some surface buckling. At this stage, I decided to mount the partially finished painting onto a board backing (see Chapter 9, "Mounting and Framing"). This served two purposes. First, the wheat paste that adhered the paper to the backing material also retarded the paper's absorption qualities and permitted me to work in more precise detail. Second, by mounting onto a white board, I was able to determine more accurately the value relationships of my ink strokes and washes. Prior to being mounted wet absorbent papers will take on a gray, translucent appearance.

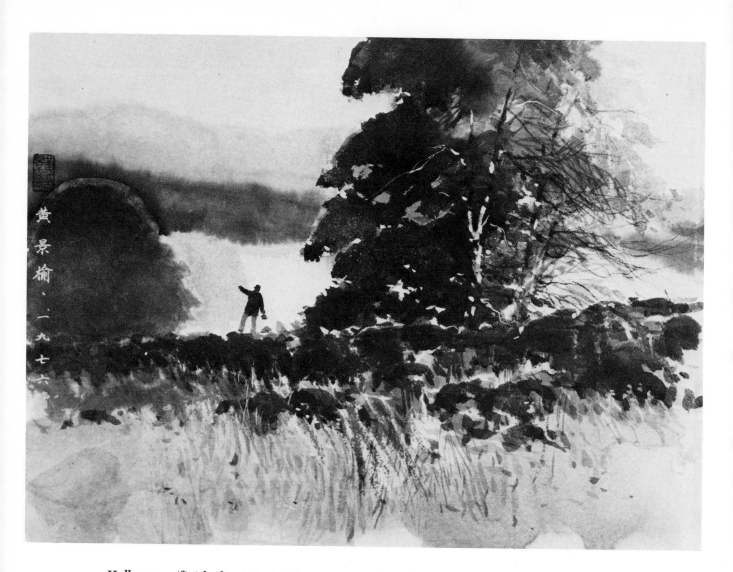

Halloween, (finished painting), *ink on paper, 14" x 18" (36 x 46 cm), collection Mr. and Mrs. Morley Cho, New York. Final touches include the two diagonal streaks running the full width of the painting. They were both painted onto a damp surface, which created the soft merging of the two values. The figure walking the stone wall was painted with a deliberate tilt to the right to offset the strong downward pull of the wall itself. Finally, the calligraphic symbols representing my name and date along with the seal imprint were placed in the standard vertical alignment on the left and above center to enclose the painting on that side and to visually offset the tilt of the wall.*

Step 1. *Urban landscapes are ideally suited for brushstroke activity, but they contain obvious hazards. Perspective considerations can sometimes be overwhelming, and the exceptional number of details can be distracting. Care should be exercised initially in selecting subject matter that will offer a combination of both vertical and horizontal effects rather than weighing more heavily in one direction. In this work, done in black ink, I used absorbent paper specifically for its ability to immediately retain the stroke. Using a very light ink mixture, I roughed in the broad aspects of the scene with a small, round sable, paying attention to the general perspective of the mixture of structural forms. The paper is unmounted at this point.*

Step 2. *Having established the general layout in the previous sequence, more strokes were added across the entire painting, building up a sense of detail over the total surface rather than emphasizing one area. I tried to work in both horizontal and vertical strokes in order to develop a pattern effect. The strokes appear flexible and soft to fight the strong angularity of the structures. The gentle arc shapes of both the bridge and foreground vehicles also help to balance and offset the "hardness" of the structures.*

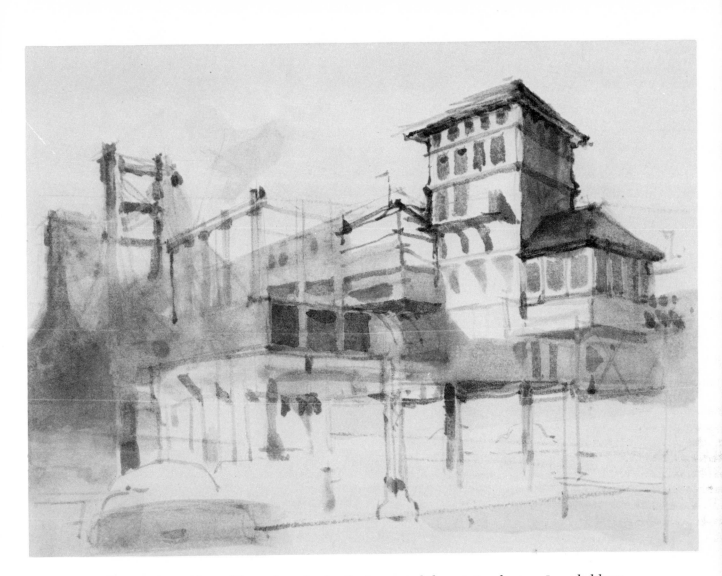

Step 3. *After adding additional stroke details, I mounted the painting because I needed large wash areas to indicate shadow distribution. Once pasted to a stiff, board backing, of course, very wet washes can be used without fear of the paper buckling and causing problems in the even flow of the pigment. I used a 1-inch hake brush to quickly lay in the broader washes. For smaller shadow areas, I used a round Oriental brush of medium size.*

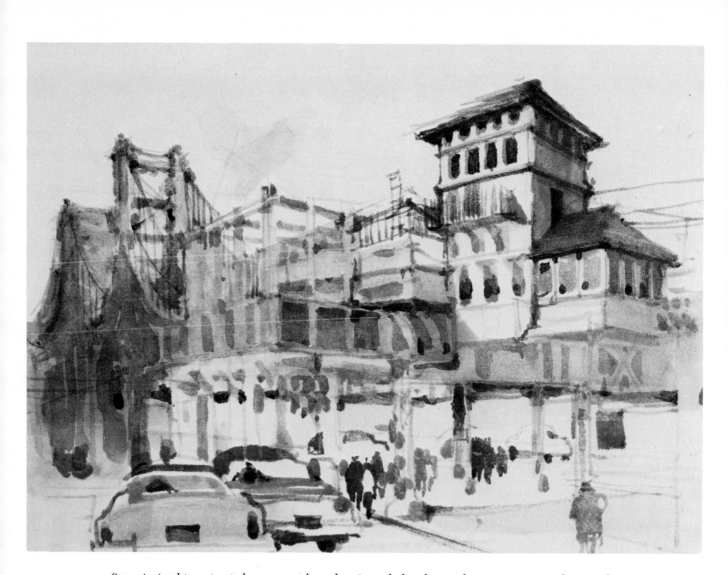

Step 4. *At this point it became evident that I needed to bring the painting into sharper focus. To do this I began adding darker accents throughout the scene, developing a patterned movement of human forms among the girders. Windows were given greater depth, and the upper structures of the bridge were clarified more. Architectural details were also indicated, but only where they helped to define the form, such as in the concrete footings for the girder work and in the supporting iron beams.*

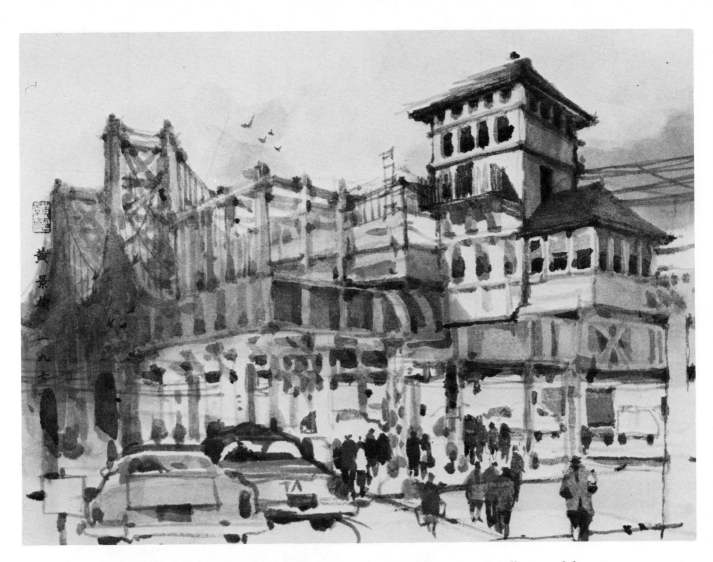

Queens Plaza, (finished painting), *ink on paper, 14" x 18" (36 x 46 cm), collection of the artist. In bringing a painting to its conclusion, it is important to know when to stop. I took a moment to step back for an overall look, trying to evaluate the distribution of lights and darks, the contours of specific areas and the possible need for either a greater sense of activity or for accent lines to contain subject matter of such energy. As a result of this quick "spot check," I decided to increase the number of figures moving beneath the ponderous iron structures. I also accented the vertical line in the lower right-hand corner and added the oblique stroke at the bottom for containment.*

My final touches included darker wash accents in the sky to suggest a greater feeling of space behind the structural masses and to soften the feeling of their hard silhouettes. A small flight of birds was tipped in with a small, round sable above the bridge area, creating a nice feeling of movement and warmth in contrast to the massive iron forms.

5.SPECIAL EFFECTS

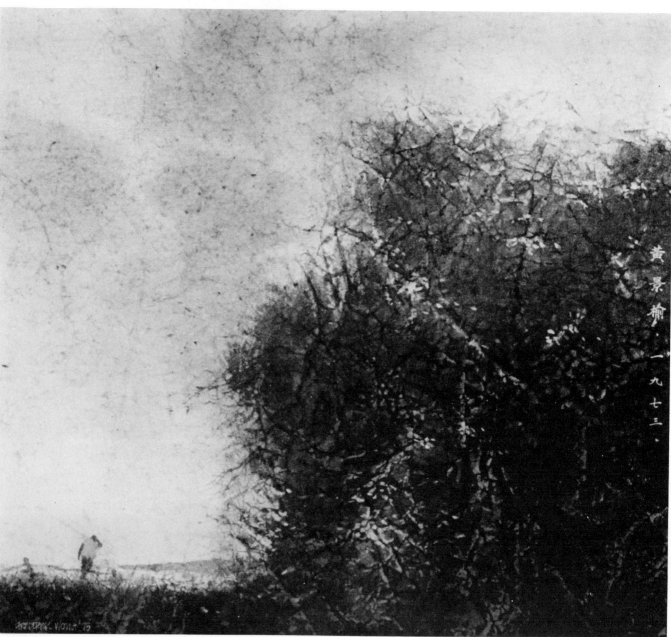

High Wind and Rain, *16" x 18" (40 x 46 cm), collection of the artist. I tried to create a strong sense of movement in this painting. I have suggested wind blowing through the tops of the trees, by indicating considerable agitation around the edges of the trees, with branches bending inside the mass itself. The overall feeling of the painting hopefully gives the impression of a sudden storm blowing up, heralded by a strong gust of wind stirring the trees and sending leaves and other small debris flying. The posture of the small figure in the lower left-hand corner is important in suggesting this sudden change in the atmosphere. One arm is raised to shield his eyes, and the entire figure is slightly tilted against the force of the wind. Because of the quality of light seen in the distant background, there is also a sense of the storm being localized and brief.*

THE MOST COMMON phrase heard in the studios of art institutions might well be, "I know what this should be like, but I can't seem to get it right." Not getting it "right" can, of course, be attributed to any number of causes, beginning with the inability to draw with accuracy and ranging to less than skillful use of color. But even the sure-handed draftsman and colorist will occasionally have problems that are purely technical, that relate directly to rendering of subject matter. It is no easy matter to paint a beach covered with glistening, wet pebbles, or to catch accurately the effects of the slanting light of an evening sun dancing on the surface of a still sea. Sometimes the brush seems an inadequate tool, unable to define a texture too complex to solve by brushwork alone.

Extraordinary problems often require special solutions. To help you channel your thinking, may I suggest two alternatives? Putting esthetic concerns aside for the moment, the painter is left with these areas of focus. The first is the ground—in our case, the paper. Is there anything you can do to manipulate the paper, or is there a special paper available that might facilitate a solution? The second is the tool to convey pigment to the ground—the brush. Will a brush other than the classic round sable solve the problem? Perhaps not a brush at all is needed but rather a tool found or designed specifically for this one need.

There is no stigma attached to making departures from the more traditional approach to watercolor painting. It is as fully creative to invent the tool or process to solve a problem as it is to conceive the painting image itself. The successful painting combines both concept and execution.

WET PAPER

The wet paper technique is a more familiar effect in Western paintings than in Oriental watercolors. The reason for this, of course, is due to the fragile qualities of Eastern papers and the emphasis in Oriental painting on strokes rather than on wash techniques. The novelty for us, then, is to use the wet paper approach on these delicate grounds and see what results can be achieved.

Western practice usually requires wetting the paper with a large brush and, occasionally, with a sponge after the paper has been stretched. In wetting Oriental papers, however, particularly the unsized papers, I prefer using a plant mister or plastic sprayer. The same method can be used on the stiffer, sized papers, but some beading up will take place, and the water can be more evenly distributed by using a brush to supplement the sprayer.

Wet paper effects are basically similar in both Eastern and Western papers. If the paper is very wet, containing pools of water, colors will float. This is a convenient way to obtain a delicate tint of color over a large area. Rather than painting a large wash area stroke by stroke, the same effect can be achieved by tilting the board and allowing the color wash to flow slowly downward. The intensity of the color can be more accurately determined if you keep in mind that the wash you mix will be further diluted by the amount of water on the surface of the paper.

Allowing the paper to dry out to the point where it is damp rather than wet will cause a different effect when color is applied. The colors will flare more upon initial contact with the paper and will not flow as much when the board is manipulated.

LIMITED WETTING

This wetting process is very useful when attempting a large, controlled area of wash. It is most effective on mounted, sized papers which tend to inhibit water absorption and allow for greater surface flow. A brush is used to wet the paper. This permits you to work in some detail and allows you to extend the wash to a clean edge. For example, if you are painting a large sky area which meets a horizon line inside the body of your painting, you can wet the paper to that line, leaving the remaining portion of the

paper dry. A wash is then placed across the top portion of the wet area, and the board is tilted to force the pigment solution to run slowly downward until it pools and collects at the dry edge. The excess color can then be picked up with a damp brush. Under no circumstance should the board be tilted back to its original position. This movement would force the pigment to reverse its direction and flow into areas which have begun to dry. Sometimes this is done deliberately, but only when the results can be anticipated.

SUPPLEMENTARY TECHNIQUES

These methods all imply the use of an uncommon tool or process to apply paint in a manner that is difficult to control and often unpredictable. In offering these approaches to you, I would like to emphasize that they rarely represent a total solution to a painting problem. Most frequently, they are subtle statements that contribute to but do not resolve a painting.

Blotting is essentially a "free form" technique which involves removing rather than adding pigment. In one method, however, this is not true. The blotting paper is actually the eventual painting. Pigment is applied to a very smooth surface, such as glass or plastic. Because of the nonporous quality of the surface, the paint will bead into small pools. A sheet of absorbent, unsized paper is then eased onto these droplets of color and blotted. This absorbent paper will then retain the color, and a loose pattern will be formed around which the painting can then be developed.

Another system calls for color applied to sized and mounted paper. In this instance, washes will stay on the surface longer because the sizing and mounting solution has inhibited the paper's ability to immediately absorb moisture. A scrap piece of *Masa* paper is placed over a wet color area and rubbed gently with a soft brush. This will force the pools of color outward into free form shapes; at the same time, the paper will pick up some of the excess pigment. Do not use a blotter which will virtually remove all your color.

Dipping is a very loose method of color application. It is similar to tie dyeing in that the material is gathered and dipped into a color solution. Unsized paper is used which will quickly absorb and hold the pigment. The paper is gathered in loose folds—there is no need to tie it—and dipped into a saucer of color. The paper is then gently unfolded to reveal the results. Additional dippings can be tried if each preceding wash is allowed to dry completely. Dipping while the first color is still wet has little effect, since the paper will have absorbed the maximum amount of moisture and will retain very little color from subsequent immersions.

Sponging is an imprinting process in which the image is determined by the textured surface of the sponge and the type of paper used. Actually any material that can carry and transmit color and has a suitably textured printing surface can be used as long as it does not damage the paper surface. This imprinting method is usable in describing foliage and pebbly wall surfaces.

Dripping and spattering are also rather arbitrary methods of color conveyance. Spattering, for instance, is the flicking of paint, either with a toothbrush or bristle brush. The paint is dispatched either by bending the hairs of the brush with a finger and then releasing them in the direction of the paper or by drawing the paint-dipped brush across a piece of wire screening material placed above the painting.

Dripping is a technique in which the pigment is brought directly to the paper surface by means of an overloaded brush or sometimes poured from the paint saucer itself. The color is freely distributed and allowed to run together. Interesting effects can be obtained with the dripping method when unsized paper is used. Some control can be achieved by using an eyedropper to drip the paint.

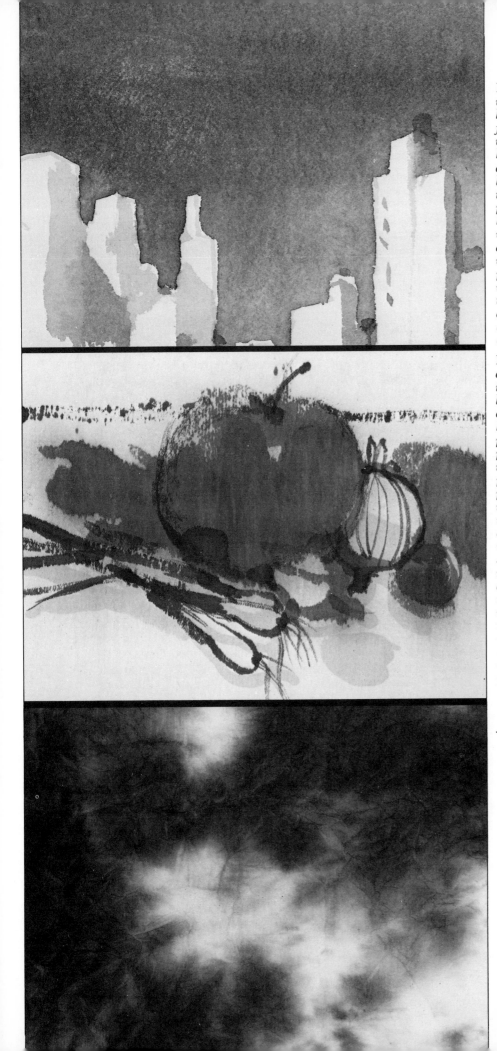

Limited Wetting. *When a large wash is required in an area that butts up against an edge that is difficult to paint quickly, it helps to use a limited wetting process. Start by brushing clear water into the area to be covered, paying particular attention to the border you want to carefully delineate. While the paper is still wet, and with the board tilted slightly, place a very wet stroke across the top edge and allow the pigment to flow downward. If insufficient color is applied, then it is possible for the wash to fade softly into and against the dry edge. A heavy flow would create a more even and flat wash and would require picking up excess color with a brush.*

Blotting. *This particular technique called for a very absorbent paper, in this example, Troya. With a loaded brush I drew rough forms onto a piece of smooth illustration board. I immediately placed the paper onto the painted areas, gently passed a soft mounting brush over it, and removed the imprinted paper to dry. When the ink forms pretty much represented what I had in mind—this is an imprecise technique at best—I mounted the paper onto the same board on which the images were originally painted. To suggest intermediate values, I did not align the two surfaces—board and paper—evenly, but staggered them so that some of the base color would still be visible through the translucent Troya paper. After the mounted paper dried, I added darker strokes to develop the forms with greater detail, taking some pain to also use an occasional dry-brush, textural line.*

Dipping. *This is probably the most free and unpredictable effect you can attempt. It forces you to accept and make whatever you can of the results. I selected a very thin but strong piece of Chinese paper. Wetting it thoroughly, I then gathered it into a tight ball, squeezing out the excess moisture, and then carefully peeled the ball open to check for any possible tears before regathering it into a much looser ball. I then dipped this mass into a shallow saucer of dark, fairly heavy ink solution. The ink was drawn into the paper about halfway into the ball, which I then removed and placed onto a clean surface with the inked area up, allowing for more staining to take place as any excess ink would then flow downward into the unmarked areas. After about ten minutes, I opened the dipped paper*

WET AND DRY CRINKLING

Crinkling is an effect unique to Oriental papers, and not all Eastern papers can be successfully employed. Implicit in this technique is the understanding that you can only crinkle a paper which is sufficiently flexible and resilient to withstand the process and still be effectively used afterward. Western papers have too much body to be subjected to this form of manipulation. *Masa* papers are ideally suited for this technique because the sizing is not excessive but does give the paper enough substance to be worked boldly without fear of irreparable damage.

As is evident in many of my pieces, I have found wet crinkling a very successful way to achieve specific effects. It is ideally suited for the total Oriental presentation because it can only be achieved in combination with the Oriental mounting technique. By this I mean that crinkling the paper represents only half the process. Mounting, in addition to its usual functions of providing more substance to the painting and giving a sturdier working surface also means smoothing out the paper. The final results of crinkling are only evident after this process.

To experiment with the crinkling technique, use a fairly large piece of scrap *Masa*. Wet the paper thoroughly on both sides with a sprayer and brush and allow it to stand long enough for it to absorb as much moisture as possible. Occasionally, and with care, raise the paper by its corners into the air so that excess water will drain off. Wait until no pools of water can be seen on the surface, and the paper feels quite limp and soft, before attempting to crinkle. If the paper is stiff, crinkling will only form long, pointed creases, and the paper will often tear at these points. What you hope to achieve is a web of small lines rather than long folds.

When you have ascertained that the paper has softened sufficiently, crumple the paper by first gathering it from the outer edges inward horizontally, and then gather it vertically. Do not compress it into a tight ball. Merely bring all four borders of the paper inward, gradually squeezing it into a soft sphere. Now carefully peel this ball open. I do emphasize care from this point on because the paper is very soft now and can tear along any of the creases you've formed. Once the paper has been returned to its approximately rectangular form, take a moment to evaluate what you've done. Depending on the content of your subject matter you may decide a finer "crackling" is called for. If so, use a dry, hake brush and gently smooth the paper out as much as possible, allow it to dry completely, rewet it, and start the process over again. This should add more and new creases to the paper rather than duplicating the folds from your first efforts.

Having manipulated the paper successfully to create a pattern of small "mountains and valleys," the next step is to make use of this high-relief surface. The degree of wetness is still a critical factor in determining the end result. The wetter the paper, the softer the image. A surface that is barely damp will return a sharper impression. Also, the amount of pigment carried by your brush will influence the image. A fully loaded brush drawn across the crumpled surface will fill in some of the "valleys" in addition to skimming the "peaks." A drier brush, held at a low angle to the paper, will touch only the "peaks," creating a more distinct and crisper patterning.

When you've determined that a workable effect has been achieved, allow the paper to dry thoroughly. At this point, you may want to add another wash over the first, which means going through the wetting and crinkling process again. In any event, the crinkling should be held to a minimum. Obviously, the more the paper is handled, the greater is the likelihood of it breaking down completely. The final step calls for mounting the paper. This will smooth out all the creases and leave a mottled effect of small painted areas interspersed with dots and open flecks of white paper showing through.

Dry crinkling is a less effective method of patterning and is only usable with soft, unsized papers. The process is the same as in the wet method, except that wash applications are made onto an entirely dry surface. Spraying the paper after it has been crinkled will only smooth out the "peaks" and remove the contrived texture, thus defeating your purpose.

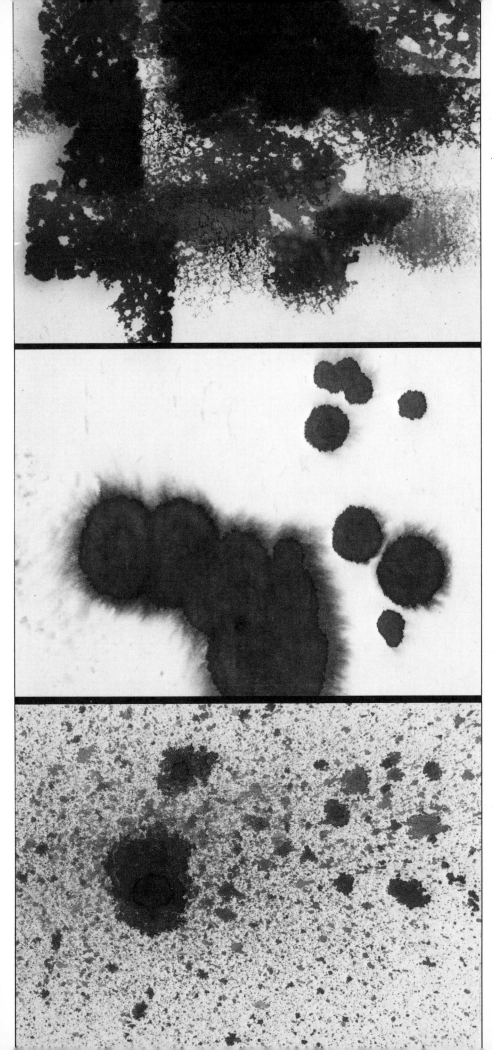

Sponging. *The technique proved to be very exciting for me. I was quite surprised and pleased to be able to develop textural effects with such ease. I cut several small shapes from a cellulose sponge, dampened them, and dipped them into a heavy ink mixture. I chose Hosho paper, with a heavy but loose weave, for its printing surface. By holding a sponge on the surface for a few seconds, I achieved a fully opaque blackness. Touching the surface quickly left a lighter but crisper impression. The use of Hosho paper for this exercise seemed critical in achieving these highly effective results. Its ability to absorb and hold the impression cleanly was impressive.*

Dripping. *A technique I've been unable to successfully integrate into my paintings, dripping always seemed to suggest possibilities. In this example, I simply discharged a loaded brush randomly above, but in close proximity to, the surface of a sheet of Moriki paper. The initial impression was quite clear and crisp. After the mounting process, it became evident that in wetting the paper, some of the pigment buildup loosened and spread, as seen in the fuzziness that developed around the central forms.*

Spattering. *Loading a toothbrush with pigment and then spattering it created this effect on Kozu paper. Because the brush was flicked without any attempt at control, the result is a little too coarse-grained. Had the brush been drawn across a fine mesh screen held above the paper, a more even result would have been obtained. Spattering can be effectively used to suggest granular textures on large surfaces such as wall areas or expanses of beach or field.*

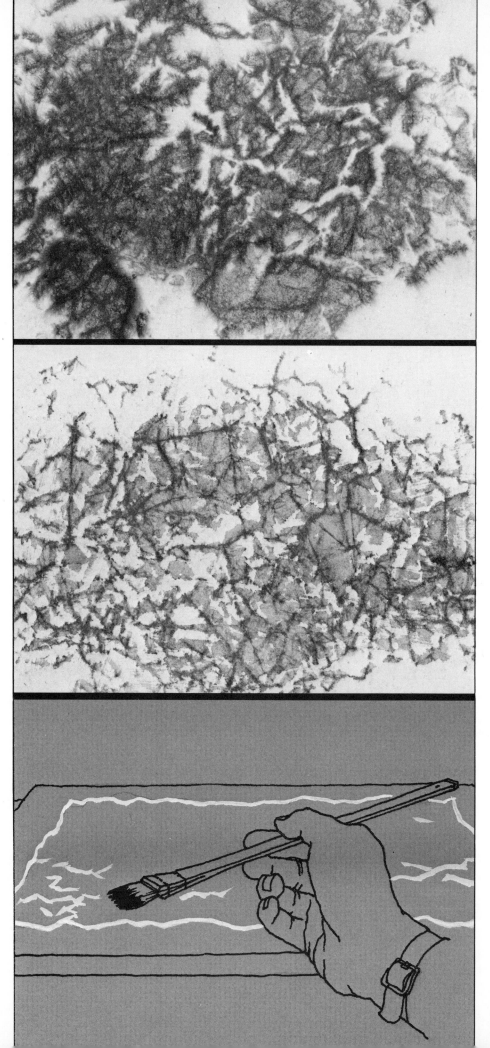

Wet Crinkling. *In this instance, the Masa paper was crinkled, and while still quite wet, pigment was applied. The result, after it was mounted, was soft in feeling, with less evidence of line structure than is usually seen when the sizing has been cracked. With a bit of imagination, you can almost see the suggestion of a snow scene in this raw beginning, perhaps a winter vignette of pine boughs softly covered with wet snow.*

Damp Crinkling. *Another example of crinkling entails the use of Masa paper after much of the moisture has evaporated. While the paper is not entirely dry, it is damp enough to prevent long, straight cracks from developing. The results here show a more crisp, less soft image than in the previous illustration. Small creases, some quite delicate, are evident, and the white areas are clear and nicely distributed. I use this textural base frequently in painting large masses of trees.*

Painting Crinkled Paper. *The actual application of paint is as important as the crinkling of the paper surface. This illustration shows the hake brush being held at a low angle to the paper. The flat side, rather than the edge of the brush, is drawn across the dimpled surface, touching only the crests for the most part and leaving the depressions untouched and white.*

BACK PAINTING

Back painting, at least for me, always seems to be most effective when it is unplanned. It usually occurs when I've worked the surface of a crinkled, unmounted painting to the degree that a substantial portion of my washes will seep through to the back. The reverse image sometimes has more appeal because of its spontaneous feel resulting from the fragmentation of the washes. The semblance of my original intention is still visible, but in a freer expression. When this happens, and I find satisfaction with this side, I will continue to pursue the painting using the reverse image.

This method can be used deliberately on unsized papers, but a drier brush-and-stroke technique must be used. The wet approach will bleed through and create an equally strong impression on both sides of the paper. By using the drier method, only portions of the pigment will seep through, and strokes will have a softer impact.

LIMITATIONS

When the painter successfully resolves a particularly difficult problem through the clever use of an inventive tool or technique and brings the painting to a happy conclusion, there is a terrible temptation to regard the achievement of effects as the end rather than the means. To call these methods mere "tricks" would downgrade their value. I suspect most artists have more than one "trick" up their artistic sleeves and take considerable pleasure in occasionally unveiling them. However, to direct all of one's energies toward contrivances and facile methods will only stunt one's growth toward being a well-rounded painter.

6. TREES AND VEGETATION

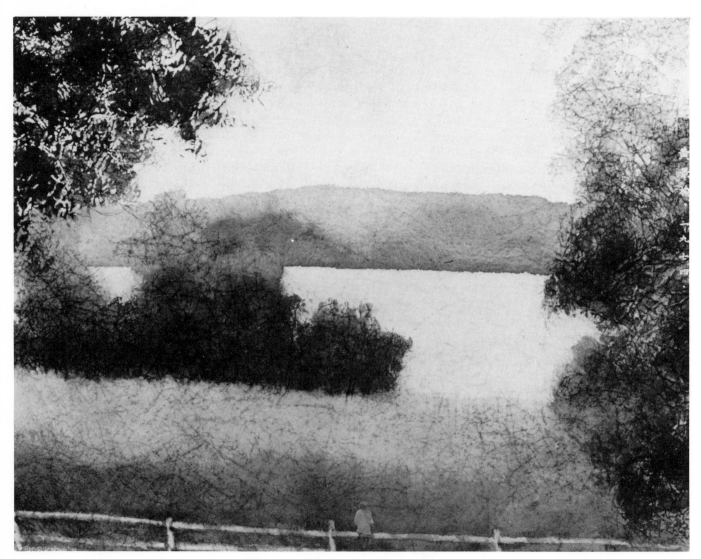

Harbor View, *25½" x 34" (65 x 86 cm), collection Mr. and Mrs. David E. Watts, New York. This painting was developed quite slowly over a period of several months. The painting started out compositionally static, composed in total, of strong horizontal lines balanced and enclosed by the vertical thrust of the tree forms on the right. Eventually, through the manipulation of color and light contrasts, this static quality developed into a feeling of serenity, and emptiness began to suggest a light airiness. Of particular pleasure for me was my handling of edges—the frayed line butting against the dense shadows of the copse of trees in the center moving toward the left, that same line softly blending against the water, the crisp bottom edge of the far shore land form, and the crest line silhouetted against the sky. After the painting was finished, I discovered, somewhat to my surprise, that I had subconsciously developed a quality of the classical Oriental landscape in both mood and technical interpretation of natural forms, particularly in the minimal handling of sky and water.*

O NE OF THE great joys in landscape painting is contending with living, moving, changing subject matter. Even in the cold stillness of a winter setting, there is still a sense of vitality, a feeling of life's forces or energies temporarily resting. To capture the essence of a landscape and its changing moods really means arriving at some understanding of the movement of land forms and the covering carpet of trees, fields, and shrubs which not only conceal the land but also help define its contours.

A TREE'S STRUCTURAL PATTERN

There is logic and orderliness in nature's growth pattern — not, mind you, in the stylized form of well-tended lawns or cultivated gardens, but in these growth patterns in their most natural state. This logic does not imply symmetry or uniformity, although this may occur. Rather, it suggests that growing things develop along a patterned route, a system, which when considered broadly, will assist the fledgling landscape painter to more accurately define nature.

Observing leaf-shedding trees in the late fall or winter months will reveal their basic structure with immediate clarity. A tree, whether deciduous or evergreen, will develop from its main trunk upward and outward, from large to small. An oak tree, for instance, will show a massive trunk, splitting and spreading into large branches at a relatively low point in relation to its overall mature height. A variety of birch tree, in contrast, will have a more slender trunk sometimes developing almost as a cluster of trunks, splitting early and near the ground line. Subsequent branching occurs tighter to the main shaft compared to the spreading oak or shade elm.

Structural patterns, therefore, are broad evaluations that the artist should make immediately, a determination based on proportions within the tree itself and an assessment of its direction of growth.

TRUNKS AND BRANCHES

The process of painting a tree and other vegetation usually can be approached in its broadest aspects followed by a gradual focusing in on larger details. After a tree's overall shape has been determined, consider its main branches in terms of where and how they divide from the main shaft. Keeping in mind that the attitude of growth is large to small and heavy to delicate, try to follow the heavier branches outward until they, in turn, subdivide, eventually reaching the outermost fringes of new growth.

Analyzing the components of a tree is one thing; painting it is another. The classical Oriental landscape artist, using traditional calligraphic techniques, was able to render the effect of complicated branch structures with great facility. Western painters use a similar approach, at least in delineating the more delicate reaches of a tree. A drybrush technique combined with fine line stroking is the solution for both East and West. It is the handling of the larger branches and trunk that shows marked differences in technique. The Oriental painter will either continue to use a stroke approach or actually outline the form, unlike his Western counterpart, who will begin to rely on a wash technique as the shapes increase in size.

FOLIAGE

Great masses of foliage, whether in a single tree or in a combination of trees, can be treated in many ways. The Oriental method would employ a stroke or dotting process (see Chapter 4, "Strokes") in which the impression of each leaf is represented. This very graphic approach is appropriate to the total context of Oriental painting. The Western artist is more likely to see foliage as a large, fluid form which can best be described with washes used with textural, drybrush strokes.

For very large foliage areas, I like to use the crumpled paper technique (see Chaper 5, "Special Effects") combined with a dotting of individual leaves.

THE TOTAL TREE

A tree to a child is an enormous trunk on top of which is a small billowing, scalloped mass of green. A child represents a tree in this manner because of his own diminutive size in relationship to the massive bulk and height of the tree. The trunk, that part of the tree nearest to him, is impressively huge. Branches and foliage are complicated masses looming far, far above him. The tree, understandably, is honestly and naively rendered as component pieces, with no particular concern given to relationship of size or proportions.

But the tree, in a simple analogy, is no more than an umbrella form, with a trunk for the shaft — branches are the ribbing, and the foliage is represented by the cloth covering. With this image in mind, you can then understand that a tree is not a silhouette form in which the structure is fully visible and foliage merely slipped in behind the branches. Leaves conceal and come forward between the viewer and branches, breaking and intruding into the smooth flow of the tree's structure. Thinking again of a tree as an umbrella, the trunk would become its center shaft, penetrating upward into a covering sphere that moves not only in a circle around the trunk but also in an arc flowing alternately toward and away from you.

The naive eye and hand of the child can teach us how best to represent graphically the total tree in a very direct manner. A child's impression of an evergreen is depicted as a two-dimensional triangle, sometimes with a short stub for the trunk. This simple interpretation effectively conveys accurately the basic form of one type of evergreen. A more sophisticated, but equally direct, study might be that of a three-dimensional cone.

It is important, I think, to be able to visualize tree forms in their most fundamental postures and see their distinctiveness before they can be recorded with clarity. I usually advise students to do a quick "thumbnail" sketch before attempting the total tree. This way, they are immediately made aware of both shape and proportions. This little diagram might be no more than a simple line "lollipop" type drawing of a tree, but I would still insist that the handle be accurately scaled to the size and shape of the candy disc.

Rendering the complete tree would depend as much on the season as on the type of tree itself. A deciduous tree in winter would leave you no alternative but to work directly with the completely visible structure. A tree in summer, however, in full and lush bloom, permits more flexibility. The foliage conceals much of the supporting branches, and both technique and color can be more boldly handled. I prefer developing the mass of leaves first, taking care not to unconsciously allow my wash shapes to become too monotonously similar in dimension. Working the great ball of foliage first also immediately places the entire tree into the painting area, whereas painting the trunk first can, if not precisely delineated, force awkward compromises in adjusting the foliage to the trunk size.

If the foliage has been correctly painted, branches and trunk can be quite easily "tucked in" among the leaves; the trunk particularly should feel as though it sits underneath and penetrates the middle of the leaf mass. This feeling can be conveyed if some leaves are shown overlapping the trunk surface, and a deep shadow accent is placed on the upper portion of the trunk.

THE FOREST

Painting the forest scene or a massive stand of trees is less complicated than at first glance. It is not, of course, a single tree multiplied a hundred times. No one ever paints or even attempts to record every leaf, branch, vine, and twig. The talented landscape painter can, however, create the impression that all the details are there.

A forest, generally speaking, can be defined as a dense mass of growth, its visual degree of density determined by its proximity to the viewer. If you are standing at its edge, then the nearest forms will be rendered in greater detail, selectively picked out against a receding and merging mass of fragmented colors and shapes. If you are standing in the forest itself, then truly you will be "unable to see the forest for the

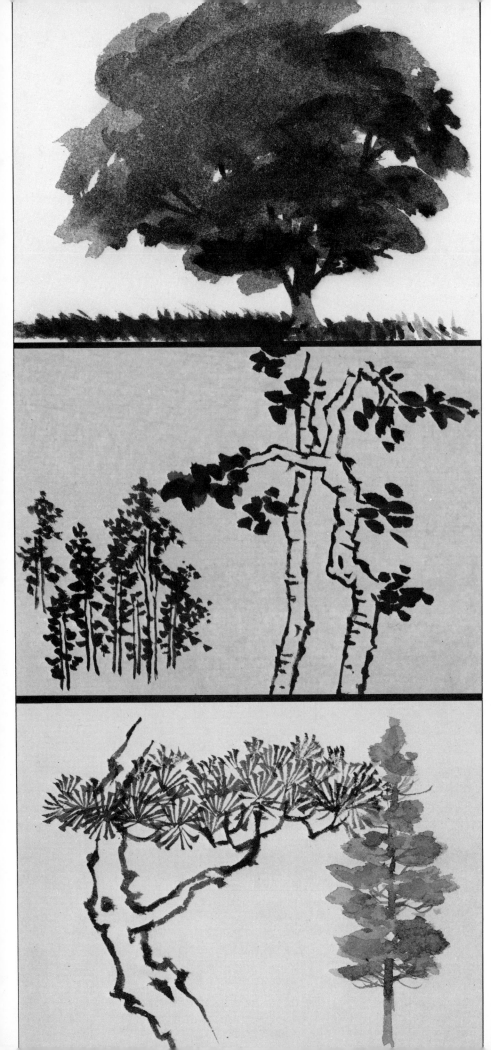

Mature Oak. *A large, mature oak tree grows massively, spreading low, heavy limbs outward from the main trunk. This rendering was done on mounted Masa paper with the textured side up. Heavy, wet strokes were used, and occasionally strokes were put in with the side of a round sable. A very dark shadow on the upper portion of the trunk suggests a heavy overhang of foliage and also conveys a feeling of depth.*

Tree Forms. *An Oriental painter's approach to tree forms is graphic and precise. Closeup views of the trunk are always outlined, as are the larger branches. A middle-ground grove of slender trees will still show trunks as outlined forms. Foliage can vary (see Chapter 4, "Strokes and Textures") depending on the type of leaf. Some are drawn as little round circles, while others are more quickly indicated by dots.*

Eastern and Western Techniques. *The evergreen on the left is very typical in Chinese landscape paintings. The trunk is gnarled and twisted. The needles are handled with precise exactitude; in this case, a sharp stroke like a nail is used in clusters. The tall pine on the right is treated in the Western manner in which washes are used for both trunk and foliage.*

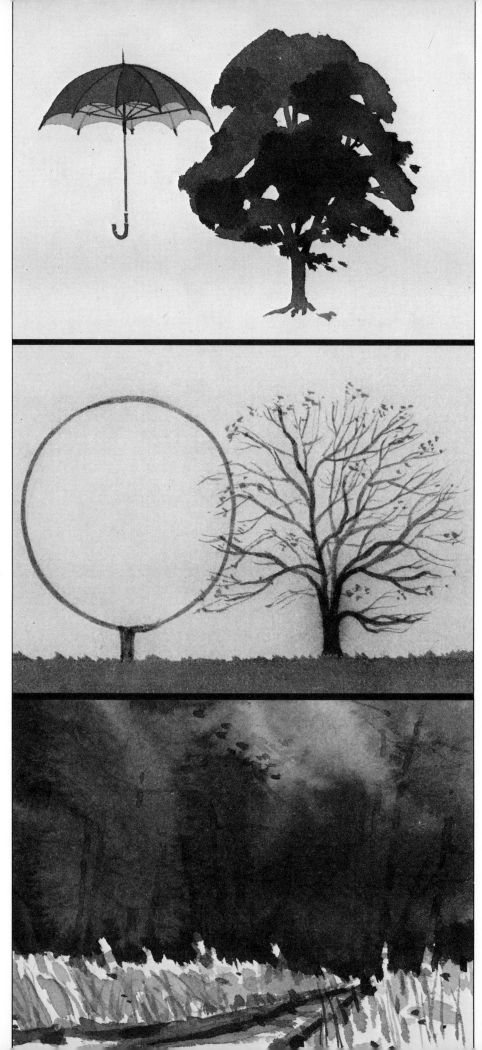

Umbrella. *This form illustrates how a tree can be visualized structurally. The trunk penetrates upward into a covering mass of leaves, much like the umbrella handle which branches outward with its metal ribbings and struts supporting the fabric shield.*

Thumbnail Sketch. *The enlarged "lollipop" on the left is a "thumbnail" sketch of the tree structure on the right. The object of this little exercise is to train the eye to look at tree forms in their simplest shapes and proportions.*

Forest. *A forest can be defined without having to include every tree and branch. Try working the whole mass, using a mixture of shapes and values. Allow some hard edges to develop, some colors to flow together. After this dries a little, while the paper is still damp, pick up some of the pigment and create a light source. Trunk and leaf indications can be added after the painting has dried completely.*

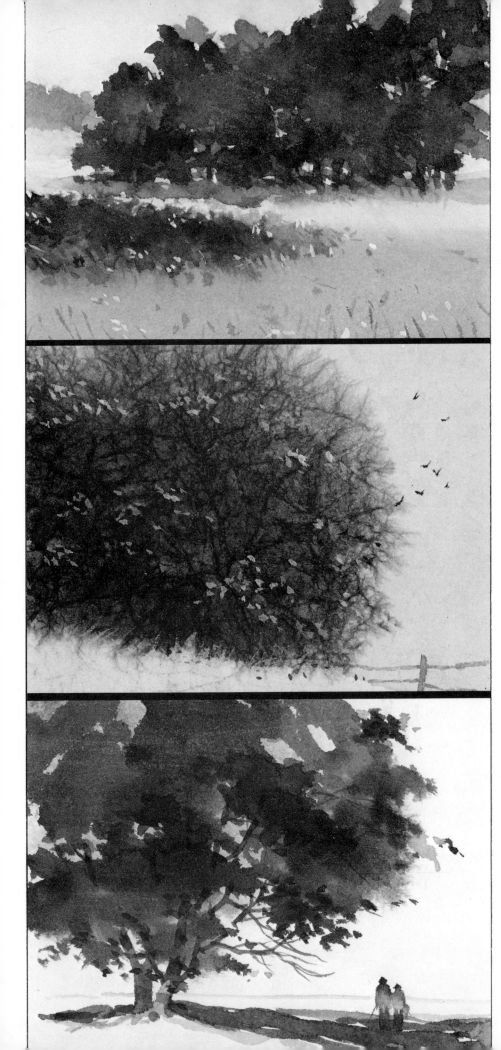

Combined Vegetation. *The feeling of a field, shrubs, and trees can be overworked easily. Of these three areas, I felt the field would be best kept uncomplicated to contrast against the other growths. Using a few thin, faint strokes combined with touches of opaque white and gray, I was able to get the effect I wanted. The darker foliage and shrub areas were painted wetly, with lighter accents put in afterward.*

Spring. *I decided to represent spring rather darkly, almost somberly. This gave me a chance to give a sense of new leaf growth by placing small, delicate accents against a very dark mass of branches. This dark area was achieved by using the crinkled paper technique (see Chapter 5, "Special Effects").*

Summer. *Foliage typical of summer can be painted nicely in juicy, wet washes that suggest a fullness and lushness of growth. The shadows are deep and dark to heighten the feeling of bright sun. Light areas on the two figures were picked up by washing clear water into each form and picking up pigment with a damp brush.*

trees," because the mass will break down into its component parts. Trees, under-growth, and foliage will be seen with clarity and painted as such. The forest seen at a great distance returns to being a compact, solid-appearing unit. There will be occasional openings in this distant mass, representing forest clearings, and, depending on the quality and source of light, some sense of surface texture will be evident.

SHRUBBERY, FIELDS, AND GRASSES

Low-growing, wild forms serve a very precise and convenient function in nature and for the landscape painter. These varieties of ground cover act as handy visual bridges, effecting gentle transitions between ground contours and larger, vertical growths.

Fields and grasses are essentially flat expanses that are frequently mishandled by artists through overworking. Because these forms are basically fine-line growths, their visual impact is usually of considerable density but not weight. Putting down the right color wash to represent the whole field area is of greater importance than the delineation of the individual forms. After this wash has been painted, then smaller details can be added, with particular attention paid to the verticality of these types of growth. Delicate verticals of greater length can be stroked into the foreground areas, and, as the field recedes into the distance, these strokes can become shorter. These lines can also be painted as clusters of fine arcs, suggesting the effect of a breeze moving across the field's surface.

SEASONAL CHANGES

The effect of seasonal changes on growing things is reflected primarily in two ways. Color, not only in foliage but also in support structures, is the most obvious change. Density—the feeling of closeness giving way to more airy openness—is a more subtle consideration.

The cyclic change of seasons is most apparent in its effect on leaf coloring. Spring is the time of new growth, fine and delicate. Soft yellows and pale greens dominate, but the soft, warm rains will affect branch and trunk structures, turning them dark. With little overhead shelter from the newly formed leaves, rain will penetrate more deeply into these growths, and the ensuing wetness will deepen and heighten color contrast.

Summer greens and browns are lush and intense. Light, gentle, and diffused in the spring, they become direct and brilliant in summer, with colors intensified and shadows deepened. Trees are in full foliage, shrubs and all forms of low-ground vegetation are mature, and the feeling of the tree is one of great density.

Autumn explodes with virtually a complete spectrum of color. Of relatively short but intense duration, the effect is almost overwhelming. Again, as in the spring months, growth structures slowly become more apparent as leaves fall, exposing the supporting members to cold rains. A favorite autumn theme is that of bright-colored leaves contrasted against the deep blackness of tree trunks and limbs. Shadows become longer, as the earth's axis tilts away from the sun.

Winter colors are muted and somber as the full structure of trees and shrubs reveal themselves with the loss of their foliage cover. Fields die back and show more of the land contours. Evergreens, of course, retain their color but show a cool deepness in intensity that is less obvious during the warmer months. Shadows cast by the winter sun can be crisp and hard, deep and black.

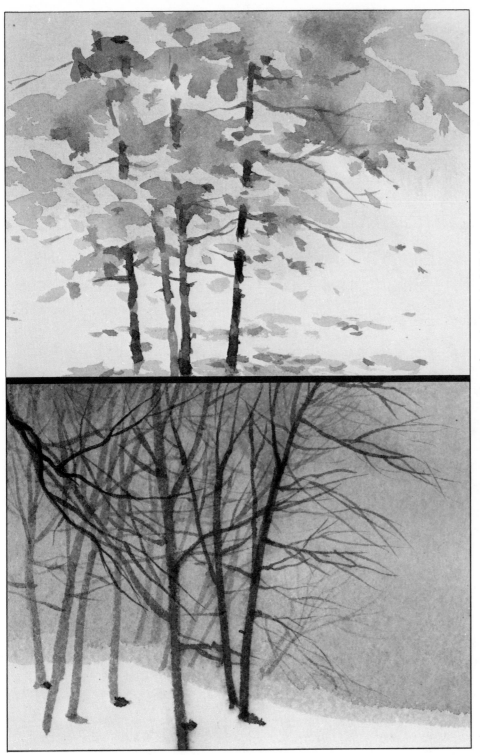

Autumn. *A sense of autumn, for me, means brightly colored leaves against dark trunks and branches. In this picture, I also tried to show more of the tree structures, as leaves are blown to the ground. After putting down a light base wash, I was able to pick out the foliage with strokes and quick dottings of individual leaves.*

Winter. *The total tree structure can be seen in winter. In this case, I tried to build up the stand of trees by starting with the ones farthest away, using the lighter gray values. The nearer ones are darker and more clearly defined. Some feeling of left-to-right movement is conveyed by the general direction of the smaller branches along with the tilt of some of the trunks.*

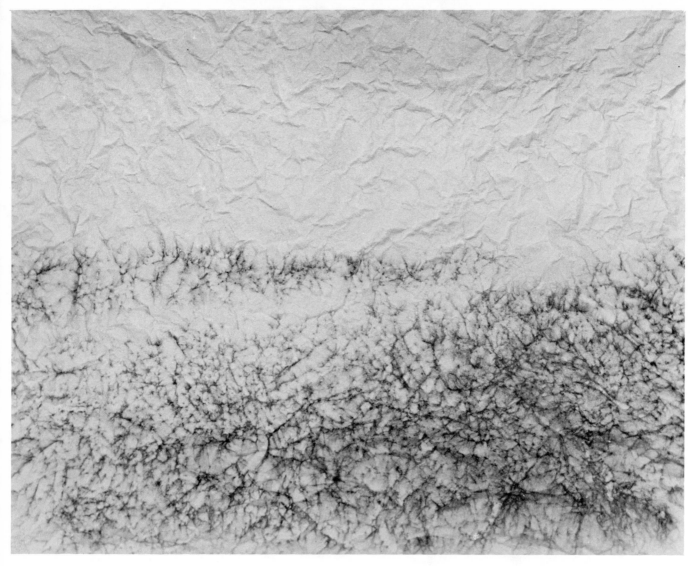

Step 1. *In painting this particular landscape, I was able to combine several techniques previously described in Chapter 5, "Special Effects." I first sprayed a sheet of unmounted Masa paper on both sides thoroughly, allowed it to soak for ten minutes or until soft and limp, then crinkled it. With considerable care, I then opened the ball of damp paper and gently placed it onto my taped mounting board.*

The first actual painting to be done on crinkled paper is fairly tricky. The technique is imprecise, so the composition should be conceived in very broad outlines, allowing for the possibility of surprise. Using a 1-inch hake brush dipped into a very loose wash solution, I stroked in the foreground area, leaving a narrow, unpainted strip suggesting a path. The brush was held at a low angle to the paper and drawn firmly across the surface. Because the crinkled paper was still quite damp and the ink solution heavy, much of the pigment penetrated through the cracked sizing onto the reverse surface. In the next illustration, the effect seen is actually the back of the paper, rather than the side on which I painted. This back surface is the side on which I continued the painting.

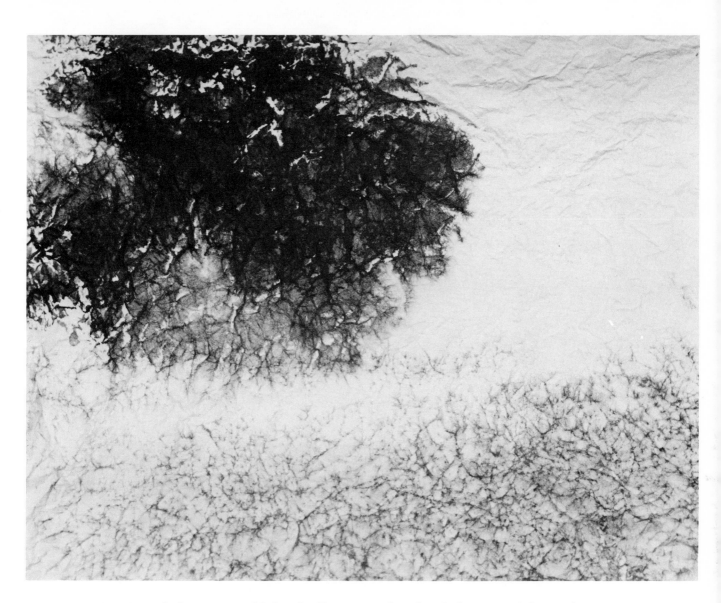

Step 2. *With the paper crinkled and still unmounted, and with the reverse side now face up, I proceeded to add the large mass of trees and foliage in the upper left quarter of the paper. Again using my hake brush, dipped this time into a darker and denser ink solution, I stroked in this large mass. The brush was held at the same angle as before, but only enough pressure was applied to skim across the top of the crinkled surface. Pigment was deposited on the peaks, while the valleys remained a pattern of white dots. This process was continued with alternating shades of gray mixed with much darker values. At this juncture, having established the tree mass to my satisfaction, the paper was allowed to dry completely.*

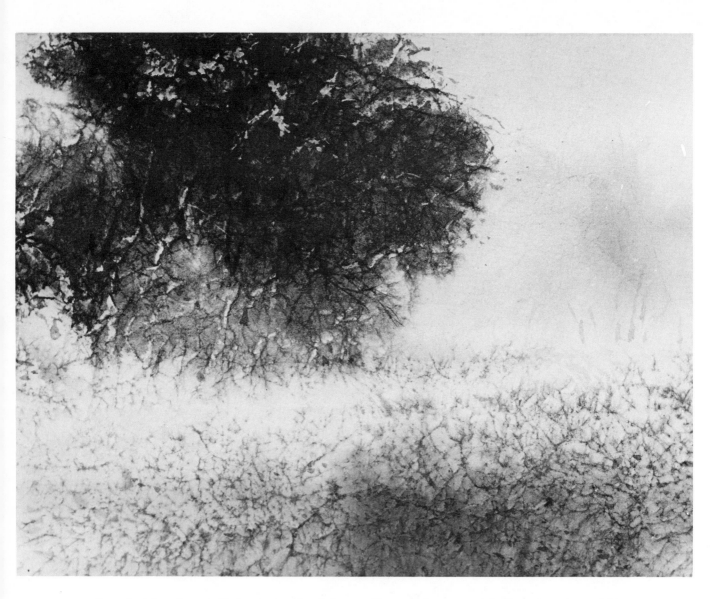

Step 3. *After the crinkled painting dried thoroughly and the pigment had time to set into the paper I decided to mount it. I again sprayed it on both sides, and using a wheat paste mixture (see Chapter 9, "Mounting and Framing"), I glued the painting to the mounting board. In this process, all the wrinkles were gently smoothed out. Some running and smearing occurred in those areas where I had a pigment buildup, but I was able to pick this up with absorbent tissue. With the painting completely smooth and flat, it had become much more readable. The image had taken on firmness.*

After again allowing the paper to dry out, I rewetted the surface lightly in order to flow washes into the foreground field and also to indicate a distant grove of trees on the right-hand side. Details in the dark foliage mass were picked out by augmenting the crinkling effect with dots and strokes. Drybrush branches were added to the edge of the tree forms.

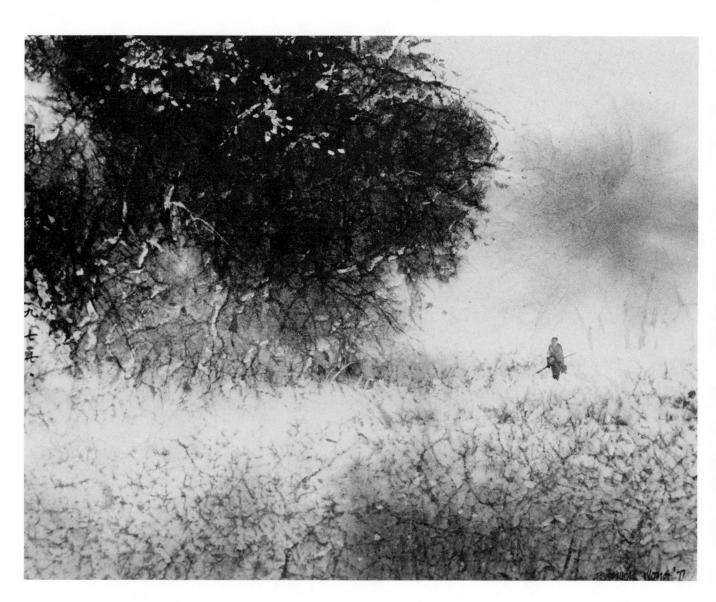

Morning in Summer, (finished painting), *ink on paper, 11½" x 15" (29 x 38 cm), collection of the artist. Among the finishing touches, I included the small figure in the middleground. Its size and placement was of considerable importance, since it helped to establish the scale and perspective of the entire painting. Its location served to offset the weight of the heavy tree forms on the right. Thin strokes, both wet and dry, were added to the foreground field and into the wild grasses bordering the road and trees. Dark strokes were also painted into the foliage to suggest tree trunks and limbs. Some opaque white was dotted near unpainted areas left by the crinkling process. This created a better transition from light to dark.*

7. SKY, WATER AND FOG

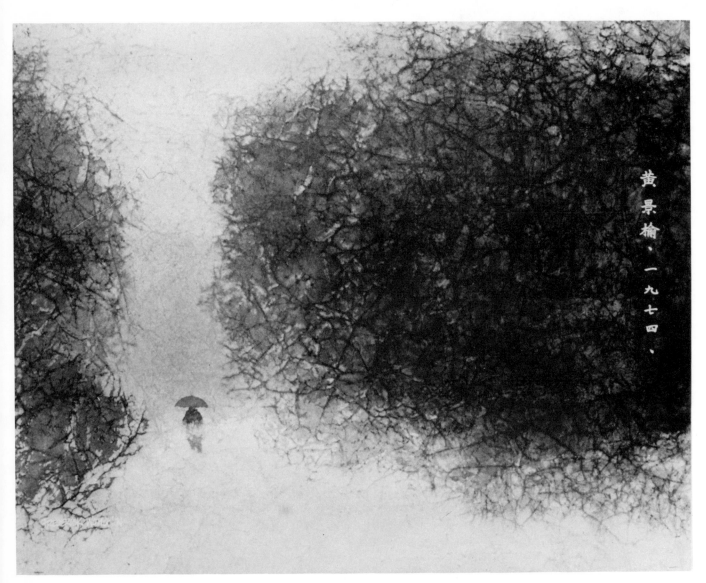

Nightfall, *12½″ x 16″ (32 x 41 cm), collection Theodore and Elsa Novak, New York. The use of the crumpled paper effect is quite evident in this painting. Both dark masses on the left and right were handled in this manner, along with the suggestion of brush growth at the base of the trees. Atmosphere is conveyed by both the mistiness bisecting the walking figure and the figure's vague definition. While the center of interest is the man with the umbrella, the eye tends to first travel across the large mass of tree forms on the right. This movement is caused as much through the weight of this shape as it is by the directional tilt of the form.*

W

HEN I WAS a very young boy, I was frequently asked by my elders what I wanted to do when I became older. I would always reply, "I want to paint pictures." And they would ask, "What kind of pictures?" My answer would invariably be, "Son-sui."

In Chinese, the phrase, "Son-sui" means landscape, but literally translated, it means, "mountain and water." This elegant phrase encompassed, of course, more than just these two areas of subject matter. Painting mountains meant painting land, rocks, trees, and hills too. Water included streams, rain, rivers, and waterfalls. Perhaps "Son-sui," in its broadest interpretation, can mean "natural vistas" or panoramic views of nature. As the visual scope of Chinese landscape painting expanded, it became obvious that the representation of solid form through sophisticated brushstrokes was equaled in importance by what was left unpainted: the sense of space and atmosphere.

In Chinese landscape paintings, this feeling of space includes more than the effect of distance. A sense of tangible atmosphere is conveyed by gentle mists settling softly into valleys, while craggy mountaintops loom overhead. The broad expanse of a river is left unpainted and is defined only by the minuscule boat floating on its surface. Fog, sky, and water are often the same color or no color at all and explained only by their respective positions within the boundaries of the landscape.

In both technique and attitude, painting sky areas, fog and mist, and bodies of water is, of course, unlike treating man-made structures or the solid forms of nature. In the one case, we can accurately plot and draw the forms through our understanding of perspective. Solid substances of nature are anchored to a common ground plane and have identifiable color and texture. Sky and fog, however, are nebulous "forms" having no definable shape and color and are of a rather intangible quality. Water has many faces. Dense and opaque at times, violently alive or calm and still, water frequently is better explained and made more real by its surrounding circumstances than the painting of water itself. Chi Pai Shih, a master painter of living forms, so successfully described the swimming movements of fish, shrimp, and crabs that there was never the necessity to represent their environment.

EFFECTS OF LIGHT

An understanding of light, which is of paramount importance in our use of color and definition of forms, is equally significant in explaining water, sky, and fog. The light qualities in a clear sky, a cloudy sky, or a threatening or peaceful evening sky influences and establishes the mood in the entire composition. Light contributes to the surface attitude of water. A lake shimmers and glistens or appears leaden and still due to a combination of surface activity reflecting the quality of light. Fog and mist can appear opaque or translucent depending on whether light is intense or diffused.

Curiously enough, we can learn little about the effects of light on sky, water, and fog from Chinese landscape painting. Scenes are usually suffused with a uniform, gentle light, with no evidence of cast shadows or no shimmering mists rising from the base of a tumbling waterfall; only calm and total stillness pervades.

CLEAR SKY

An absolutely clear sky, with no cloud formations, is not as easily painted as it might seem at first. The effect of a perfectly uniform blue can create a sense of opacity which might become too strong a color statement in terms of the context of the landscape. There is the risk then of the sky area feeling like a two-dimensional backdrop rather than an atmosphere which moves from directly above the artist/viewer downward in an arc to the horizon line. The feeling you want to create is that you are standing underneath and directly in the center of a large inverted bowl. The blue wash should be quite delicate so that in combination with light and shadow in other portions of

the painting and in contrast to the solid forms, the impression of blue is visually intensified.

"EMPTY" SKY

This expression of mine, the "empty" sky, was contrived in particular to describe those expanses in Oriental landscape painting which have little or, more frequently, no pigmentation at all. I use this effect to subtly soften the contrast between the solids and the voids. Rather than use a pronounced color for the sky, I mix a very fluid blend of Prussian blue and burnt umber, creating a neutral, pale tint, ever so slightly warm in feeling. The entire sky area is then flatly washed in with this color. There is enough definition in this color mixture to both suggest atmosphere and at the same time soften the effect of raw, white, unpainted paper.

CLOUD FORMS

While the cloud motif is frequently seen in Oriental design, it is less evident in landscape paintings. When used, the representation is a mere suggestion, a wispiness of high, thin streamers executed in delicate, gently twisting brushstrokes.

Western watercolorists enjoy the more dense cloud formations, the drifting, billowing, three-dimensional masses that float and cast shadows on the land surface. Whatever the nature of a particular cloud formation, however, it is important to maintain a consistent character in all the forms and not haphazardly combine several varieties.

Basically, painting clouds can be fun because, once the character has been determined, the shapes can be fluid and arbitrary. A thin cloud covering, for instance, is thin in feeling and appearance, but who is to say how thin?

Technically, cloud masses can be created with both wet and dry approaches by using Oriental papers particularly suited for the wet attack. Experiment by wetting a piece of sized paper evenly. This type of paper retards absorption, which will permit you to manipulate the wash as it floats on the surface. Allow the paper to dry until it is damp, without any pooling of water. Now wash in the entire sky area with your cloud color. This pigment mixture should be fairly dark in value and should represent your final color effect because the remaining steps in this exercise call for removing parts of this wash.

Next, using a round brush dipped in clean water, place a series of short, horizontal, egg-shaped strokes into the sky area nearest to you. Rinse your brush out by dipping it into clean water again, but this time shake some of the moisture out before continuing the stroking process. The strokes should slightly overlap and vary in size and thickness as you interpret the cloud mass forming an arc toward the horizon. Return to your first wet strokes which have expanded and merged with others and, using a virtually dry brush, pick up some of the excess moisture inside these first strokes. If you find the results suitable at this point, allow this painted area to dry completely. In the event that the effect is too dark overall or has started to dry with too many hard edges, wait until the painting is almost dry. Now respray and, with a wide, barely wet hake brush, soak up the entire area with broad, even strokes. The result will be a softer and lighter image. The final effect should give the impression of an overcast day, with a full cloud covering moving from overhead all the way to the distant horizon.

BODIES OF WATER

The coursing, tumbling river winding its way between sheer cliffs, a spilling waterfall, or a calm, inland sea, are all common subject matter in Chinese landscape paintings. What is unusual, however, is the seemingly casual treatment given to defining these water forms, particularly when compared to highly detailed renderings of trees, rocks, and mountains. A few delicate, vertical strokes are used to suggest the downward plunge of a waterfall. Wavy lines in a faint gray wash suggest surface movement in a

Fog, Sky, Water. *In this representation of traditional Chinese painting, fog, sky, and water are the color of the paper. There is no need, although it is done, for the Oriental landscape artist to add water movements or billowing clouds. Given the amount of information available, no further definition is required.*

Defining Space and Environment. *This modest attempt on my part to copy some of the living forms painted with such mastery and vigor by Chi Pai Shih serves to illustrate that, given the skill to depict accurately the spirit and movement of things in nature, space and environment are also defined in the process.*

"Empty" Sky. *This is a description I coined for lack of a better word to suggest vast space. Frequently in my work, I find active skies detract from the mood I want to convey. In lieu of clouds or blue sky, I've been using a very neutral wash of the faintest value to fill the area. As seen here, the sky is not the white of the paper, and yet this delicate tint seems to define a vast space and lend a subtle emotional impact to the scene.*

still lake. The impression of white water rapids is created by a series of stylized waves, but without any feeling of great agitation.

Water, then, in Chinese landscapes, is not meant to be meticulously rendered. Rather, it functions as space, sparingly contrasted against massively constructed land forms. Along with sky and fog or mist, water becomes a third compositional element in these paintings, emphasizing the many contrasting partnerships, large against small, hard against delicate, active against calm, open space against confined space.

Winslow Homer painted a shadowed pond in such black density that, were it not for the glistening trout splintering its surface in a thrusting leap, the eye might well have perceived the substance as anything but water. Thus, the impression of water is often determined and reliant upon other circumstances for its reality. Any body of water, in order for it to have a shape, must be contained, whether in a spanless ocean basin or a small depression in your front walk. This fact implies a boundary or land perimeter bordering the body of water. It is this edge, where water and land come in contact, that must be accurately and graphically identified in order for water to be logically assimilated into a landscape. Ocean waves will crash and break against the hard rock edge of a New England coastline, but it may also lap gently up the sloping grade of a sandy beach.

REFLECTING SURFACES

The color of water varies greatly, affected by a multitude of circumstances. A handful of water scooped from an ocean surface is colorless, not the rich blue-green of water seen from a distance. Water is really the color of light, determined by the amount and type of light reflected from its surface and by the degree of light penetrating into its depths. The clear, clean water of a Caribbean lagoon will allow light to penetrate all the way to its sandy bottom. The color effect will then be a combination of that sand along with reflections of light on its surface. A deep, dark pond derives its feeling of density from the amount of silt held in suspension by the still water, allowing little light to enter its depth.

Perhaps the simplest way to explain surface reflections is to compare the effects of a piece of window glass to a mirror. Glass, held to light, is completely transparent, revealing all behind it. This is the effect of water in the Caribbean lagoon just mentioned. Glass, with a silvered backing, becomes a mirror, stopping light from entering beyond the thickness of the glass, and will bounce light back reflecting an image. This is the effect created by a heavily sedimented pond. A boat floating on the clear lagoon will cast a shadow almost directly to the sandy bottom, whereas a leaf floating on the murkier water of the pond will reflect a much more precise image on its surface.

WATER MOVEMENTS

Unless you are painting a seascape, where water occupies the greater, if not total, portion of the surface, then your area of prime concern is probably at the water's edge, where the shoreline is joined.

In open seas, surface movements are determined by forces of nature, usually winds and weather. At the land's edge, however, water movement generated by nature is affected by the configuration of the shoreline, which frequently alters the character of the water. Water can lap, bump, or collide with a shoreline, depending on the strength of the impelling force. The attitude of the countermotion of water at this point of impact rests on the structural nature of the shore itself. A smooth beach will allow a tidal flow to return smoothly, whereas piers and pilings break the normal movement of water, causing small, swirling eddies.

Painting the surface action of water calls for considerable restraint. The tendency is to over-render, to add an excess of wavy strokes, or to create a turmoil of conflicting directions. It is also important to realize that the movement of water in a landscape is not an isolated effect. A strong wind roiling and ruffling a lake surface will also fill sails, stir trees, wave grassy fields, and flap garments. Discreet handling of agitated

Clouds. *The standard classical approach to the rendering of clouds by the Oriental painter usually entailed a few wispy lines which curled and floated lazily in space. Rarely are these clouds painted against an open sky. They are more frequently used as settling mists on mountain peaks or into valleys, where they veil rocks and hills. More often than not, they bisect a rocky peak, leaving its highest point looming above this cloud form.*

Wet Clouds. *Soft, wet-looking clouds can be a handsome effect in a watercolor, and they're fun to try. The trick is to get them to stay in place once you've decided to use the wet approach. If the sky area is very large, try using a sprayer. However, if the space is tight and butts up against a critical shape, use a wide hake brush for more controlled wetting. Before stroking in color give the paper a little time to dry, so there is no pooling of water evident. Allow the pigment to flow with the paper. Dry your brush and pick up some of the color in the center of some of the forms. As the surface dries more, use a brush dipped in clear water and spot into the rounded forms. Be careful that hard edges do not develop.*

Overcast Sky. *A cloudy, overcast sky can be interesting if some definition is added to relieve this gray expanse. Use the same technique as in the rendering of billowing clouds, except keep the shapes more elongated. Start with larger forms to suggest sky which is directly above, and gradually brush in smaller, thinner clouds. Pack them together until they fade into the distant horizon. A few faint and freely drawn lines, as seen in the sketch for wet clouds, will also help "move" the sky away from the viewer.*

Thin, High, Clouds. *A high sky with rather thin clouds can be portrayed with a series of wash strokes of close value, drawn as though they were rushing toward a gathering point at the horizon. An occasional patch of blue breaking through gives the effect of cloud movement.*

Billowing Clouds. *A familiar sight in the Southwest—at least when the sky is not perfectly clear and blue—is a billowing white cloud drifting and momentarily covering the sun's glow. Clouds then show an outer edge of light, with the center portions darker. To create a sense of clouds floating easily in space, I like to keep their bottom edges fairly flat and straight, with a good amount of blue sky showing.*

Agitated Water. *In Oriental painting this takes on a very distinctive, rhythmic, design. Even the foamy whitecaps become well conceived designs. Representations of more quiet waters call for less high arc-shaped swells. One type of pattern frequently used is called "fishnet" because of its obvious resemblance to fishing nets.*

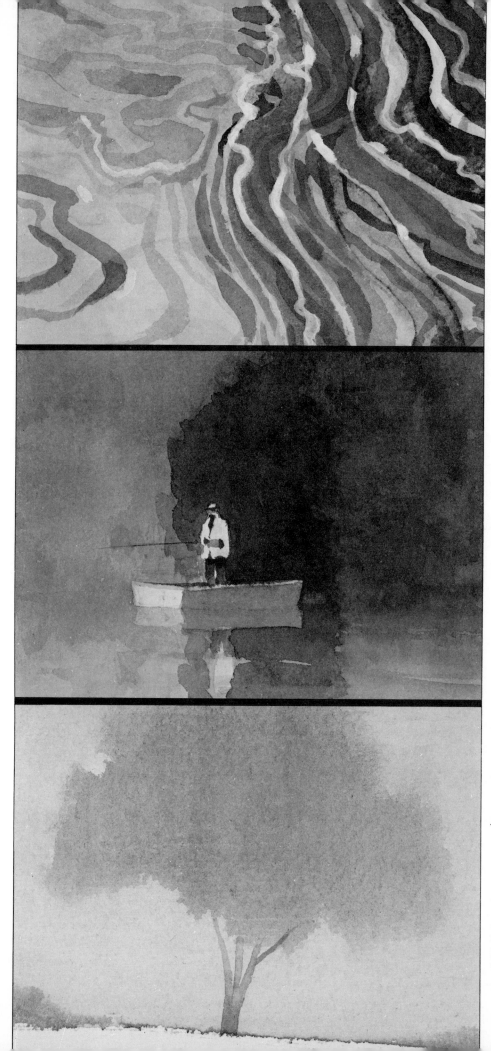

Swirling Water. *In this illustration, I've used a series of strokes of varying value and rhythm to suggest both surface movement and shadows beneath the surface. The lightest lines suggest reflecting highlights in contrast to the dark movements below. The total effect is of clear, gently swirling water.*

Calm Water. *Absolutely still water would reflect a very precise image. This illustration shows calm water, but with a slow, slightly undulating movement. The boat is reflected quite clearly, but a small wave has rippled the fisherman's reflection and disturbed the cast shadow of the dark tree directly behind him.*

Tree in Fog. *A single tree in fog is easily done if the tree itself is handled with accuracy. In this case, I chose to place all the foliage in mist and the lower trunk areas in more clarity. I wet the paper first and allowed much of the water to evaporate before laying in a loose wash for the foliage. I tilted the board a bit in different directions to control the running of the pigment. A happy accident occurred in the upper left-hand corner where the wash flowed up against a dry spot, and a little harder edge developed. The effect—at least to my mind—is of a pale sun trying to break through the mists. The trunk was put in last, in a value just a little darker than the foliage.*

water movements combined with their reactions to land forms can often convey a more effective impression of a scene than can focusing too tightly and overworking one aspect.

FORMS IN FOG

Creating a sense of fog or mist is less a case of painting these hazy shapes than it is of delineating the forms affected by them. Solid forms seen with clarity and of darker value in color suggest a light fog covering. As these forms lose their definition and deep color value, the sense of fog becomes more enveloping and dense. Clarity of objects and value changes, in addition to revealing fog density, also establish distance. An ill-defined shape in light silhouette suggests it is well ahead of you. These are only broad observations, of course, and would be affected by the relative size of the forms and their normal color value.

Fog, in itself, has no color, but shows the impression of color depending on its thickness and the light situation. A thin, vaporous ground mist may only faintly obscure forms, but these forms will still show their coloration, although some color intensity is lost and values will lighten. Fog, which is composed of tiny water droplets suspended in the air, will reflect light, as those of you who have driven in a heavy fog bank with your headlights on, will be well aware of. Thus, fog can take on some effects of light consistent with the time of day and circumstance.

To successfully convey the perimeter of fog—those vague edges where the scene returns to its normal clarity—you must blur and soften all emerging forms until you gradually bring them to their true distinctness.

Fog, like water and sky, is probably most successfully represented when understated. To restrain any desire to overpaint the effect of fog, keep this concept in mind. Think of your white paper as the most dense, surely the most opaque, form of fog imaginable. Consider each solid form added to this white mass and its effect on the misty impression you want to create. In your attempts to suggest the color of fog, evaluate what each wash does in altering the relationship between the forms already painted and existing in the mist and those forms outside the mist. The approach is a combination of adding forms and color and gradually subtracting white "fog." You may well find that less is better.

Try it. It works!

Step 1. *Density of fogs and mists are determined by the clarity of detail. In this painting, I proceeded with considerable care, trying not to develop any forms too distinctly at this early stage. I placed a very light wash across the top portion of my mounted Masa paper. The lower half, left essentially unpainted, approximated the area in which the fog would be most evident. I also darkened the center of the upper portion slightly, with the idea in mind that this would be where I would later locate some structures. Mounting the Masa paper first, with the smooth side up, allowed me to lay and blend washes evenly and with ease. This first wash was painted onto a damp surface with the board slightly tilted to allow a slow, downward run. As the pigment approached the area I wanted left unpainted, I returned the board to a flat plane and quickly picked up the excess paint with a damp brush.*

Step 2. *When painting a scene in which fog is the dominating characteristic, it is advisable to leave those objects which require greater definition for last. I decided to work on the ground plane next. In keeping with the sense and mood of soft rain and fog, I tried to develop this area in a loose, fluid manner. I dampened the lower half of the painting with a wide hake brush and immediately washed in a very dark streak across the entire width of the surface. Again, I tilted the board slightly to allow the pigment to run to the bottom edge, which also created a soft blending at the top. This wash was permitted to sit until almost dry. I then used a #5, rounded sable brush dipped in clean water to stroke in the light colored streaks. The water left wavy, light impressions by diluting the base wash. Quickly rinsing my brush out to remove any residue of color, I immediately went back into these small areas and picked up any excess moisture. After the ground area dried, I reversed the board, dampening the top half. While the surface was still wet, I floated a wash onto the surface representing a large foliage mass. The board was kept flat in order to keep this dark color in place. I did not want to create any directional flow. Finally, with this portion of the painting almost completely dry, I painted in the silhouette shapes of the distant skyscrapers, making sure that the bottom edges graded out evenly into the horizontal representation of the fog.*

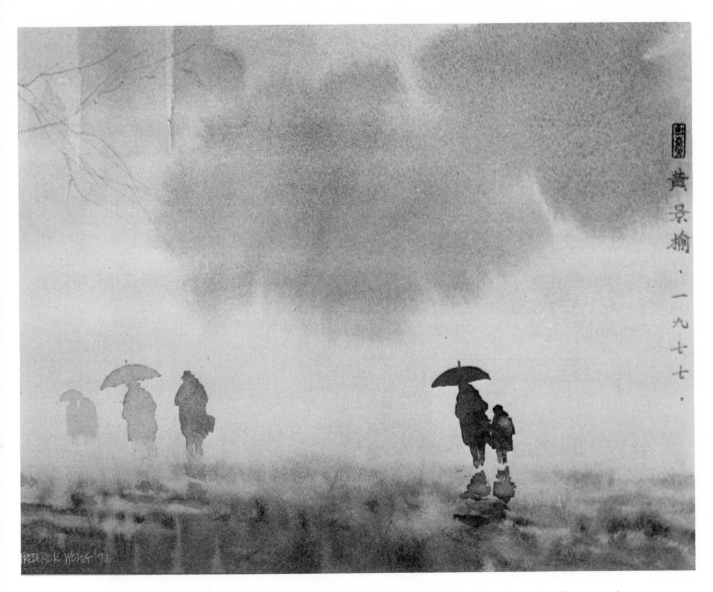

Fog This Evening, (finished painting), *ink on paper, 11½" x 15" (29 x 38 cm), collection of the artist. The last, and perhaps most critical, touch called for figures moving into the fog. The nearest forms had the most clarity and were the largest in size. They were also the darkest in value. As the figures moved into the fog, they diminished gradually in size and lightened in value. Reflections were also added to the closer forms, but not to the others. This helped further establish the fog density. A suggestion of overhanging branches was stroked into the upper left-hand corner to offset the massive movement of the foliage on the right.*

8. STRUCTURES

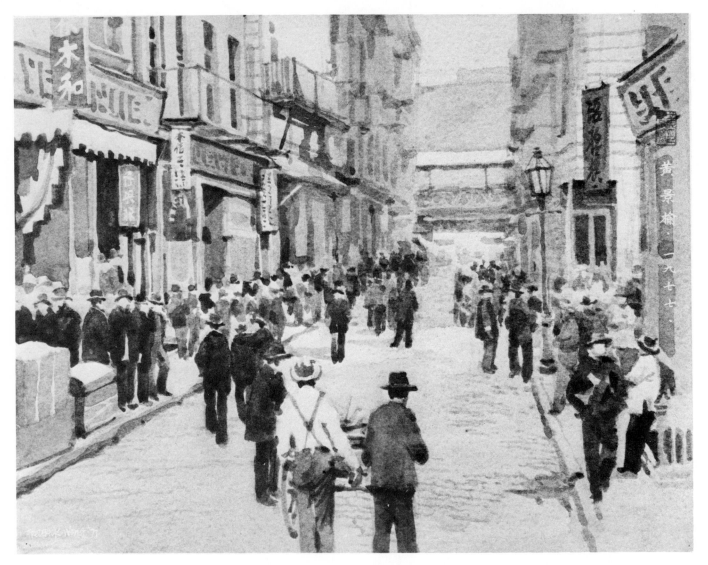

Chinatown Sunday, *14" x 19" (36 x 48 cm), collection of the artist. The most interesting aspect of this painting is the interplay of shifting masses of people against the entrenched stolidness of the building structures. To develop the feeling of a continuous whole, a perspective was chosen in which the setting could be viewed from above ground level. This viewpoint opened up the composition by tilting the street downward, allowing more space in which people could be placed. To counter the great sense of activity and movement on the street level, it was important to develop the architectural detailing on the building facades—windows, signs, awnings, balconies—all the necessary elements that would either penetrate or extend from the flat surface plane of the structures. The flanking building facades, strongly vertical in feeling, are broken up by the intrusive relief of another street opening from the right.*

PAINTING STRUCTURES,

whether in an urban or a rural setting, usually suggests a necessity for tightness, of bearing down, because the forms are more precise. An understanding of perspective, which is often "fudged" in a landscape, seems to become of paramount importance in treating man-made forms.

To a degree, this is true. Perspective problems, of course, also exist in painting the panoramic natural forms and can be even more difficult because the shapes are fluid and the feeling of space and distance overwhelming. Rolling land movements, with concealing growth and trees of varying heights intertwined and covered with foliage, present very difficult perspective considerations.

Urban landscapes, in contrast, convey some sense of logic. The ground plan is reasonably consistent, angles can be plotted, everything appears solid. Forms are placed against forms and grouped at different heights; some are sliced, sheared, and stacked, and others are penetrated. Over these geometric solids are veneers of ornamentation and then, attached to this outer decorative "skin," we have sprinklings of urban litter, billboards, neon signs, wires, antennas, lights, etc. To take all this visual material and give it an artistic rationale can be enormously difficult — but very exciting.

In Oriental watercolors, structural forms seem to fall into two categories. In the first group, there is the small country house tucked into an overwhelming landscape or a tiny cluster of provincial dwellings, again dominated by the environment. These forms are rendered in quick brushstrokes which define only the essential forms. Then there are those paintings which include the more courtly, more palatial buildings, which are handled in meticulous, ornamental detail. Common to both types of rendering is a perspective attitude unlike that used in Western art, which calls for parallel, horizontal lines to converge and meet at some point on the horizon. Oriental artists interpret the third dimension through isometric representation, which means lines are always parallel and do not meet. As a result, to the untutored Western eye, structures appear to tilt and open up more and seem to be stage settings rather than an accurate representation of existing form. At the same time, there is an appropriateness to this technique when seen in the total context of a traditional Oriental painting.

UNDERSTANDING SOLID FORMS

Understanding the cube, being able to visualize and draw it accurately, is probably the most direct method of understanding solids. Combined with other basic geometric shapes—the cone, cylinder, and sphere—virtually all structures can be analysed and understood. By using this approach, a simple farmhouse becomes a gathering of cube forms, and by splicing, attaching, penetrating, cutting diagonally, then reassembling them, much as a child playing with building blocks would do, we can give the structure its form again. Another visual approach might be to imagine the cube as a large container into which the farmhouse is tightly placed. The size of this cube is determined by the largest dimension in the farmhouse. After the form has been contained, imagine you are removing all the air space from this box, leaving only solid form behind. This, of course, would be the farmhouse.

UNDERSTANDING STRUCTURAL GROUPS

Developing a successful urban landscape painting is being able to first make a discriminating selection from a vast amount of visual material, and second, to resolve the accurate placement of the selected forms so that they work in visual comfort with each other.

Perhaps the biggest problem is simply making all the structures feel as though they are related and logically attached to the ground plane while, at the same time, they also occupy their own space. Student work will frequently reflect a misunder-

Structural Motifs. *A farmhouse, rooftops of a distant village, or a small mountain retreat are common structural motifs seen in the traditional Oriental landscape. Sparingly rendered, usually in drybrush lines, these provincial buildings, seen in the context of a panoramic landscape, are small human notations placed against the overwhelming forms of nature.*

Eastern Perspective. *Another example of structural representations in Oriental paintings is the more ornate, courtly type of dwelling, in which details are meticulously noted. Close examination of such a work would reveal the difference in the way perspective is used in Eastern and in Western painting. Parallel lines, as seen in this drawing, seem to remain parallel to each other, rather than draw together at a common vanishing point on the horizon, as would be the case in Western perspective.*

Western Perspective. *This wash drawing shows a strong sense of perspective lines, as evidenced in the individual steps in the set of stairs. These lines move together toward a distant point. Lines seen in the other structures also suggest a movement to a distant point. This feeling of converging lines is at the heart of Western perspective.*

Geometric Forms. *The cube, cylinder, sphere, and cone are all basic geometric forms from which most man-made structures derive. The representations seen here show how each of these forms can be contained, while still establishing their outer perimeters. Drawn in darker outlines are the areas of space each form would occupy. Although the containing box might seem to overlap and intrude into the space taken up by another solid form, the dark, rectangular bases indicate there is sufficient space between the forms that none of them touch each other.*

Box Units. *A structural group can be logically established using the "box containment" method in which each building form is visualized as being contained by an invisible enclosure determined by the solid form's greatest dimensions. As seen in this cluster of simplified farm structures—house, barn, and silo —each unit is boxed in. Seeing man-made forms in this way helps to simplify and more accurately determine proportions of buildings and their proper placement in relationship to other buildings.*

Skyline Scene. *In order to effectively paint a skyline scene in which an overwhelming mass of geometric forms and structural details have to be confronted, it is important to realize that only the impression of all this activity need be conveyed. It is also critical that a sense of three-dimensionality is suggested to avoid the feeling of having painted a flat backdrop. In this study a number of shapes float across the foreground water. These shapes diminish in size as they approach a shoreline studded with small, huddled forms suggesting, perhaps, piers, docks, warehouses, etc. The middleground is occupied by the great bulk of buildings, defined by shadows, for the most part. Finally, there are the distant silhouettes of background structures.*

standing of group forms and the need to substantiate the visual and physical fact of solids, each having a fixed amount of space determined by its own dimensions which can't be intruded upon by another solid. You must give each building, each car, each bridge, each structure, its own territory, and, even when these forms seem to overlap each other visually, this feeling must still be conveyed.

SIMPLIFYING STRUCTURAL GROUPS

In painting any cluster of solid forms, the eye should first perceive the basic shapes without stressing the surface details. It is more important in the early stages to treat what may at first glance seem vastly complex in as direct and fundamental a manner as possible. Record the proportions and angles of the large surfaces accurately and set aside any anxiety over the need to immediately include windows, fire escapes, drainpipes, etc. I ran into a problem of this nature in my painting, *The Old Corner*, (page 134), in which I became totally and prematurely involved in drawing and painting the foreground debris. I eventually had to start over, stressing the broad, interlocking wall surfaces and solving the sharp, diminishing angle of the turning street, before returning to the litter of the razed structures.

THE SKYLINE

Painting a skyline—and particularly a skyline as familiar as that of New York City—is, in many ways, less a drawing problem than one of artistic interpretation. My concern in coping with any urban skyline scene is how to employ color, light, and mood to make what are essentially silhouette forms into something of greater depth and interest.

It is a problem to solve the visual sensation of a skyline being no more than a two-dimensional backdrop. My suggestion is to develop greater interest in foreground activity, which would provide a feeling of stepping stones leading to the middleground area, where the skyline structures would then begin. Compositionally, a bridge would be ideal to lead and direct the eye into the horizontal movement of the skyline.

STREETS AND BRIDGES

Unlike the street scene in a Western painting, Oriental perspective would permit a tilting of the street plan in order to reveal greater space in which more activities could then be described. The Western view would follow the laws of perspective, and the straight street would gradually draw together at a point on the distant horizon. However, the street scene rarely shows the street itself, but instead, offers all its related activity. The turning angles of building facades reveal the direction of the street, and changing roof lines suggest its dips and rises.

How to contend with painting the street also means solving the problem of that great block of vertical air space which is structurally unoccupied over the street itself. To lend interest to this void and to compositionally offset the strong verticals in the flanking buildings, I like to include lines of wiring, horizontal cast shadows, flagpoles projecting from the structural surfaces, and even pedestrian and vehicular movements.

A bridge is a beautiful structure, a combination of swooping arcs, distant filament-like strands that become enormous cables upon closer inspection, and great massive pylons of steel and stone. A bridge can be difficult subject matter if only in terms of how to position yourself, how to establish a feasible viewpoint from which you can convey the massiveness and, at the same time, the delicacy of form. Seen from one angle, it is an obvious horizontal composition of measured segments gracefully linked together. Viewed from another perspective, the bridge becomes a looming, thrusting vertical shape, scored with an intricate latticework of steel girders and other support members.

A bridge, particularly one that spans a great distance at a great height, is ideal subject matter for stroke and wash techniques. Washes could be appropriately used to develop the broad, massive pylons and, at the same time, treat the more delicate

Street Scene. *Unlike painting a skyline, a street scene calls for more involvement. The activity is near at hand, and this sense of bustle should be reflected in your painting. This particular street view suggests a position a few steps above ground level. The street itself is not visible, but all the movement on its surface is conveyed by representations of people, vehicles, signs, etc. The direction of the street itself takes its definition from the perspective of the building facades and is further accented by the overhead tram wires. The horizontal connecting wires help to offset the severity of the diagonal movement to the lower left created by the angle of the buildings and the pull of the center cable.*

Windows. *Interesting details such as windows in structures can be painting problems. Done badly, they are simply rectangular shapes drawn onto wall faces, rather than actual openings into the wall itself. The window on the left is open, while the one on the right is closed. Both effects are suggested by reflections. The open window shows no reflection in its lower portion but does reveal shadows cast on the curtains and conveys the feeling of two layers of glass, the lower sash having been raised behind the top. In the closed window, the lower pane of glass shows a suggestion of reflected light that could also be a vague form behind the glass. The upper panes catch and reflect a strong light combined with the dense shadows of space behind the glass.*

shadow areas on the underside of the ribbon of roadway. There is, of course, so much linear activity in a bridge that the temptation is to overdo the stroke work! Some caution should be exercised in handling the excessive number of lines that physically exist in this subject matter. Drawn with precision and minute accuracy, the effect becomes too architectural, less free, less painterly. Represented casually, the image would then appear weak and uncertain.

RURAL STRUCTURES

The farmhouse or mountain retreat is familiar content in the traditional Oriental painting. It is rare, however, to see either of these rendered in great detail. These small structures, tucked into the massive folds of a mountain landscape, partially hidden in large forests, or spotted along the banks of a tumbling waterfall, are boxlike units, drawn in quick, precise strokes, and used to heighten the contrast between man and nature.

Rural structures are also a fond theme in Western landscape painting, ranging from New England's steepled churches to the flatland ranches of New Mexico. The significant difference in the treatment of common subject matter by two different cultures seems to be a matter of emphasis. Nature dominates the Oriental attitude, whereas man, represented by his structures, is more frequently in the forefront in the Western approach.

CHECK YOUR VIEWPOINT

Even the most static, indifferent cityscape can often be enlivened by a change in your viewpoint. We are accustomed to standing, feet firmly planted on the ground, surveying everything about us at eye level. But structures are permanent fixtures. *We* have to move about and actively search for the interesting angle, the intricate, interlocking forms, the niches and crannies, the interplay of planes, and the vibrant mixtures of strongly linear and curved forms.

To break the routine of ground-level views, try an occasional bird's eye perspective of more unfamiliar rooftop planes, angles, shapes, and lines. An even more challenging problem would be to develop this view of structural forms using only visual information obtained at ground level!

STRUCTURAL DETAILS

A successful painting involving structural forms usually conveys a sense of rightness, of details properly handled to help accurately define the whole. Windows, for instance, badly positioned and proportioned, can distort the entire facade of a building. A poorly painted window becomes a two-dimensional blemish. Handled properly, a window is an architectural detail reflecting a variety of information. It should reveal a feeling of space behind the panes of glass and, at the same time, show light and color across its surface. It is a vertical duplication of clear, still water in which images are reflected on the surface plane, but with a simultaneous sense of depth.

WHAT TO INCLUDE

In any city scene, there is usually an enormous amount of visual clutter that need not be a vital consideration in conveying the feeling of that scene. The other side of the coin would be eliminating useful bits and pieces of information which can contribute to the character of your setting. For instance, I have found fire hydrants useful, not only for their interesting details, but also for their shape and color. In addition, they can easily be shifted about to suit compositional and color needs and still appear logical and appropriate. Similarly, I've found lane markings a very convenient solution in handling dull expanses of black asphalt.

There are many everyday, mundane objects that we overlook but which are a part of our normal day's living pattern. Sometimes, by taking a second look, we can discover a charming quality in them, and they become that nice touch that often brings a painting together successfully.

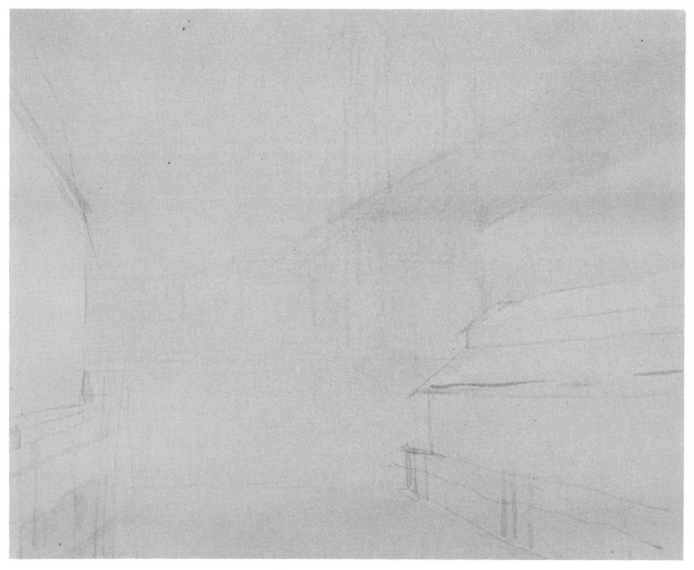

Step 1. *This ink wash study of a bridge in lower Manhattan was an exciting view which presented some unanticipated problems. Compositionally, the bridge was so massive it dominated its immediate surroundings. It also presented such a strong diagonal movement that I felt it necessary to counterbalance this action line with verticals and support angles which would keep the eye focused within the total viewing area. For this particular structural study, I selected a sheet of nonabsorbent Masa paper and mounted it with the smooth side up. This gave me a surface on which I could slowly develop the necessary details without fear of runaway washes. Using a very light gray wash, I indicated all the general shapes in line and mass in their appropriate positions and in proper perspective. I also tried to give some rough indication of a light source.*

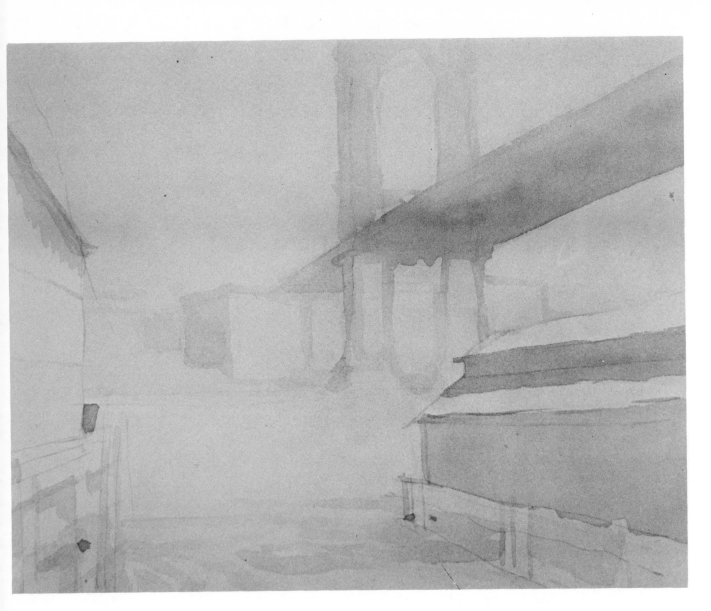

Step 2. *After the general layout had been established, I tried to develop a more accurate relationship between the critical diagonals, the bridge, of course, the roof line of the warehouse on the left, and the shed on the right. The cast shadow underneath the roof overhang was darkened for emphasis. Some indications of building structures were placed on the far shore to arrest the movement and swoop of the bridge. The supporting arch was more firmly washed in to lend a sense of stability to the center middleground area with its powerful verticality.*

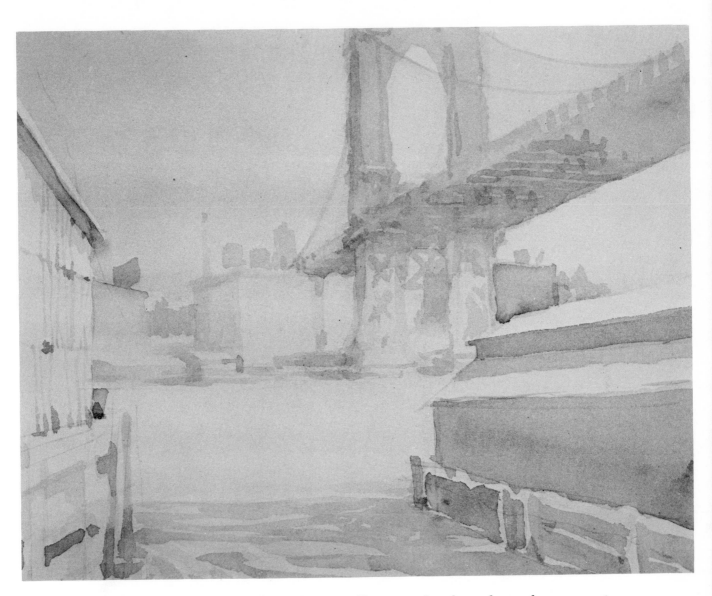

Step 3. *With all the major forms in place, my efforts were then directed toward a more precise focus on lighting and structural details. Both the underside of the bridge and the supporting arch needed to be more accurately delineated. The sky area was slightly darkened in the left-hand corner, which also emphasized the light catching the leading edge of the roof on the left. Water movements in the cast shadow area in the foreground were washed in with broad, horizontal strokes to suggest a sluggishness in the low, undulating waves. Light vertical lines, not quite parallel, were drawn in rows on the side of the warehouse to indicate the corrugated metal sheeting.*

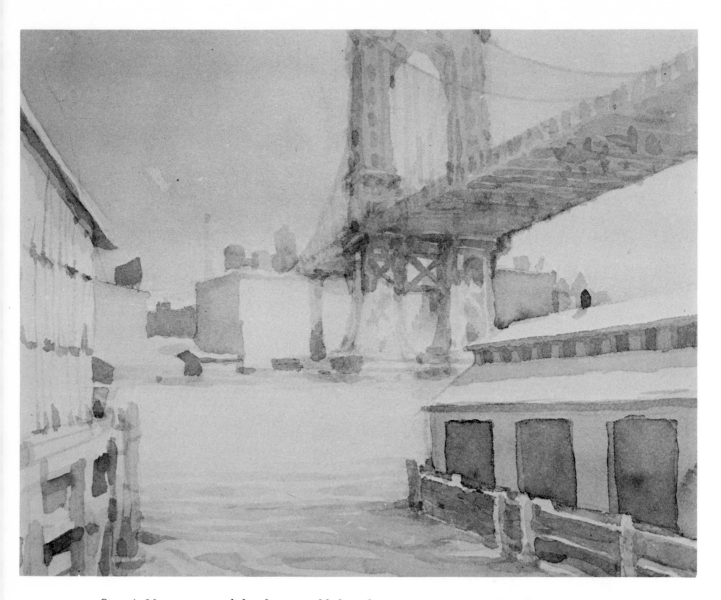

Step 4. *More structural details were added, with greater attention paid to the two structures and their supporting timbers. The effect of light on the clerestory roof of the shed was treated in some detail, as were the shadows cast by the bridge onto the girder work of the arch. At this point, I stopped all activity and backed away from the painting. Sensing that I was approaching a rather satisfying solution, it seemed advisable to allow it to dry completely and place it on my easel with a rough covering mat for a long, careful look. By doing so, I hoped to view objectively the total impact of the painting and perhaps sense rather than see what more needed to be done.*

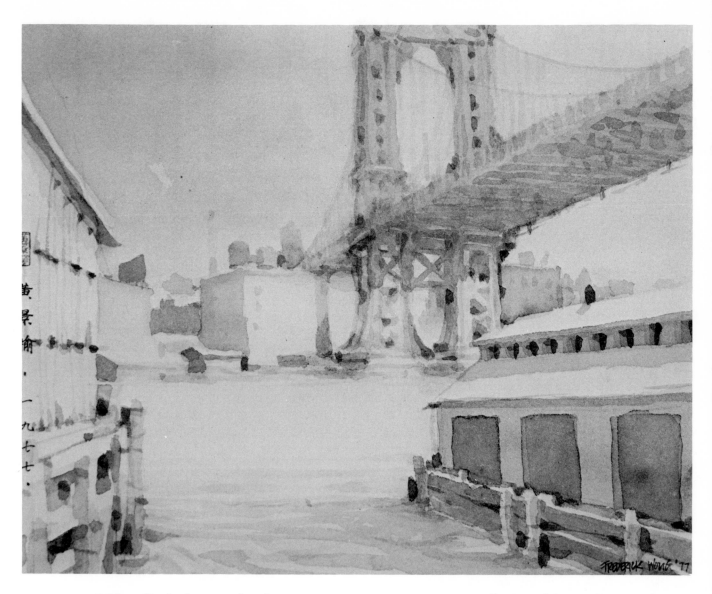

Bridge, (finished painting), *ink on paper, 11½" x 15" (29 x 38 cm), collection of the artist. It seemed to me, after a period of just looking, that very little needed to be added beyond placing some dark accents in the windows of the shed on the right. I fussed a little more with structural details in the bridge, picked at the distant buildings, and played some with the sky values. I think I was quite pleased with the results, had enjoyed the whole process, and here at the last stage, was a little reluctant to let go.*

DEMONSTRATIONS AND GALLERY

Step 1. *The floating image, a favorite theme of mine, was again used here. The overall dark setting this time is called for painting around and holding out the young boatman. Since the crumpled paper effect was used, precision was very difficult to achieve in this early stage. A very coarse effect was established across the center portion of the paper, leaving only small bands of unpainted areas at the top and bottom. The burnt umber texturing was held away from one small, central portion, which would eventually be occupied by the boatman.*

Step 2. *This step is identical to the first, with minimal changes or additions. All my efforts were directed toward a clearer definition of the area for the figure. I used a finely pointed sable brush on the crumpled paper surface to bring the background textures into firmer outline around this area. The space allotted for the reflection was also brought into tighter focus. This patch of unpainted paper permitted my colors to react brilliantly against the dark, murky shadows formed by the overhanging foliage and the shadows cast onto the water's surface.*

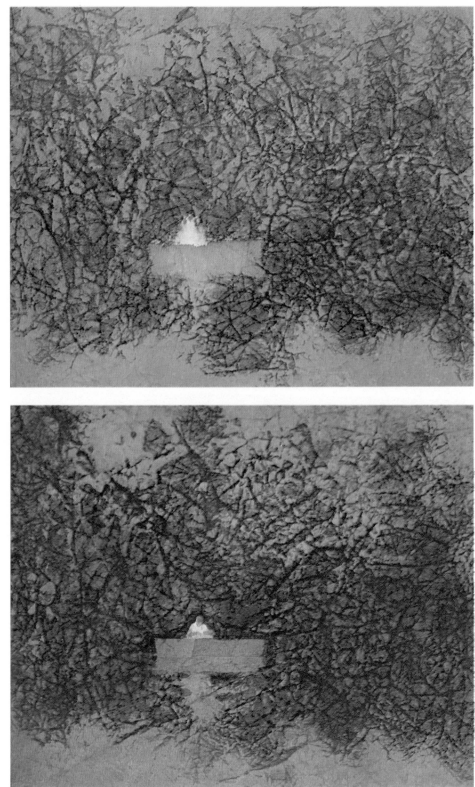

Step 3. *Both the foliage mass and the water were painted over broadly. The color of the water was brought into both the reflection and the boat, while a sense of settling light works downward through the overhead leaves and branches.*

Step 4. *The boat and reflection was worked up in finer detail, while the figure was still held back from final definition. Surrounding colors were deepened gradually in order not to prematurely develop intensity in the figure.*

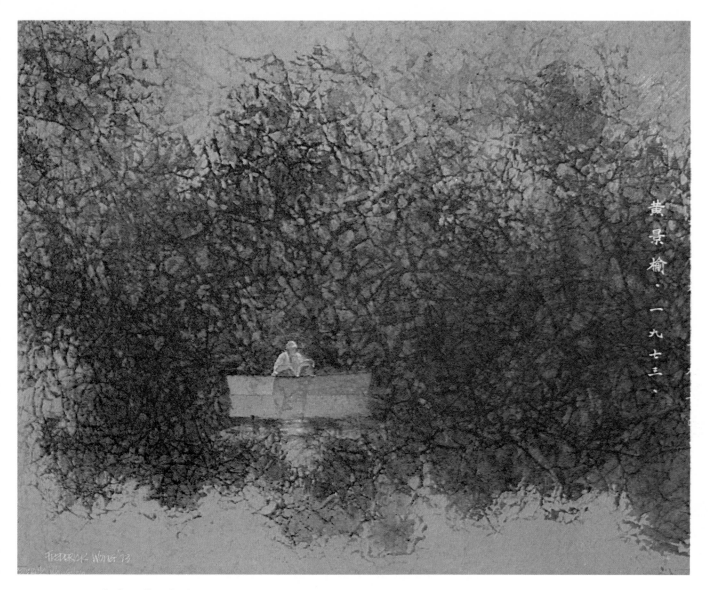

Scholar, (finished painting), *16" x 18" (41 x 46 cm). The seated boatman was finally picked out, using touches of flesh colors for a warm accent amid the mass of surrounding dark, cool colors. These warm color tones were also carried into the reflecting surface of the water. Focus on this figure area was accentuated by the addition of darker washes into the surrounding color and shadow areas.*

Step 1. *I used a sheet of mounted Masa paper, smooth side face up, for this painting, since I recognized the need for some degree of precision in describing these more structured forms. I used a very pale wash line of burnt umber to rough in the general disposition of all the major shapes, paying close attention to the diminishing angles of the windows in perspective on the right side.*

Step 2. *In this step I began to establish the light situation by setting the scene almost entirely in soft shadow, except for the upper right-hand quarter, which is tinged lightly in red. The wash, in this instance, flows smoothly into the pale blue shadow, merging gently to convey the reflected light of a setting sun.*

Step 3. *As the painting proceeded, my general line of attack was toward a greater definition of the forms, consistent with the sense of light already conveyed. At this stage, the painting shows fuller development of the window areas along with the basic structure of the fruit stand, the two figures situated at the juncture of the two major wall planes, and the wash line indicating the curb that also defines the street. On the left, there is a suggestion of a secondary light source and one short, dark stroke of umber. This mark was used to help me visualize how dark a value I needed in order to successfully relate the shadow half of the painting to that portion cast in brighter light.*

Step 4. *By this point the painting began to assume a stronger visual impact, as the smaller forms acquired a more pronounced three-dimensionality. The larger shadow areas were darkened by first wetting the entire surface with clear water, and then washing in the color. This way, the soft blending of the light red into the blue was maintained without a crisp edge occurring.*

Step 5. *The sense of light became much more apparent as color values were deepened. The large red area was broken into with a slightly darker wash of the same color to suggest a shadow variation within that expanse. The left side has been partially covered in a flowing wet wash, projecting some shapes forward, while others are blended into the background. The single test stroke has begun to feel very much a part of the surface, as the surrounding values establish a closer relationship.*

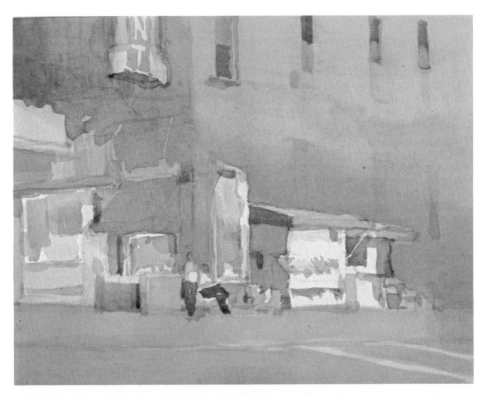

Step 6. *The painting at this point was almost complete. All that was required was a tighter focus on some of the details. In this particular composition, where the picture plane is divided vertically, the sense of balance is critical; the weight of color and activity need to be distributed evenly from both left and right. I found at this juncture that the right-hand wall, with the busy fruit stand, had become more pronounced.*

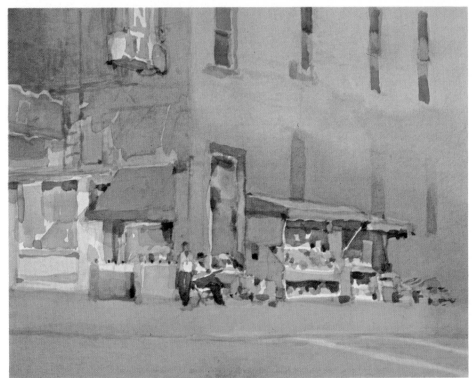

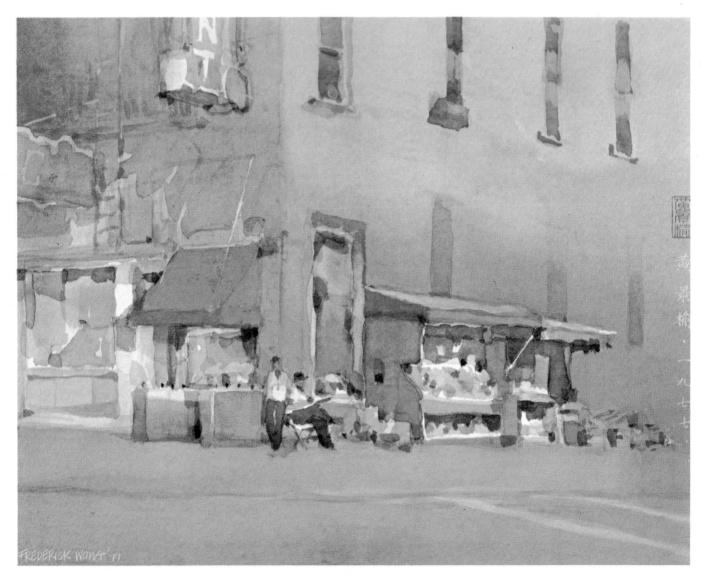

Vendor (finished painting), *11½″ x 15″ (29 x 38 cm), collection of the artist. In bringing this painting to its conclusion, I added small accents throughout, stressing the left-hand side a little, until I sensed a more even balance had been achieved. The awning on the extreme right was lightened with a thin wash of white to suggest reflected light. Finally, the single stroke of umber, placed down early in the painting process to establish value relationships, has become fully integrated.*

Step 1. *This painting was conceived as a mood piece conveying a sense of dimly remembering times past—a scene with warmth, but only fragile definition. Using the smooth side of mounted Masa paper, I moistened the entire surface with a sprayer. I then let the paper dry until all pools of water had disappeared, and the paper was completely mat without any reflecting sheen. The first strokes of olive green mixed with yellow ochre were placed and allowed to spread softly. A damp, 1-inch hake brush was used to restrict excessive movement by picking up some of the color flow.*

Step 2. *I developed this passage of color by using the same technique as in the first sequence, applying a Prussian blue mixture onto a damp surface, letting the color develop a softness without hard edges, and occasionally overlapping the yellow base to create a warm green edging. The placement of these washes of blue was determined both to establish a visual balance in size of forms and to begin indicating sky and water.*

Step 3. *A faint umber image was placed into the low middle area to better organize the composition and to establish a focal point around which I could build succeeding color intensities. Using the lightly defined figure as a guide, I then darkened all the wash areas, giving them more weight and body.*

Step 4. *The image of the pensive boatman was brought into greater clarity in this sequence, and the boat itself was brought into three-dimensional relief. Sensing that my colors had developed almost too smoothly, appearing fresh but bland, I decided to generate some textural feeling by adding a fairly dark value of burnt sienna across the lower middle portion of the painting. As this wash began to settle, I dabbed into it with clear water, which I immediately picked up with a damp brush. This created a horizontal movement of slightly textural forms working against the verticality and smoothness of the earlier washes.*

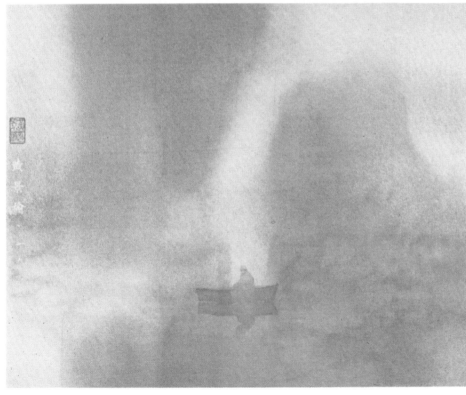

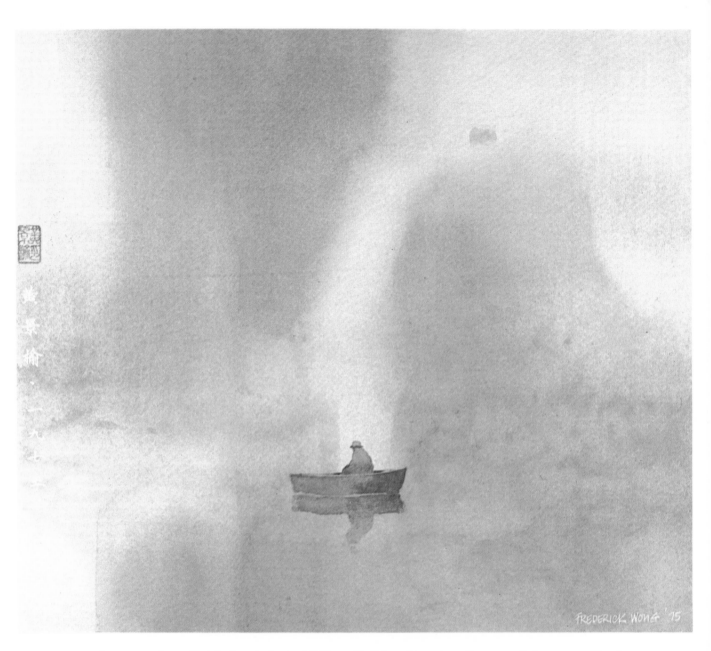

Summers Ago, (finished painting), *14½" x 17" (37 x 43 cm), collection of the artist. Final touches mostly involved establishing the degree of clarity necessary to better define the figure, the boat, and the reflection without bringing them too far forward and, in effect, removing them from their surroundings. The reflection was treated as a mirror image to suggest very calm water.*

Step 1. *In trying to capture the flavor of this traditional Chinese New Year's activity, I chose to use Hosho paper, a thick, sturdy, but highly absorbent ground. Hoping that the paper would prevent my being too picky, too attentive to meaningless details, I proceeded to delineate the broad areas through a combination of washes and fine outlines. As seen in this step, my washes immediately flowed into the paper, spreading well beyond the area I had intended to cover.*

Step 2. *Still in the early stages of the painting, I decided to rough in some sense of light distribution, choosing to place emphasis on the lion's head and the upper portions of building facades. The lower portion of the painting was washed in a faint tint of Prussian blue to suggest a haziness which, in fact, developed from the bursting firecrackers. I also began to draw in some of the surrounding buildings and indicate their approximate perspective.*

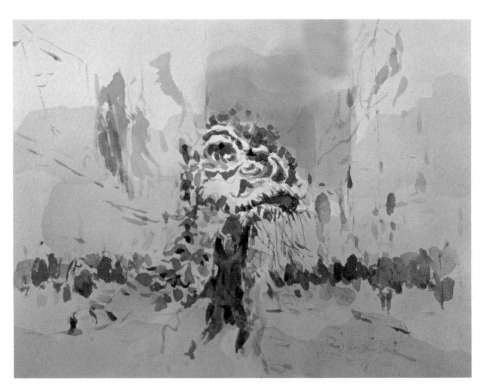

Step 3. *The lion's head is an ornate, papier-mâché structure, colorfully decorated with tassels, fringes, paint, and cloth balls. The total impression is one of extreme busyness, and so vibrant in spirit that it can easily dominate the painting. With this in mind, I felt it best to begin to suggest its impact in order to better relate and balance the surrounding elements.*

Step 4. *Having described the general costuming of the lion and its two attendant dancers, I began to position the figures in the watching crowds situated behind barricades. Once I felt the grouping of figures was sufficient, along with suggestions of pennants and flags waving overhead, creating a complimentary sense of color and movement, it seemed safe to return to a better definition of the gyrating head. I also randomly spotted in small strokes of opaque white to suggest light flickering and dancing across the entire surface of the painting. At this juncture, I felt the painting was complete enough to add my seal, name, and date along the right-hand edge.*

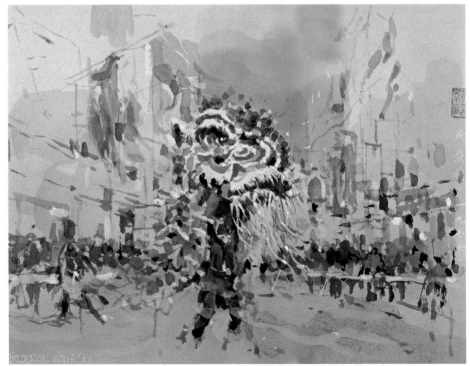

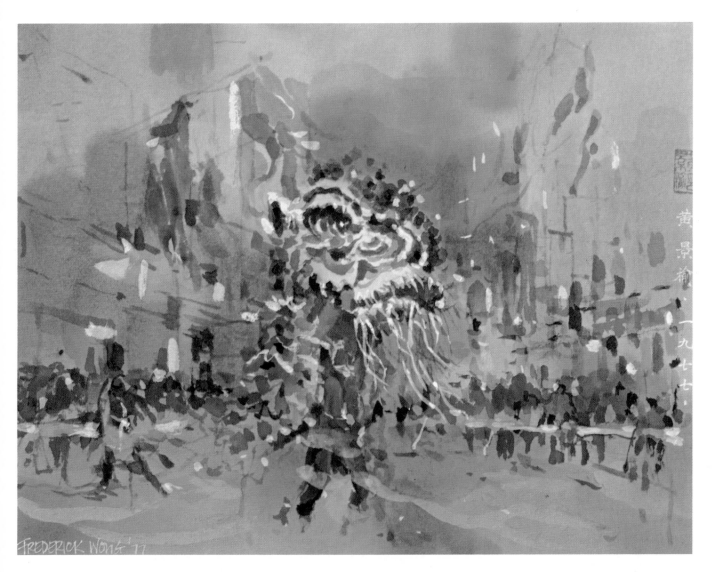

Lion Dance (finished painting), *11½" x 15" (29 x 38 cm), collection of the artist. After a brief period of rather disappointed viewing, I admitted my dissatisfaction, primarily directed at the loss of color intensity. The Hosho paper absorbed so much of the pigment that relatively little stayed on the surface. With this in mind, I went back into the painting and meticulously deepened virtually all the colors and added darker shadows on the left, into both the patch of sky and foreground area. I was able to paint directly over the white highlights, which held in place. The overall effect became immediately apparent and gratifying.*

Step 1. *Because this composition was uncomplicated, I began the painting process with some firmness, without fear of establishing an area of color that would exert too much pull on its surrounding forms. A crinkled wash effect comprised of olive green, yellow ochre, and burnt umber was placed into an area covering more than half of the surface to be painted. This form tilted downward toward the lower right-hand corner, suggesting the angle of the land direction.*

Step 2. *The crinkled paper was allowed to dry, then redampened in order to add the foreground mass in the lower left-hand corner. Additional darker accents were worked into the larger mass to suggest shadowy depths. Following this sequence, I mounted the painting to give myself a smooth working surface. Faint washes of cadmium red light were added to the tree masses, and the same color was used to define both the foreground land form and the distant range of hills.*

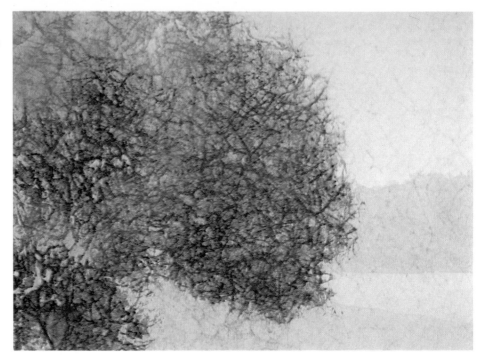

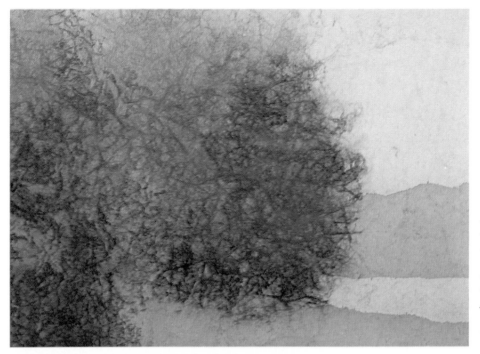

Step 3. *Washes of Prussian blue were stroked over parts of the tree masses to accentuate the roundness of the forms and to suggest a distinct cool shadow effect in the areas away from the light. This same color was washed over the land forms, changing the red base to a softer purple, with the foreground color reading deeper in value than that of the far background.*

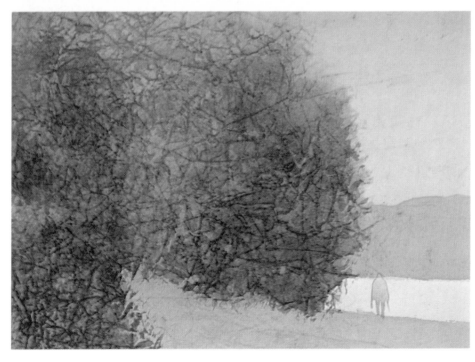

Step 4. *A little more red was added to the top of the foliage mass to suggest a warmer light glow. Indications of a striding figure was placed onto the lower foreground land area, but bridging and overlapping into the background mass of hills. Visually, this more firmly established the movement of land from that which gradually recedes into the distance. The size of the figure also helped to determine the scale of the total painting contents.*

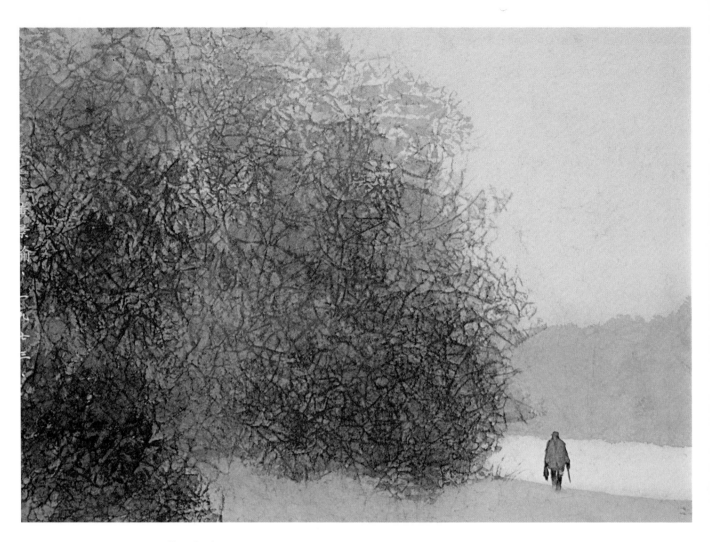

Returning, (finished painting), *15" x 21" (38 x 53 cm), collection Mr. and Mrs. Gunter Brocki, Katonah, New York. The figure was developed in final detail with just a touch of brilliant color in the hat. The remaining parts of the figure are more restrained in intensity but deeper in value to convey the impression of shadow.*

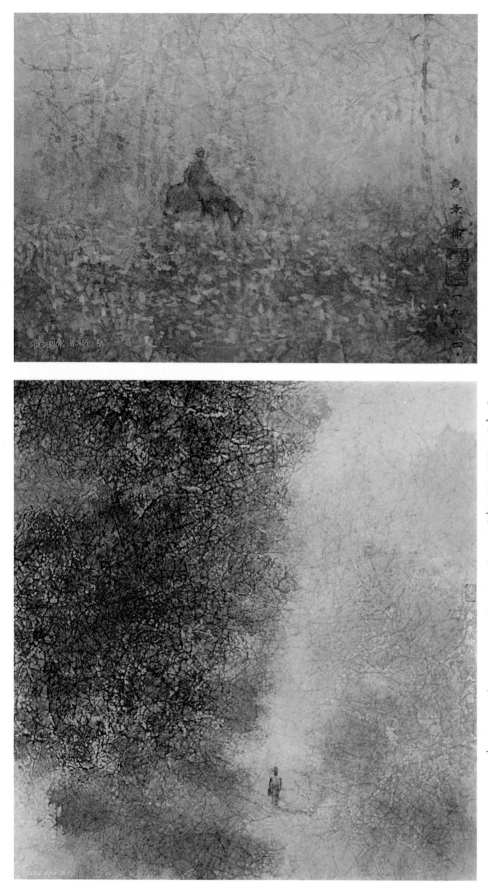

Troubadour, *8¼" x 11½" (21 x 29 cm), collection Mr. Ben F. Rummerfield, Tulsa, Oklahoma. The quality of light is the most significant aspect of this painting, in which the shadowy substance of the horseman plays a secondary role to his setting. The effect of filtered sunlight was achieved by first crinkling the paper, then lightly brushing the upper portion with a wash of olive green. After the Masa paper was mounted, I followed with a wash of yellow ochre and cadmium yellow light to bring up the intensity a little. The lower portion was effected through a combination of Prussian blue, burnt umber and raw umber. Highlights in this area were picked up using the background colors combined with opaque white of various densities.*

Late Summer, *27" x 26" (69 x 66 cm), collection Mr. and Mrs. J. Dennis Delafield, New York. A hot day in late September suggested this setting to me. I wanted to create the feeling of heat in addition to light. The emotional content, in my mind, was designed to suggest the last warm day of summer, with foliage still thick but beginning to change color. To emphasize this sensation, I exaggerated the colors, deepening the umbers on the left and heightening the intensity of the reds and ochres on the right. An olive green was used throughout, keeping my palette within a totally warm range of colors. The only cool note is found in the boy's trousers. Compositionally, I felt this scene could be better explained in a large vertical rectangle, rather than a horizontal format. This allowed me sufficient space to develop the large tree mass on the left for heightened contrast against the small figure and the brighter, but smaller, foliage area on the right.*

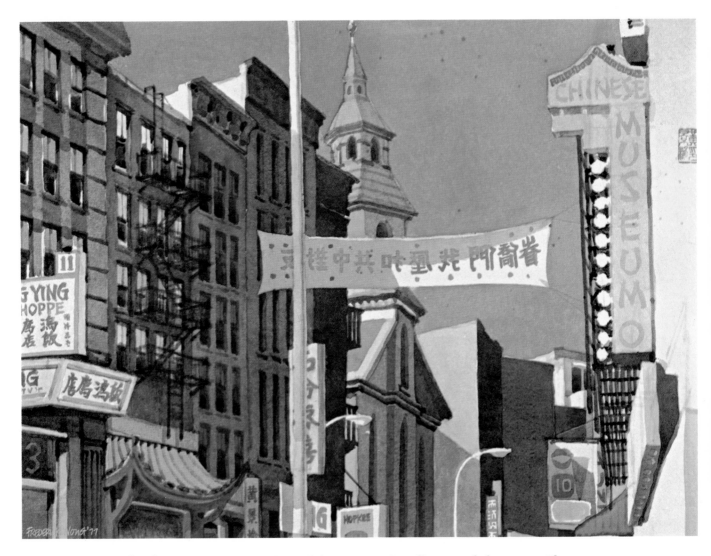

Overhead on Mott Street, *14" x 19" (36 x 48 cm), collection of the artist. This painting, suggesting a feeling of sunny stillness, was deliberately contrived. By raising my focal point above street level, I managed to eliminate all the visual aspects of what is normally a scene of considerable urban turbulence and frantic activity. The clarity of light allowed me to define the structures precisely, using sharp cast shadows to create a strong feeling of three-dimensionality. The use of premounted Torinoko paper also permitted area washes that would hold a clean, crisp edge.*

The inclusion of the thin vertical light pole, which might easily have segmented the painting, was offset by the strong horizontal movement of the white banner. It worked well in combination, because the overlapping of the two forms created a feeling of visual depth and movement in the picture plane.

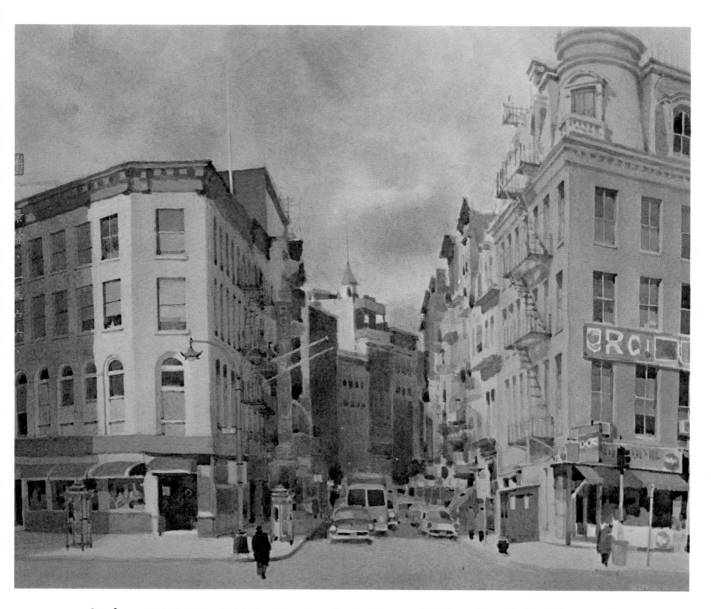

Sunday on Mott, *24" x 36" (61 x 91 cm), collection Yvonne C. Wong, New York. Architectural definition, along with obvious strong perspective considerations, made this painting difficult to execute. I had a very clear mental image in mind and the sense of mood I wanted to create, but the need to be structurally accurate almost forced me to scale down my rather grand concept.*

Working on a large sheet of mounted Masa paper, I started to compose all the forms, using a fine sable brush dipped in a light neutral mixture of olive green and burnt umber. I had to resist the temptation to include all the details, which I am prone to include, hoping this might give me a greater sense of security once the painting process began. When I started to wash in the larger areas with color, I tried to keep in mind the effect of light and its source, in order not to overpaint an area that might be better defined if left virtually unpainted. I also kept the intensity of my colors more muted than I usually do at this stage, until all the surface areas were explained. Eventually, I built up my colors in both value and intensity, until there was an effective balance between light and shadow, particularly on the face of the building on the left and in the deep recess of the street.

Final touches included establishing the effect of an overcast sky with a patch of blue to suggest the possibility of a sunny day. Windows were accented to convey both depth and reflection, depending on their location in relation to either the main light source or a secondary source. I was quite pleased with the overall impact on this painting, feeling that a nice balance was effected between mood and structural accuracy.

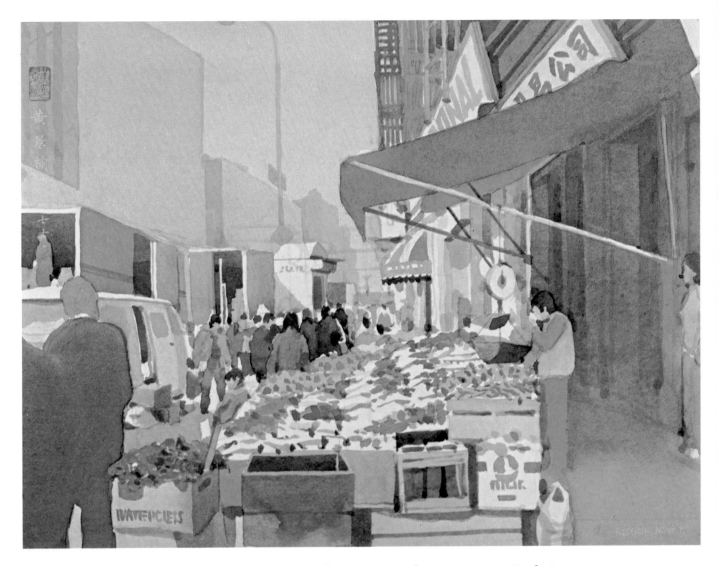

Canal Street, *14" x 19" (36 x 48 cm), collection Mr. Paul C. Huang, New York. I was particularly intrigued by the amazing amount of color, activity, and movement in this shopping scene. It was a challenge I was not entirely sure I could cope with, since my tendency is to work with a fairly limited palette. However, as the painting progressed, I found, much to my surprise, that I did not have to use less familiar pigments.*

After I determined my viewpoint, I discovered that the focus of the painting was quite centrally compressed, the main ingredients being the orderly displays of fruits and vegetables and the milling shoppers and pedestrians. I deliberately allowed some open space in the lower right foreground to accentuate the congestion in the middle, and to play against the uncluttered effect of the buildings in the background in the upper left-hand corner. Painting the masses of produce was less of a problem than I had initially anticipated, once I realized I could not record, nor was it necessary to render, every object in glistening textural detail. By using accurate color strokes, I was able to suggest the impression of many items.

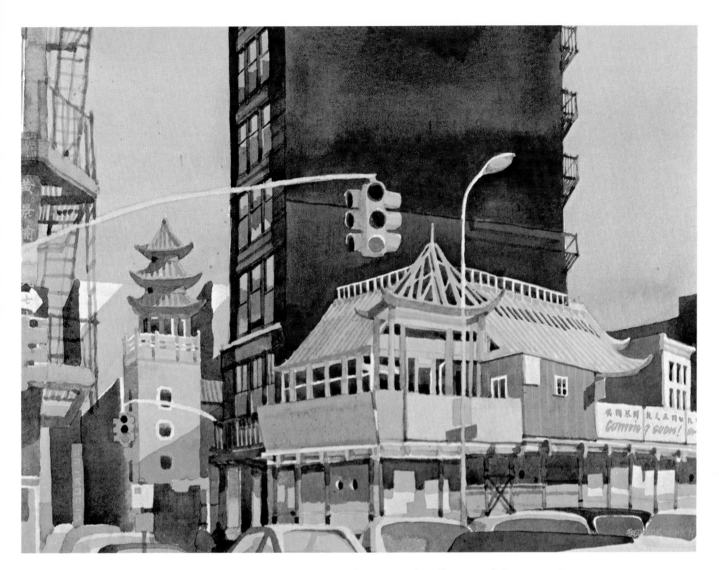

Construction on Catherine Street, *14″ x 19″ (36 x 48 cm), collection of the artist. In painting urban landscapes, particularly when the scene is washed in clear, direct light, I cannot resist the temptation of giving my colors quite full intensity. I began this painting by delineating the broad forms, using a very light, neutral color brush line. Because the focus of this particular scene lay in the building under construction, with its brightly colored structural members, I decided first to wash in lightly the plunging vertical mass of the exposed brick wall leading to that building. Compositionally, the painting assumed an inverted "T" configuration as this large color mass, occupying the vertical center area, deepened in value. It became obvious immediately that the vehicular traffic in the foreground was essential in arresting this very emphatic downward movement. In committing myself quite early to this large dark plane, it was, of course, necessary to equalize the massive weight by developing the surrounding forms both in color intensity and variety of shapes.*

Old Corner, *12″ x 16″ (30 x 41 cm), collection Mr. and Mrs. Francis C. Huntington, New York. The thing that caught my eye initially about this scene was the set of concrete steps and the adjoining covered entrance to the basement left intact, but leading nowhere. The more I studied this once familiar site, which was on my daily route to my studio, the more interested I became in the exposed brick walls that showed the lines of a once attached roof and surfaces. The corner, in its entirety, almost delineated the boundaries of the composition. I subsequently decided to include the curve of the street on the right leading to a barely discernible sunlit park. Neither the drawing nor the painting of this scene proved as difficult as I imagined. I did fumble about somewhat in trying to establish accurately the relationship of cool purples in the exposed wall surfaces played against the warmer effect of an airy spring light. After the painting was completed, it was enormously gratifying for me to discover small pieces that I felt were treated with some distinction. The total painting was a satisfying experience, but the painter occasionally will take particular pride in extracting a tiny bit from the whole and revel in his ability and achievement.*

Winter Sun, *12½" x 15" (32 x 38 cm), collection Ms. Jean Wong, New York.* As in so many of my paintings, this one concerns itself with light determined by time of day and time of year. Defining changing qualities of light is achieved less through the description of light itself than through the effects of light on forms in nature. In this painting, the effects of light emanating from behind a cloud bank turns a winter sky into gold; its afterglow penetrates a grove of trees, picking out leaves and branches, touching the back and shoulders of the walking man, and finally transforming the dead whiteness of snow into a lavender blanket.

Last Run, *15" x 18" (38 x 46 cm), collection of Mr. Paul S. Rodocanachi.* I have never felt terribly confident in handling colors in the purple range, particularly of any intensity. This painting started as an experiment in which I deliberately set out with a palette which included these colors. To establish my immediate commitment, I painted in the strong patch in the upper left-hand corner. The rest of the painting was a constant battle to balance both the placement and the intensity of this first placement. To offset its impact, I treated the remaining areas in the painting in a lower key and with cooler pigments of the same color range. In addition, I composed the picture so that through the use of strong diagonal shadows, its action focused away from that corner. Then, to prevent everything from running to the right, I included a large background form in a cool violet to stabilize the border. Because this shape developed too geometrically, I decided to wash in a band of clear water across its face, which I immediately soaked up. The result was the suggestion of haze moving across the crest of the hill.

136 ORIENTAL WATERCOLOR TECHNIQUES

Doves (*top*) *10" x 13½" (25 x 34 cm), collection of the artist.
This small painting, originally conceived as a Christmas card, has
proved to be one of my more popular paintings wherever exhibited
over the past few years. It started badly—at least I thought so—
when I decided to crinkle only the bottom half of the paper in order
to keep the upper portion totally smooth. I felt this was necessary in
order to lay in a very light sky wash of neutral value in which I held
out the moon disc. I placed a rather heavy wash of cadmium red onto
the crinkled portion and sensed immediately I had overstated the
color intensity. Nonetheless, I allowed it to dry and proceeded to
mount it. In trying to subdue the red, I began to lay a series of Prus-
sian blue washes over the red. As it turned out, the blue did neut-
ralize the potency of the red and, at the same time, filled in the white
areas left by the crinkling with a nice clear wash of blue.*

 *Feeling considerably heartened by this recovery, I moved onto the
sky area. Using a faint tint of Prussian blue combined with burnt
umber, I washed in the upper portion, holding the circle for the
moon. When this dried, I decided the whiteness of the moon con-
trasted too much with the subtlety of the sky, so I painted another
wash over the entire area, including the moon. This brought the
value relationship closer together. The final step was painting the
flight of birds in a pattern moving away from the viewer and toward
the moon. This was done in opaque colors, a combination of white
with faint touches of blue.*

March Flight (*bottom*) *21" x 25" (53 x 64 cm), collection Dr. and Mrs.
Ian Van Praagh, New York. I approached this painting with a vague
concept in mind, precise only in knowing the feeling I wanted to cap-
ture, which was the mood of a late day in winter that contained an
activity suggesting warmth. I finally settled on kite flying in the late
afternoon on a barren field. The stand of trees bordering that field
got a little too heavy too soon, which forced me to focus the activity to
the lower right and place the figures in such a position that a triangu-
lar tension would materialize in their relationship to the location of
the kite. This helped in diverting attention from the seeming impor-
tance of the tree mass.*

 *Both the field and the tree areas were developed through the use of
crinkled paper. The field was painted in several stages. I first placed
olive green, yellow ochre, and burnt umber washes in a spotty pat-
tern, leaving other areas uncovered. I then washed over the entire
field with a tint of red followed by a very delicate Prussian blue. The
result suggested a muted, shadowed field, with a soft, purplish haze
rising from its surface. The sky was also washed in wetly with these
same colors.*

9. MOUNTING AND FRAMING

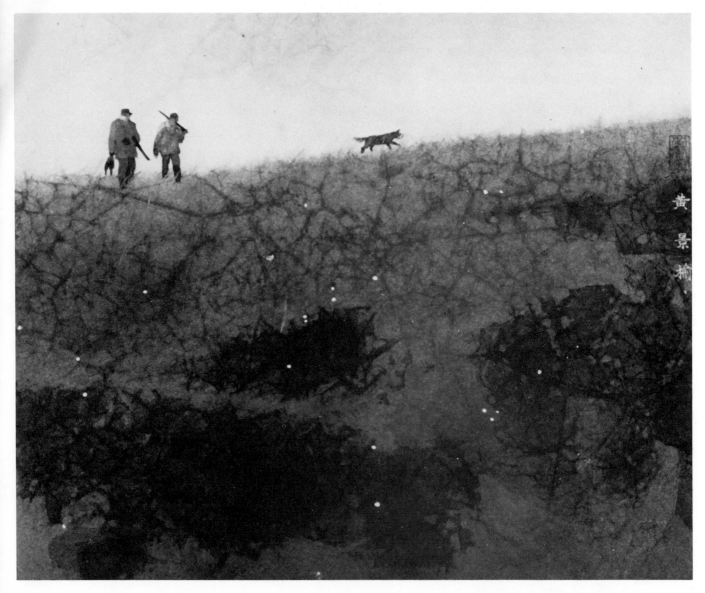

Hunters, *15" x 18" (38 x 46 cm), collection of the artist. Two hunters working their way toward home on the downward slope of a hill are silhouetted against the light of a setting sun. The darkening of foreground forms indicates a beginning dusting of snow and the coming of twilight. In a painting as compositionally simple as this, content must be developed to its fullest potential. The foreground mass, occupying two-thirds of the painted surface, was broken up with heavier masses of exposed rock forms, with particular emphasis on the shape in the lower left-hand corner. It was deliberately tilted upward to offset the downward angle of the hill. Finally, the dog was positioned looking to the right to bring the viewer's attention back into the center of the painting. The two hunters, although placed to the extreme left edge of the painting, are striding to the right, which redirects the eye into the main picture area.*

T IS NOT unusual to see an exhibition-quality watercolor suffer needlessly through poor presentation. This may be the result of indifferent and careless matting, mounting, or framing. It is needless because the artist/craftsman should follow through in meticulous detail until the painting is finally contained and ready for hanging. Each step should be under his control, because each step has a direct bearing on the visual success of the painting. While it is probably true that a handsome presentation will not save a poor painting, it is also true that an indifferent presentation will hurt a good painting.

I've also included in this chapter some thoughts on setting up one's studio. A very subjective observation on my part is that watercolorists seem to maintain very neat, organized work areas. However, I may be the exception. The ideas I will project to you concerning your studio setup will, therefore, be more a case of what I would do if I had it all to do over again.

MOUNTING MATERIALS

A Western watercolor is not mounted but is simply pasted to the back of a mat and then framed. However, a painting done on fragile, Oriental paper must be mounted, which is a process used to give these delicate papers more protection and more substance for handling. These are the basic materials you should have at hand for the mounting process.

1. A one-pound package of water-soluble wheat paste (wallpaper paste obtainable in any hardware store).

2. A hake brush 2 or 3 inches wide for paste application.

3. A Chinese brush consisting of several round, pointed brushes doweled together to form a wide, soft-haired edged to be used for smoothing out the painting (see Chapter 1, "Brushes"). A 3-inch hake brush can be a good substitute.

4. One sheet of 100% rag, one-ply, mat board or illustration board. The size of this mounting board should be at least 1 inch larger all around than the painting.

5. One sheet of ½-inch plywood large enough to accommodate the above described mounting board.

6. One roll of gummed paper tape, 1½ inches wide.

7. Several large sheets of newsprint.

8. Push pins or thumbtacks.

9. Plastic water sprayer or plant mister.

10. Box of absorbent tissues.

MOUNTING AND COUNTERMOUNTING

In any wet-mounting process, it is always a good idea to countermount in order for the painting to lie flat and not curl. To do this, it is necessary to equalize the tension on both the front and back of the mounting board by pasting a sheet of the same kind of paper on the reverse side. I prefer to countermount first and then follow by mounting the painting. The process is the same. I prefer this sequence because it allows me to finish with the painting face up and visible at all times during the drying process. The steps in mounting are as follows:

1. Fill half full of water a bowl large enough to accommodate your wide paste brush. Sprinkle in the paste powder gradually, stirring it at the same time to break up any lumps. Add enough paste until the mixture is smooth and creamy in consistency.

2. Place the mounting board onto the plywood, using the gummed paper tape, and glue all edges down. Be sure the tape overlaps the board by at least ¾ inch.

3. Place the painting face down on a sheet of newsprint and spray evenly and thoroughly. Turn the painting and spray the face side in the same manner.

4. Remove the painting carefully from the newsprint and line it evenly onto the mounting board. Be sure the painted portion does not overlap the paper tape, which will show through even when the painting has dried.

5. After the painting has been properly located, double one half over the other, allowing the top portion to extend beyond the bottom part by an inch or so. If there are any areas of heavy pigmentation in the painting, you may want to interleaf between the folded halves with a clean piece of newsprint to prevent the possibility of colors running.

6. Apply a light, even coat of paste to the exposed half of the mounting board. Smooth out any ridges of paste caused by the brushstrokes and remove any loose brush hairs or sediment in the paste.

7. Now raise the top half of the doubled-over painting by the one-inch overlap, cradling it with one hand in the middle of the near edge. With your other hand, apply the smoothing brush at the center of the painting and begin to stroke outward gently, smoothing and forcing all air bubbles out from beneath the painting. Continue working from the center outward until the first half has been pasted down evenly without any wrinkles.

8. Turn the board around, remove the interleaf, and repeat the process with the other half.

9. After the painting has dried completely, it may be removed from the plywood by cutting through the gummed tape at the edge of the mounting board. At this point, if you have not done so already, you should turn the painting over and countermount. The process is essentially the same, except you will be mounting a blank sheet of paper identical to the type used for your painting.

Here are some additional observations that are important in this process that you should keep in mind.

1. Do not rework your paste mixture excessively on the mounting board. This will tend to saturate the surface with moisture, and even the highest quality board will yield its top sheet and bubble as the moisture softens the binding glue.

2. After the painting has been mounted, you will probably see considerable buckling across the surface. This is to be expected in any wet-mounting process. After the painting dries, the board will attain its desired flatness. However, if there are signs of buckling and lifting at the edge where the board is meant to be held flatly with the gummed tape, insert a few push pins to keep these edges tightly sealed.

3. As is true in the Western method of paper stretching, a raw, unpainted piece of plywood or an old drawing board is preferred over tempered masonite or any nonabsorbing surface. You want a material underneath your painting that will soak up some of the accumulated moisture.

4. Have several pieces of plywood on hand to accommodate paintings of different proportions. Do not use ¼-inch plywood; it is too thin and will warp under the stress and pull of the drying process.

5. Immediately after the painting has been completely mounted, check to see if colors have run or have been pulled by the strokes of the smoothing brush. If this is evident, quickly spray the area and use absorbent tissues to pick up the unwanted colors.

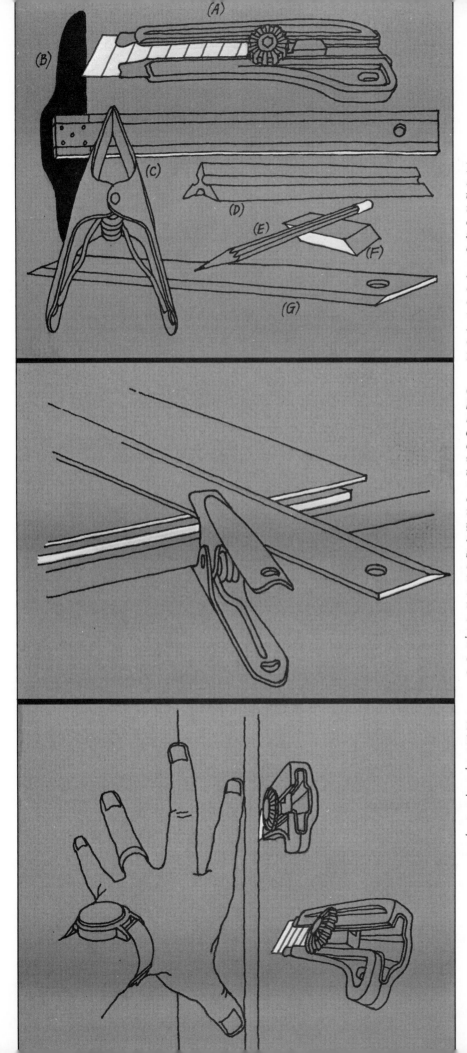

Basic Tools. *For mat cutting the basic tools are quite uncomplicated, the most important being items A, the mat knife, C, the hand clamp, and G, a heavy, stainless steel straightedge. The remaining tools are fairly common studio accessories: B, a T-square, E and F, a soft pencil and eraser. The architect's rule, D, is a very efficient instrument for accurate measurement because the edge is cut sharp and flat. It will lay in close contact with the surface, permitting precise pencil markings.*

Cutting Beveled Edge. *After the hole has been drawn on the mat board, using the architect's rule and T-square, the board is placed onto a scrap piece of Upson board, which is a heavier fiber board than the mat board. Make sure the Upson board is directly beneath the cut you intend to make. Bring these two pieces of board to the edge of your work table and line your steel straightedge precisely to the pencil guideline for your first cut. Use the hand clamp to tightly "sandwich" the steel edge, mat board, Upson board, and work table together. In this illustration, you will note that a beveled edge is being cut into the face of the mat board rather than the back because the wider portion of the board is to the left of the steel edge.*

Finger Placement. *The left hand is placed on the steel straightedge with fingers spread to hold it firmly in place. The small finger and ring finger are on the board surface for balance, while the thumb and other fingers apply the necessary pressure. The upper drawing of the mat knife illustrates the position used for a straight cut, while the lower drawing shows the knife canted to the right to cut a beveled edge.*

6. Do not keep a large mixture of paste on hand. It will turn moldy if kept in a closed container too long and will quickly harden if exposed to air for any length of time.

MATTING MATERIALS

There are several mat cutting devices on the market capable of cutting both straight and bevelled edges. However, over the years, I have become comfortable and confident in using the more basic tools which include the following items:

1. Heavy-duty mat knife.

2. A 30-inch steel straight-edge. I also have one 4 feet long for large mats.

3. Hand clamps.

4. T-square.

5. Ruler or an architect's rule for greater precision.

MAT PROPORTIONS AND CUTTING

There are several schools of thought on mat proportions, meaning the relationship of the width of the side borders to the top and bottom borders. In the classical Oriental technique, a vertical scroll would have narrow borders of the same width on the left and right and very wide borders on the top and bottom, with the top being wider than the bottom. Horizontal paintings, which are viewed in segments by unrolling from right to left, call for a wider border at the beginning than at the end, and narrow borders on the top and bottom.

In Western matting, the sides are narrower than the top and bottom borders, but not extremely so. Sometimes the top border is a shade smaller than the bottom so that there will be three different dimensions in one mat. In any case, keep in mind that the function of any mat is to focus the viewer's interest on the work of art by isolating it from surrounding distractions. The mat should not call undue attention to itself by being too wide, too narrow, or too colorful. Some framers recommend high-intensity colored mats, attempting to "pick up" some of the colors of the artwork. I much prefer the plain, understated mats, allowing the painting to speak for itself. Under no circumstances would I recommend the use of a colored mat to match room decor.

Given the proper tools, mat cutting is not terribly difficult. A heavy-duty knife, a stainless steel straight-edge (not an aluminum yardstick, which is too soft and flexible), and a hand clamp are indispensable tools. The blade must be continually sharp, which will save you both time and labor and give the mat a clean, crisp edge. Unless you can hone your own blade, I would recommend the mat knife, which consists of a plastic handle with a locking knob and one long blade scored across its width into a dozen snap-off blades. As the tip wears down, it can be snapped off and replaced by another segment moved outward into place from the handle, locked, and quickly positioned for immediate use.

A mat can be cut from the face side or the reverse side. Most framers recommend working from the back, which permits all sorts of dark pencil guidelines to be drawn without having to worry about the need to erase afterward. Working on the face of the mat calls for more care in general handling and very faint guide marks, which will have to be erased. Cutting a straight edge, either from the front or back, should present no problem. The blade is held vertical to the matboard surface, and the cut is made straight downward. To cut a bevelled edge calls for tilting the blade at approximately a 45-degree angle and holding it at that position through the length of the cut. If you are cutting a bevelled edge from the back, keep in mind that you are working in reverse—the mat will be turned over—and the matboard should be positioned so that its greater width should always be to the right of the blade. The cutting process is as follows:

1. Use the T-square and ruler to draw the crop marks indicating the corners of the hole to be removed.

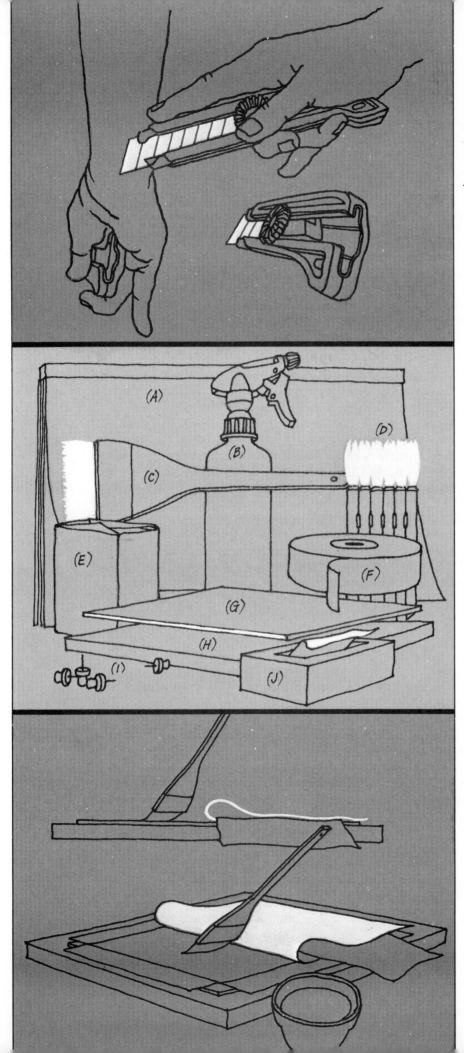

Hand Position. *The posture of the hand holding the mat knife for a bevel cut is shown in this drawing. The profile view illustrates the proper positioning of the index finger on the top edge of the knife and is used to apply pressure for the cut. The other fingers and thumb are used for control. The little finger particularly, as seen in the drawing on the left showing a back view of the hand, is in contact with the board surface for balance and to help maintain a consistent tilt to the cut. Remember, the knife and blade must be tilted for an angled cut and held at that angle throughout the length of the cut.*

Mounting Tools. *These include A, a pad of large newsprint paper, B, a water sprayer or plant mister, C, an old hake brush to apply paste, D, a soft-haired brush to smooth out the paper, E, a package of water soluble wheat paste, F, a roll of gummed tape, G, a piece of mat or illustration board, H, an old drawing board or piece of plywood at least ½-inch thick, I, push pins, and J, a box of absorbent tissues.*

Wet Mounting—First Stage. *Using strips of the gummed tape, the illustration board is pasted to the plywood. The paper is then sprayed with water evenly on both sides, using newsprint for backing. After the paper has been allowed a few minutes to soften (this is more necessary with sized papers, of course), it is aligned onto the illustration board. The paper is then doubled over, allowing for a slight overhang, as seen in the top profile illustration. If this is a painting to be mounted, a scrap piece of paper should be used for an interleaf to prevent the possibility of colors running together. Paste is then applied to the exposed half of the illustration board with the old hake brush.*

2. Place the matboard on a scrap piece of Upson board longer in length than the cuts themselves.

3. Line the steel straight-edge to the crop marks and lock the near end to the work table with the hand clamp.

4. Position your left hand firmly without exerting extreme pressure on the straight-edge above the center of the line to be cut.

5. With your right hand holding the knife, tilted for a bevelled cut, insert the blade at the top guide marking, using your little finger to support and maintain a consistent angle. Do not push against the steel edge, which might cause it to swing out of alignment.

6. Exert pressure downward and pull the blade toward you in one steady movement. With practice, you will be able to cut through one-ply matboard in one stroke, keeping a consistent angle at the same time. Using several strokes will only alter the angle of the bevel giving the cut a wobbly appearance.

SINGLE AND DOUBLE MATS

The single mat is probably the most frequently used. It is quite simple to make and very direct in appearance. To enrich and vary your presentations, while still maintaining a subtle simplicity, you may want to try a double mat.

First cut a single-ply mat, using either the straight or bevelled cut. Place the mat over a piece of Upson board of the same size. Upson, or beaver board, incidentally, comes in 4-by-8-foot sheets, is ¼-inch thick, of paper pulp composition, and can be cut with a mat knife. Draw pencil guidelines inside each corner of the single-ply mat onto the Upson board beneath. Remove the top mat and, at each corner marking, measure in ⅛ inch or ¼ inch depending on the overall size of the mat. The larger dimension is more suitable visually for larger paintings. Cut the Upson mat with a bevelled edge. Paint this edge white as well as the surrounding surface at least ½ inch in depth. When this painted portion has dried, place the top mat over the Upson mat and align it precisely. If all has gone well, a neat interior border, even all around, will show. The two mats can then be attached using double-face tape.

I like to vary this combination by using a subtly toned fabric mat on top to accentuate the white border of the interior, thicker mat.

FABRIC-COVERED MATS

While fabric-covered matboards in materials ranging from silk and linen to burlap are readily available in most art supply stores, I much prefer to make my own. By using fabrics of varying textures, colors, and thicknesses, in combination with mats of different colors, an almost unlimited number of effects can be achieved.

The color of a fabric-covered mat is determined in one of two ways. A dense, opaque material is used, and that will be the actual color of the mat. The second way is selecting a thinner, translucent fabric which will allow some of the mat color to come through. A white mat will lighten the fabric color when bonded together. A cream-color mat will not only lighten but warm a covering of cool, gray silk. To make your own fabric-covered mat, follow these steps.

1. Cut a piece of cloth large enough to cover the mat with a 1½-inch overhang on all four sides.

2. Coat the mat with a solution of white plastic glue slightly thinned with water and let it dry completely.

3. Check for missed spots by tilting the mat to the light. The areas covered with glue will have a slight sheen.

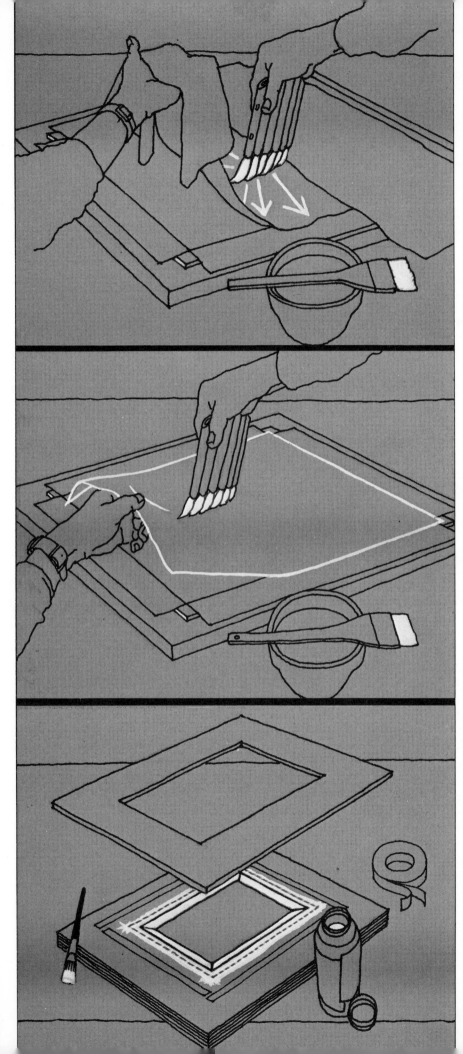

Wet Mounting—Mid-Stage. *While the paste is still wet, lift the top half of your paper by the overhang and cradle it gently in your left hand. Try to lay the paper smoothly onto the paste-covered surface nearest to the interleaf. Now, with the soft-haired smoothing brush, begin stroking gently from the center of the paper outward to the edges, removing all air bubbles. Do not press too hard or you might develop wrinkles in the surface of the paper. Continue this stroking process as the left hand slowly lowers more of the wet paper into contact with the paste covered board.*

Wet Mounting—Final Stage. *After the first half has been pasted down smoothly, remove the interleaf, rotate the board around so that the unglued portion is nearest to you and repeat the same procedure. Use the absorbent tissue to soak up excess paste and moisture on the gummed tape. Should you see any excessive warping along the edge of the illustration board or any signs of the tape loosening its grip, use the pushpins to tack it down in place again.*

Double Mat. *This calls for a combination of a single mat on top of an Upson board mat, of double thickness which is cut a little smaller to create an interior border. As seen in the drawing, the edge of the thicker, bottom mat is beveled and painted white. When the thinner, top mat is placed in perfect alignment with the bottom mat, the white painted edge will become a nice accent border for the painting. The roll of double-faced tape is used to hold the mats together and to prevent any shifting.*

4. Use a steam iron to remove any wrinkles and creases in the fabric and place it evenly on the mat.

5. Now bond the fabric to the mat by pressing the steam iron lightly into the middle of one side. Then press outward to either side of the center and complete that one border.

6. Press the two parallel borders of the mat by working alternately one side, then the other, keeping an even pace until the last side is reached.

7. Bond the remaining border. If you have not forced the fabric out of shape by pushing the iron too hard and distorting the weave, the mat should be smoothly covered.

8. Cut out an interior hole leaving at least a 1½-inch overhang.

9. Cut diagonally into the corners, turn the flaps under, and glue to the underside by the same method used for the face of the mat. The flaps on the outside edges can also be handled in this manner.

One last thought. Through trial and error I've learned to favor the natural, untreated cottons, linens, and silks. Materials which have been chemically coated for wrinkle resistance along with some of the man-made fibers seem to resist adhesion in this particular bonding method. Some of these fabrics will stick to the iron and should be tested first by placing the iron on a scrap piece of the questioned material.

FRAMING MATERIALS

Framing one's work has been considerably facilitated by the availability of many varieties of made-to-size frames of wood, metal, and plastic. Currently, the metal section frame made of extruded aluminum in silver and gold finishes is very popular. I have found this type of framing time-saving, and combined with a fabric-covered double mat, it is quite a pleasing setting for my work. While I do not use it exclusively, the simplicity conveyed by its narrow, display edge of either gold or silver often provides just the right accent. My paintings would be totally overwhelmed in an ornate, busy frame.

When time permits, I enjoy using hardwood moldings such as walnut and the softer woods, particularly bass, for my frames. These unfinished wooden frames then can be oiled and waxed, painted, stained, shellacked, leafed, or worked in any of these combinations.

The basic tools for making a frame are quite uncomplicated, the most critical being a mitre box with an accurate angle setting and a strong blade-locking device. The mitre box should also be capable of being firmly anchored to a work table. Accessory items include the mitre saw, brads of varying lengths and gauge, a tube of white plastic glue, corner clamps, wood filler, a nail set, tack hammer, steel wool, and sandpaper of mixed grades.

THE FRAMING PROCESS

To accurately cut your moldings, you must remember that all measurements are *inside* dimensions. This means that you should measure only on the side of the molding where the rabbet has been cut. This is the side where the glass will eventually have to fit when the frame has been assembled.

After the four sides have been accurately cut in length and angle, they must be joined, which is the most difficult and critical part of the frame-making operation. Pre-drill holes, slightly smaller than the size of the brads you intend to use, into one end of each section of molding, making sure they are evenly spaced across its width. For uniform distribution of strength, these holes should all be placed either in the right or left end of each piece. Smooth a small amount of glue onto the cut surface of two sections, align at a 45-degree angle, and lock them tightly in place with a corner clamp. Duplicate this process with the two remaining pieces of molding. Insert the

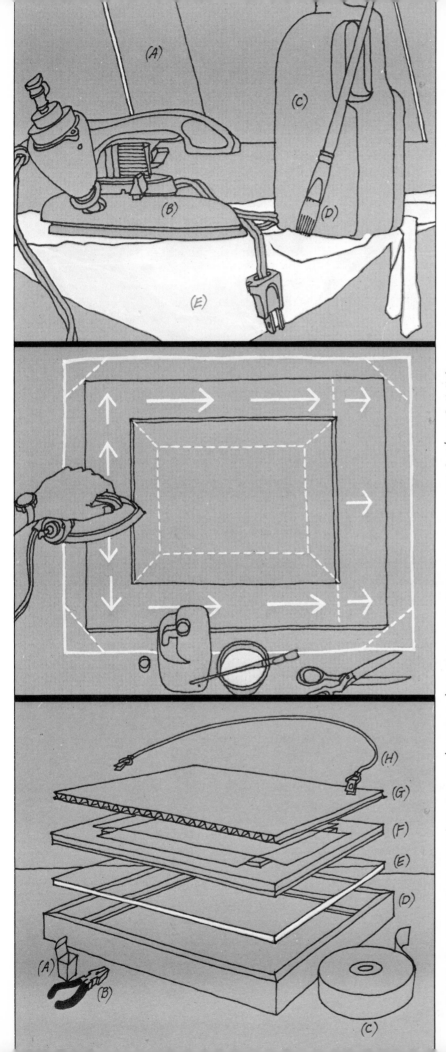

Tools for Fabric Matting. *In order to cover a mat with fabric, you should have A, the pre-cut mat, of course; B, a steam iron (I prefer a light-weight travel iron); C, a container of water soluble, white, plastic glue; D, a bristle brush to apply the paste; and E, the piece of fabric cut to size.*

Fabric Matting. *Apply a thinned solution of the plastic glue to the entire surface of the mat and allow it to dry completely. Place the fabric over the mat evenly, with an overhang allowance. With your iron set for steam, begin pressing at the middle of the short side. Work evenly from the center outward, until this side has been bonded. Now press the long sides alternately, so that you arrive at the last border indicated by the dotted lines at about the same time. The final side is ironed toward the outer edge, again working from the middle to the sides. Final steps include cutting out the center hole with an allowance for flapping around the edge and gluing onto the backside. Cut with your scissors into each corner at about a 45-degree angle to create the four flaps to turn under. Also make diagonal cuts at the outer corners so that the overhanging fabric can be turned under and glued.*

Assembling Finished Painting. *The component pieces for this process include, from bottom to top, D, the frame, E, glass, F, double mat with painting attached, G, corrugated board backing, H, hinged hooks with picture wire. Items A, B, and C include a box of 1-inch brads, pliers, and a roll of gummed tape. After all the pieces are placed inside the frame, the brads are inserted into it to hold everything in place. The tape is used to join the frame to the cardboard backing. In the process, the tape will also cover the unsightly brads and provide additional protection against dust and humidity. If the frame is deep, you can start the tape on the back edge, bend it onto the inside surface of the molding, over and across the brads, and finally onto the corrugated board.*

brads and tap into place. You should have a pair of L-shaped forms after these operations. After allowing a few minutes for the glue to dry and take hold, remove the sections from the clamps and place them on a flat surface in their proper frame position. Now check to see that these two units lie completely flush to the surface. If there is any wobble or tilt, it means that the pieces have been improperly cut or joined, or the molding is warped, and the frame will have to be remade. While the frame can be assembled with this built-in warp, you will find that the frame will not sit evenly to the wall when hung, and one corner will always be awkwardly raised from the surface.

After the frame has been successfully joined, use your nail set to punch the brads slightly below the surface of the wood at each corner. Fill these holes with a small dab of wood filler and, when dry, rub it with sand paper and steel wool to form an even surface. The frame can now be finished to complement the painting and mat.

ASSEMBLING PROCEDURE

The component pieces in a finished painting should include these items.

1. The mounted painting.

2. The mat, either single or double.

3. Glazing material, either glass or plastic.

4. A protective board backing. Corrugated cardboard is usable if it does not come in direct contact with the artwork.

5. Frame.

6. Protective kraft-paper dust cover.

7. Hanging hooks and picture frame wire.

8. Glass cleaner or anti-static plastic cleaner.

The first step in putting your painting together is to attach the mounted painting to the back of the mat. I use gummed tape which has a water-soluble adhesive rather than the pressure-sensitive tapes. Next, place the piece of glass onto a cloth-covered table to prevent accidental scratches. Clean this side and place the painting, with attached mat, face down onto this surface followed by the board backing. Now turn the three units over together as one unit, so that the painting is visible through the glass, then clean this final surface. If a plastic sheet is used instead of glass, the process is essentially the same except for the need to first peel off the protective paper before applying and thoroughly cleaning with the anti-static solution. The paper-peeling process can be more easily accomplished by working one corner loose, attaching it to a cardboard tube placed diagonally across the sheet and rolling up the remainder.

Next, place the frame around the three layers and flip the entire unit over, face down again. Then force small brads, ¾-inch or 1-inch in length, into the inside of the frame pressing downward at the same time to hold the painting, glass, and backing tightly to the frame. To augment this, I also use 2-inch-wide gummed tape to further join the frame to the backing. The tape overlaps the brads and, at the same time, seals any cracks which might allow dust to seep in. Finally, a sheet of brown kraft paper is glued across the back of the painting extending to the outer edges of the frame for additional protection against dust and moisture. Hinged picture hooks rather than screw eyes, which protrude too much, are then attached, and multi-strand wire is threaded through each hook. Make sure the wire does not extend beyond the top edge of the frame when supported from the center. The painting is now ready for display.

THE STUDIO

Probably the most critical need in any studio arrangement is space. Compared to working with other mediums, the actual painting of watercolors requires very little work space. It is all the attendant elements that seem to require space.

I have two basic tables, one for painting, the other for mat cutting and framing. Both are 3 feet by 6 feet in size. The work table is located in close proximity to a water source and placed to take advantage of the north light. There are also fluorescent and incandescent lights overhead for those occasions when I work into the late afternoon and early evening. The combination seems to be fairly color accurate lighting for my work.

Located between the work tables, with aisle space at each end, is a large storage bin, 6 feet by 8 feet by 4 feet in size. This unit holds finished and framed paintings, sheets of Upson board, packing materials, and miscellaneous pieces of matboard. Adjoining the work table is a large steel cabinet containing five drawers large enough to store full sheets of matboard and other art papers. This metal unit rests on a low table mounted in casters and also has two shelves for accommodating rolls of material.

Finally, there are two drawing tables with tilt tops and parallel rules attached to both. One table is 5 feet in width and is used primarily for measuring large mats. The other, much smaller in size, is used for a variety of art activities. An easel on casters is used for occasional touch-up painting but more frequently for display and general viewing during the painting process.

Any studio arrangement will probably be determined by the basic needs of the individual artist. I think the main consideration should be the placement of all the essential units in such a way that related art activities can be handled with a minimum of movement.

While I hesitate to call my studio a haven, it is comfortable without being distractingly so. Best of all, it gives me a very functional work environment.

BIBLIOGRAPHY

Austin, Robert; Levy, Dana; and Ueda, Koichiro. *Bamboo*. New York, John Weatherhill, 1970.

Chiang, Yee. *Chinese Calligraphy*. Cambridge, Harvard University Press, 1954.

———*The Chinese Eye*. London, Methuen & Co., 1960.

Ecke, Tseng Yu-ho. *Chinese Calligraphy*. David Godine in association with Philadelphia Museum of Art, 1971.

Mayer, Ralph, *The Artist's Handbook*. New York, Viking Press, 1970

Sze, Mai-mai. *The Way of Chinese Painting*. New York, Random House, 1959.

INDEX

April Morning, 30
Assembling finished painting, illus. of, 147; procedures for, 148

Bamboo, 12; branches, illus. of, 48; complete painting of, illus. of, 49; leaves, illus. of, 47; segments, illus. of, 46; stalks, illus. of, 46
Bridge, demonstration painting, 107-111
Bridges, techniques of painting, 104-106
Brush, basic function of, 11; breaking in, illus. of, 19; broad, illus. of, 16; construction of, 12; construction of Oriental, illus. of, 13; creating, 12; drying of, 20, illus. of, 19; extending life of, illus. of, 21; feel of, 11; functions of, 12; hake, cleaning of, 20, using of, 18; holding of broad, illus. of, 17; holding of short-handled, illus. of, 15; Japanese hake, illus. of, 16, manipulating of, 14; Oriental, 11-12, illus. of, 13; rare bamboo, illus. of, 16; red sable, 11; rinsing of, 20; short-handled, illus. of, 15; sizes of, 11; square-ended hake, 14; starch used on, 18; storing of, 20; transporting of, 20, illus. of, 21; variations of short-handled, illus. of, 15; washing of, 20; Western, 11, illus. of, 13
Brush rest, 20; illus. of, 19
Brushstrokes, combining Eastern and Western, illus. of, 53; definition of, 43; impact of, 43; reverse, illus. of, 50; suggestions for creating, 57; types of, 43

Calligraphy, 9, 11, 12, 23; style in, 14
Canal Street, 132
Cap, used on new brushes, 12
Chinatown Sunday, 100
Chi Pai Shih, 89
Cleansing tissue, uses of, 18
Clouds, billowing, illus. of, 94; forming, 90; Oriental interpretations of, illus. of 93; thin, high, illus. of, 94; wet, illus. of, 93
Color, layering of, 34
Construction on Catherine Street, 133
Counter mounting, 139
Crinkling, dry, 73; illus. of, 74

Doves, 136
Drawing skills, developing, 9

Evening Trail, 42
Eyedropper, uses of, 18

Ferrule, 12
Fields, using washes to represent, 82
Fog, forms in, 96; representing, 96
Fog, sky, water, illus. of, 91
Fog This Evening, demonstration painting, 97-99
Foliage, 77; autumn, illus. of, 83; combined vegetation, illus. of, 81; representing, 78; spring, illus. of, 81; summer, illus. of, 81; winter, illus. of, 83
Foliage, strokes for, illus. of, 44
Forest, 78-82; illus. of, 80
Framing, materials for, 146; process of, 146-148

Grip, traditional Oriental, illus. of, 17; Western, 14
Grass, illus. of, 45

Hair, types used for brushes, 12
Halloween, demonstration painting, 57-61
Hand, supporting of, illus. of, 17
Harbor View, 76
High Wind and Rain, 68
Hunters, 138

Idyll, 10
Ink, stick, 57; stone, 57

Kolinsky, 11

Last Run, 135
Late Summer, 129
Light, quantities, 89
Lion Dance, demonstration painting, 123-125

Making Watercolor Behave by Eliot O'Hara, 5
March Flight, 136
Matting, cutting of, 142-144; double, 144, illus. of, 145; fabric, illus. of, 147; fabric-covered, 144-146, materials for, 142; proportions, 142; single, 144, tools for, fabric, illus. of, 147
Morning in Summer, demonstration painting, 84-87
Mounting, additional cautions to be used in, 140-142; basic materials of, 139; final stage, illus. of, 145; first stage, illus. of, 143; mid-stage, illus. of, 145; steps in, 139-140; tools, illus. of, 143; wet-mounting, 143-145

Nature, substances of, 89

New Snow, 22
Nightfall, 88

Oak, mature, 79
Old Corner, 134
Overhead on Mott Street, 130

Painting on sized paper, illus. of, 33
Painting on unsized paper, illus. of, 33
Palette knife, stiff, uses of, 20
Paper, absorbent, 23; care of, 28; Chinese, 24; estimating moisture on, 38-41; *Goyu*, illus. of, 29; handling of, 28; *Hosho*, 24, illus. of, 25; invention of, 23; Japanese, 24; *Kozu*, illus. of, 25; *Masa*, 26, illus. of, 29; *Moriki*, 26, 28, illus. of, 27; mounting, 34; nonabsorbent, 24; *Okawara*, 26; "rice," 24; *Shinsetu*, 26; sized surfaces, 31; sizes of, 28; sizing of, 24; storage of, 28; *Suzuki*, 28; thickness of, 26; thin, 23; *Torinoko*, 26, illus. of, 27; *Troya*, 26, illus. of, 27; using sized, 32; variety of, 23
Pell Street, 8

Queens Plaza, demonstration painting, 63-67

Red tartar martin see Kolinsky
Returning, demonstration painting, 126-128
Rock formation, illus. of, 51

Scholar, demonstration painting, 113-115
Seasonal changes, 82
Self-portrait, 25
Shapes, geometric, understanding, 101, illus. of, 103
Siberian mink (see Kolinsky, see also, red tartar martin)
Sky, clear, painting of, 89-90; "empty," 90; illus. of, 91; overcast, illus. of, 93
Skyline, painting of, 104; scene of, illus. of, 103
"Son-sui," 89
Sponge, natural, uses of, 18
Spatial relationships, illus. of, 52
Spray bottle, plastic, uses of, 18; 69
Squeeze bottle, plastic, uses of, 18
Street, perspectives of, 104; scene, illus. of, 105
Stroke, calligraphic, 31; outline of configuration, 31
Structures, details of, 106; Eastern perspective, illus. of, 102; motifs, illus. of, 102; painting of, 101; relating, 101-104; rural, 106; simplifying, 104; Western perspective, illus. of, 102

Studio, description of, 149
Summers Ago, demonstration painting, 120-122
Sunday on Mott, 131

Technique, back painting, 75; blotting, 70, illus. of, 71; crumpled paper, 77; dipping, 70, illus. of, 71; dripping, 70, illus. of, 73; dry brush, 77, limitations of, 75; limited wetting, 69-70, illus. of, 71; spattering, 70, illus. of, 73; sponging, 70, illus. of, 73; wet paper, 69
Textures, dry, illus. of, 54-55
The Mustard Seed Garden Manual of Painting, 43
Tools, basic for mat cutting, illus. of, 141
Trees, illus. of, 45; 56; Eastern and Western techniques representing, illus. of, 79; forms, 78, illus. of, 79; structural patterns of, 77; thumbnail sketch, illus. of, 80; visualizing as an umbrella, illus. of, 80
Tree in Fog, 95
Troubadour, 129

Upson board, 141; cutting bevelled edge, 141; illus. of, 141

Vendor, demonstration painting, 116-119

Washes, 23; adding water to, 32; as a backdrop, 31; brush not fully loaded, illus. of, 37; color burst, illus. of, 39; controlling, 31; creating third value, illus. of, 40; diluted, 34; directional flow, 41, illus. of, 40; flat, 31; flat on dry paper, illus. of, 35; flat on moist paper, illus. of, 35; flowing of, 34; free-flowing, illus. of, 36; graded, 32, illus. of, 35; hazards of multiple, 34; multiple, 32, 34, illus. of, 36; overlapping, illus. of, 36; restricted, 38, illus. of, 37; testing density of, illus. of, 33; wash against, 38, illus. of, 39; wash into, 38, illus. of, 37

Water, bodies of, 90-92; calm, illus. of, 95; movements of, 92-96; Oriental version of agitated, illus. of, 94; reflecting surfaces of, 92; swirling, illus. of, 95
Windows, illus. of, 105
Winter Sun, 135

Edited by Connie Buckley
Designed by Bob Fillie
Set in 11 point Caledonia by Gerard Associates Phototypesetting, Inc.
Printed by Halliday Lithographic Corp.
Bound by A. Horowitz and Sons